Classic Ground

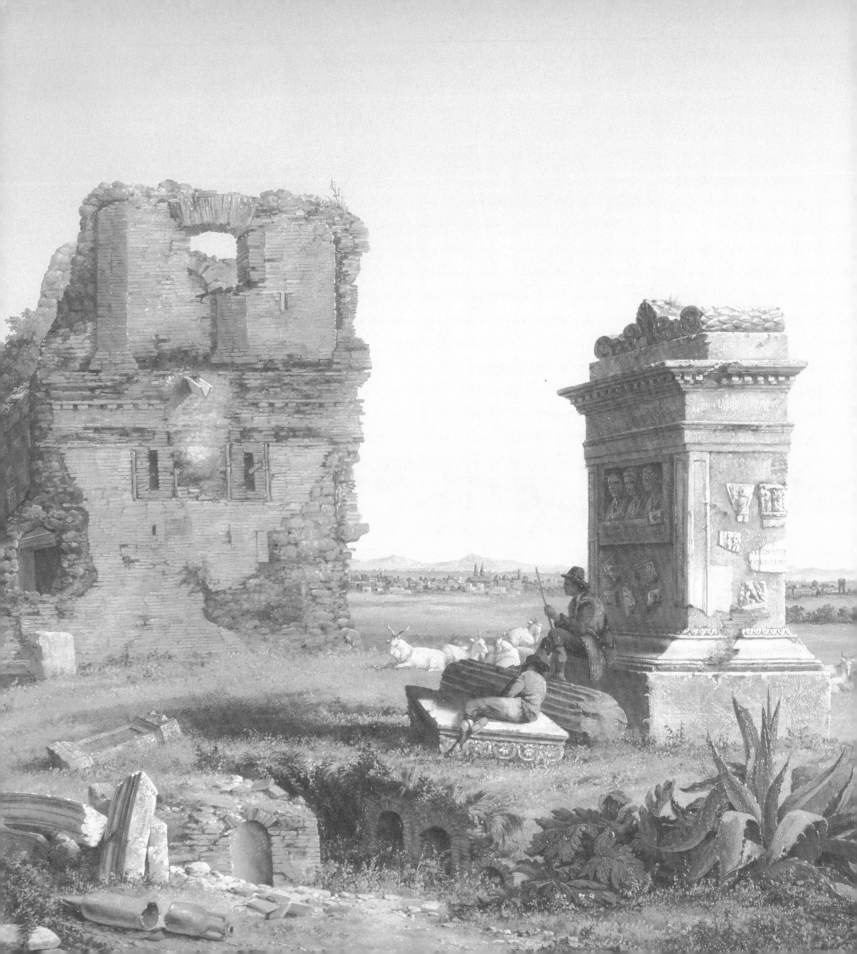

Classic Ground

MID-NINETEENTH-CENTURY
AMERICAN PAINTING AND THE
ITALIAN ENCOUNTER

PAUL A. MANOGUERRA
WITH AN ESSAY BY JANICE SIMON

GEORGIA MUSEUM OF ART & ATHENS, GEORGIA

FIGURE DETAILS: cover, John Linton Chapman, *Via Appia*, 1867; p. 6, Jasper Francis Cropsey, *The Colosseum (Coliseum)*; n.d.; p. 9, George Loring Brown, *Effect Near Noon—Along the Appian Way*, 1858; p. 10, Jasper Francis Cropsey, *Ruins at Narni, Italy*, 1875; p. 12, Thomas Cole, *Sunset on the Arno*, after 1838; p. 34, Martin Johnson Heade, *Roman Newsboys*, about 1848-49; p, 50, John Frederick Kensett, *Italian Scene*, c. 1847; p. 72, Thomas Cole, *The Cascatelli, Tivoli, Looking Towards Rome*, c. 1832; p. 88, Jasper Francis Cropsey, *Temple of Neptune, Paestum*, 1859.; p. 106, John Gadsby Chapman, *Service of Mass on the Campagna*, 1878.

Works included in the exhibition appear in color.

DESIGN: Kimberly Adis
DEPARTMENT OF PUBLICATIONS: Bonnie Ramsey, Rebecca Yates and Linnea West

Printed in an edition of 1000 by Friesens
Printed in Canada

Partial support for the exhibitions and programs at the Georgia Museum of Art is provided by the W. Newton Morris Charitable Foundation and the Georgia Council for the Arts through the appropriations of the Georgia General Assembly. The Council is a partner agency of the National Endowment for the Arts. Individuals, foundations, and corporations provide additional support through their gifts to the University of Georgia Foundation.

Library of Congress Cataloging-in-Publication Data
Manoguerra, Paul A.
 Classic ground : MID-NINETEENTH-CENTURY AMERICAN PAINTING AND THE ITALIAN ENCOUNTER / Paul A. Manoguerra ; with an essay by Janice Simon.
 p. cm.
 Published in conjunction with an exhibition held Oct. 23, 2004-Jan. 2, 2005 at the Georgia Museum of Art.
 Includes bibliographical references.
 ISBN 0-915977-54-0
 1. Painting, American—19th century. 2. Italy—In art.
3. Artists—United States—Travel—Italy. I. Simon, Janice. II. Georgia Museum of Art.
III. Title. ND210.M28 2004
 758'9945'097309034—dc22
 2004013163

Sponsors

ALFRED HEBER HOLBROOK SOCIETY MEMBERS: BEVERLY H. BREMER ✑ M. SMITH GRIFFITH

C. L. MOREHEAD, JR. ✑ D. JACK SAWYER, JR. ✑ WILLIAM E. TORRES, M.D.

W. NEWTON MORRIS CHARITABLE FOUNDATION ✑ FRIENDS OF THE GEORGIA MUSEUM OF ART

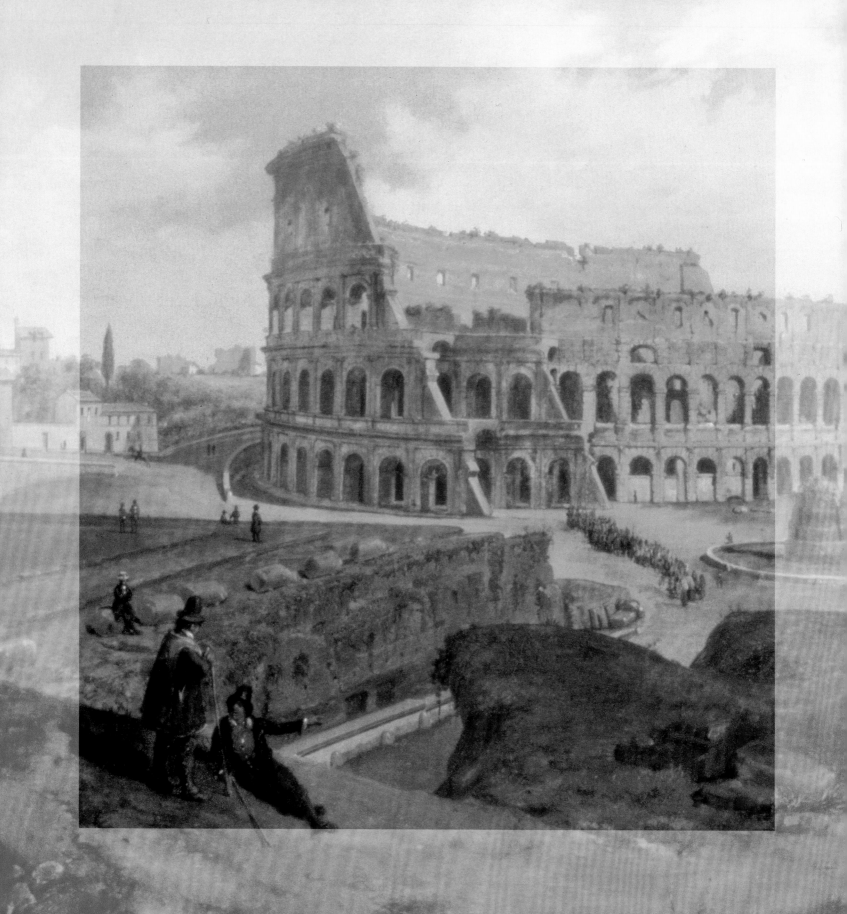

Contents

Preface

Alfred Heber Holbrook founded the Georgia Museum of Art in 1948 by donating the Eva Underhill Holbrook Collection of American Art to the people of the state of Georgia through its flagship university. Consequently, that collection has grown and become a major resource for study by our students, research by scholars, and enjoyment by our public. Our American pictures are often sent to exhibitions at national and international venues, and several among them are considered "textbook" examples of certain styles or schools in the history of American art. It is, therefore, a special pleasure to present this volume of essays, and the exhibition of which they are a record, to our audiences. Our curator, Paul Manoguerra, and our guest essayist, Janice Simon, reveal the connections between the two worlds, one Old, one New, in their insightful studies of American painting of the nineteenth century. Thus, they find in Italy—its land, its people, and its history—the classic ground for an American tradition, and American context, of which these pictures are testament and witness.

William Underwood Eiland, *Director*

Acknowledgments

THIS BOOK AND EXHIBITION ARE THE RESULT OF THE most gracious and generous assistance of many people. Thank you to the entire staff of the Georgia Museum of Art for all of their work with *Classic Ground*. My fellow curators, Ashley Callahan, Dennis Harper, and Romita Ray, and our director, William U. Eiland, create a wonderful academic environment in which this project was welcomed and encouraged. Janice Simon's eloquent reading of John Frederick Kensett's *Italian Scene* meshes delightfully with my own essays; I thank her for allowing me to include her perceptive reading in this book. Bonnie Ramsey and Rebecca Yates deserve acknowledgment for their extensive work on the production of this book. I also thank Annelies Mondi and the registrars, Greg Benson and the preparators, and Tricia Lichter for their advice, dedication, and assistance on *Classic Ground*.

In particular, I am grateful to the staffs of the lending museums and institutions: Allen Memorial Art Museum at Oberlin College, Columbus Museum of Art, High Museum of Art, Frances Lehman Loeb Art Center at Vassar College, Michigan State University Libraries-Special Collections, the Minneapolis Institute of Arts, the Newark Museum, the Newington-Cropsey Foundation, North Carolina Museum of Art, Spanierman Gallery, Toledo Museum of Art, and the West Foundation, Atlanta. A special thank you to Peter Berg,

Mark Cole, Patrick Noon, Gavin N. Spanierman, Anthony M. Speiser, Lucille Stiger, and Sylvia Yount for their assistance. I also extend my gratitude to the sponsors of the exhibition and publications: Alfred H. Holbrook Society members Beverly H. Bremer, M. Smith Griffith, C. L. Morehead, Jr., D. Jack Sawyer, Jr., William E. Torres, MD; the W. Newton Morris Charitable Foundation; and the Friends of the Georgia Museum of Art.

Classic Ground has its spiritual origins in a sophomore year abroad (too many years ago now) on the Saint Mary's College (Indiana) Rome Program. The powerful memories of that experience continue to sustain me to the present day. This book and exhibition have their foundation in my dissertation for the American Studies program at Michigan State University. I am indebted to all the readers and commentators on my dissertation, both at Michigan State and elsewhere, including David Cooper, Victor Jew, Bruce Levine, Kimberly Little, David LoRomer, Patrick Lee Lucas, and Raymond Silverman. I offer special appreciation to Kenneth Haltman for his keen and always constructive criticism, his good humor, and his unceasing encouragement of *Classic Ground*.

I could never have completed this book and exhibition without the loving encouragement, understanding, and support of my family. Above all, I thank my wife, Michelle.

PAUL A. MANOGUERRA

Paul A. Manoguerra ✵ Georgia Museum of Art

Classic Ground

IN HIS BOOK *THE DREAM OF ARCADIA*, VAN WYCK BROOKS noted that, in the mid-nineteenth century, "a Roman winter became 'the fashion'"[1] and that Italy became a popular site for many American tourists and artists. As a result of their mid-nineteenth-century Italian travels within a "Grand Tour," Martin Johnson Heade, Albert Bierstadt, Sanford Robinson Gifford, John Frederick Kensett, Jasper Francis Cropsey, and other American painters created a body of work featuring Italian landscapes, people, buildings, and life. This exhibition and publication examine the cultural history of a group of art objects, their reception and context in America just prior to and after the Civil War. *Classic Ground* does not offer a survey of mid-nineteenth-century American images of Italy. However, this exhibition and catalogue address broad issues in relation to specific paintings and their American nineteenth-century context. In their images, these American artists shaped and reshaped American political, religious, and cultural ideologies through the construction and manipulation of their subject matter. They encoded the values, ideas, and beliefs of nineteenth-century America within their works. A portion of *Classic Ground* relies upon the travel stories told by the numerous mid-nineteenth-century American painters who, along with tourists, writers, and sculptors, traveled to Italy. Much of these painters' art addresses seminal questions about faith, nature, and national destiny:

- ✺ Why visit and depict Italy? What does that tell us about American artists? What does the Grand Tour, as a whole, explain about the world-view of American artists?
- ✺ How might intersections of race, class, and gender, with the implicit questions of power and hierarchy, inform readings of American paintings on Italy?
- ✺ How might close readings of specific paintings reflect and encode the beliefs, values, ideas, attitudes, and assumptions of mid-nineteenth-century Americans?

The special relationship with Italy that nineteenth-century Americans constructed for themselves found its base in a single metaphor, which explained the United States as the heir to the democratic ideals of the ancients. One task of this project involves investigating the manner in which the visual and textual representation of a "foreign" land—Italy—ultimately becomes a commentary, not on the visited place, but on the homeland—the United States—temporarily left behind, as well as the place the homeland occupies within the larger world. American visitors often experienced their Italian sojourn as if they were traveling into some distant, noble past, with the contemporary Italians remaining a colorful, sometimes disdainful, distraction from ennobling historical associations. American tourists (including the painters discussed in this book and

featured in the exhibition) believed that they knew and understood more about the great and ancient history of the tourist sites—Rome, the *campagna*, Paestum, and Tivoli, among others—than the Italians themselves. This American "knowledge," objectified and culturally transferred through travel accounts, souvenirs, sculptures, and paintings, allowed Americans to use Italy to confirm and advance an American sense of history, perpetuating important beliefs in American exceptionalism.

Classic Ground has been so titled because of the multiple and useful meanings of the two words. The American paintings contextualized in this exhibition and publication are "classic" in the sense that they serve as outstanding representatives and models of nineteenth-century American image-making. As part of museum and gallery collections, these "classic" paintings hold lasting significance and recognized value. The artists painted in a "classic" manner, or in accordance with established principles and methods. And the primary subject matter of the images centers on the ruins (the actual remains of architecture and the remnants of past ideals hidden by contemporary Italy) of the classical era of both ancient Greece and ancient Rome. The ground, the preparatory coat of paint on which these pictures were painted, becomes an area of reference for several beliefs and premises encoded within the images. Primarily landscape paintings, these images use the ground of Italy as a symbolic area of land designated by the painters for constructing meaning related to the American experience.

Synthesizing close textual readings of paintings with concerns for cultural and social analysis, *Classic Ground* discusses paintings not only as objects of aesthetics and high art but as participants in a discourse of politics, race, gender, and religion.[2] These paintings, created by Americans and imagining Italy, take part in the definition and construction of a national identity prior to the Civil War, during the war, and throughout the era of Reconstruction. The selected timeframe for *Classic Ground* includes antebellum American

painting with Italian subject matter from the years 1848 to 1860. Several convenient benchmark events make the antebellum era useful for this endeavor: in 1848, with the close of the Mexican War, the death of "the father of American landscape painting" Thomas Cole, and the American reactions to the Revolutions of 1848 in Europe (especially the Risorgimento movement in Italy); and in 1860, with the election of Abraham Lincoln and events leading to the Civil War, and the unification of Italy minus the Papal States in that same year. Post-Civil War images in this exhibition reflect the significant cultural issues leading into the 1870s: Reconstruction of the "Union" in the United States, and the results and problems of unification in Italy.

CLASSIC GROUND BUILDS UPON SCHOLARSHIP in three areas: (1) historical texts on republicanism, Neo-classicism, cultural identity, and the social and political aspects of the mid-nineteenth-century United States; (2) art historical literature on art production in nineteenth-century America; and (3) art historical works on the history of the Grand Tour of Europe, and the English and Americans as tourists in Italy. Numerous recent works on antebellum America focus on the social, political, and cultural history of the "new" country between the Revolution and the Civil War. In *The Radicalism of the American Revolution*, Gordon S. Wood states that within a single lifetime there was a "reconstitution of American society," the overthrow of the "bonds holding together the older monarchical society—kinship, patriarchy, and patronage." He maintains that equality and, in a certain sense, democracy were the unintended consequences of the "forces unleashed" by the radical and republican reconstitution of American society.[3] This exhibition and catalogue investigate questions of cultural identity—how Americans of the Civil War era examined not only who they were but also who they wanted to become. How does this set of paintings reflect questions

I ❧ GEORGE INNESS, A Bit of the Roman Aqueduct, *1852.*
Oil on canvas, 39 x 53 ⁹⁄₁₆".
High Museum of Art, Atlanta, Georgia, purchase with funds
from the Members Guild and through exchange, 69.42

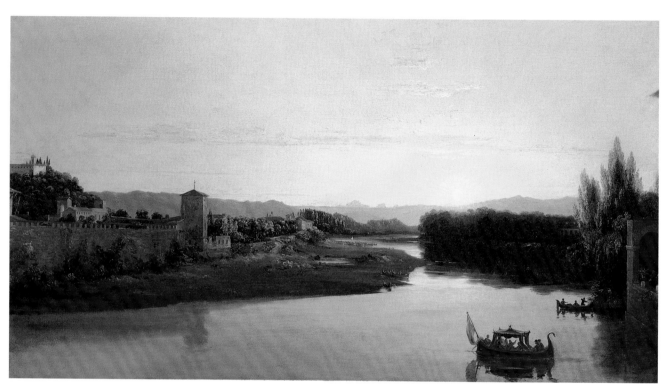

2 ❧ THOMAS COLE, Sunset on the Arno, *after 1838*.

Oil on canvas, 33 ⅝ x 61 ½".

Courtesy Spanierman Gallery, LLC, New York.

of self-government, republicanism, class, race, and gender within American visual culture? How might issues of cultural hegemony appear in specific images and in the larger mid-nineteenth-century visual culture?

ARTISTS OF MID-NINETEENTH-CENTURY America depicted Italy as the subject in many of their works.[4] American artists had many reasons to visit Italy: to view the classical world, to learn ancient history, to celebrate classical moral virtue, and to have a personal adventure. They went to copy famous paintings, to behold the galleries of Rome, Florence and Venice, and to experience the sights, the light, and the local color. American artists endeavored "to come to terms with the European past, which they recognized as their own, and their sense of living in the American present."[5] Nineteenth-century Americans in Italy were continuing the English tradition of the Grand Tour. Paul Hazard, in referring to seventeenth-century individuals including Christina of Sweden, John Locke, and Gottfried Willhelm Leibnitz, says that "philosophers went abroad, not to go and meditate in peace in some quiet retreat, but to see the wonders of the world." For eighteenth-century Englishmen, the Grand Tour almost always involved a trip to Paris and a tour of Venice, Florence, Naples, and Rome. From this itinerary, various other sites were added to the Grand Tour, often including Amsterdam, Bruges, Brussels, Berlin, Dresden, Prague, Vienna, Munich, and Geneva. Travel was an education and a valuable life experience for a proper English gentleman and thinker. For British tourists, "Rome was the goal.... In a culture dominated by the classics, Rome was the focus of interest." All of the ancient republics, Athens, Thebes, Sparta, and Rome, were familiar to learned people in the eighteenth century. The Roman writers, including Cicero, Virgil, Sallust, Tacitus and others, with their emphasis on political and social virtues, fascinated English intellectuals of the eighteenth century.[6]

By the time mid-nineteenth-century Americans traveled abroad, an elaborate cultural apparatus had attached itself to the landscape of Italy. Guidebooks provided detailed lists of sights and towns to visit according to specified routes. Followed repeatedly for decades, the routes achieved canonical status. Each site held its own associations with historical, artistic, and literary traditions. For all American painters in Italy from the 1840s through the 1870s, especially for those working for patrons while on a Grand Tour, the *veduta* tradition and the imagery of Claude Lorrain (1600-1682) operated as a constant influence. American landscape painter George Inness serves as an excellent example of a young artist who absorbed the influence of the "old masters," especially Claude Lorrain and Gaspard Poussin (1615-1675). Following his marriage in 1850, Inness and his wife spent two years in Italy, taking up residence in Florence and Rome. Back in New York in 1852, after having "studied and painted eagerly, searching and studying the masters with an intensity and an eagerness which almost consumed him," Inness painted *A Bit of the Roman Aqueduct* (fig. 1). Painting as a "young Claude," he fashioned a view of the Roman *campagna* following seventeenth-century conventions of landscape painting.[7] Mid-nineteenth-century American artists, including Inness, in Rome and its environs had also been preceded in Italy by the British watercolorists, including John Robert Cozens, Richard Wilson, and J. M. W. Turner, and by generations of French, German and Dutch painters.[8]

IN THIS BOOK, JANICE SIMON DISCUSSES JOHN Frederick Kensett's *Italian Scene* (fig. 13), also reminiscent of Claude Lorrain's paintings inspired by the countryside of Italy. Born in Cheshire, Connecticut, in 1816, Kensett was in Italy, traveling to Rome, Naples, Paestum, and Capri, from 1845 to 1847.[9] Using a hazy, illuminated atmosphere in *Italian Scene*, Kensett references the Italian past through the inclusion of an ancient Roman bridge in the middle ground. Kensett also includes

*I*taly, its landscape, its architecture, and its people, functioned as a didactic window, a living museum, of the past.

an anthropomorphized rocky cliff in the left foreground. The rocky natural form suggests a divine presence, a silent witness to the course of history. Writing from Italy in the summer of 1847, Margaret Fuller discussed the constant historical associations that an American tourist in Italy feels: "Every stone has a voice, every grain of dust seems instinct with spirit from the Past, every step recalls some line, some legend of long-neglected yore." In *The Marble Faun*, based upon observations by its author from travels in 1857 to 1859, Nathaniel Hawthorne's description of an Italian vista resonates with Kensett's painted version of the Italian ancient landscape:

> Before them again, lies the broad valley, with a mist so thinly scattered over it as to be perceptible only in the distance, and most so in the nooks of the hills. Now that we have called it a mist, it seems a mistake not rather to have called it sunshine; the glory of so much light being mingled with so little gloom, in the airy material of that vapor. Be it mist or sunshine, it adds a touch of ideal beauty to the scene, almost persuading the spectator that this valley and those hills are visionary, because their visible atmosphere is so like the substance of a dream.[10]

Simon argues that Kensett's *Italian Scene* reverberates with the dream-like history of Italy, reflective of geological time and the epiphanic, apocalyptic history of humankind. In the ancient rocks, river valleys, and venerable woods, so exhilarating to the numerous romantic poets and artists who visited Italy, resided crucial clues to Creation and the Divine Order of history. Italy, its landscape, its architecture,

and its people, functioned as a didactic window, a living museum, of the past.[11]

BUT THESE AMERICAN ARTISTS OF THE 1840s through the 1870s built upon an American tradition of depicting and interpreting Italy. Gordon Wood writes that "Classical republican values existed everywhere among educated people in the English-speaking world, but nowhere did they have deeper resonance than in the North American colonies.... The Americans did not have to invent republicanism in 1776; they only had to bring it to the surface."[12] American republicanism carried with it an affinity for the ancient history of the Italic peninsula, especially for pre-imperial Rome. During the formative years of the early republic in the United States, the classical world bewitched America. The promise of perfect beauty and a model of austere civic virtue (and American patriotism) were some of the ideals that classical taste held for wealthy Americans.[13] In the colonial era, Benjamin West and John Singleton Copley sought the fellowship and artistic life of London and Rome. In the first half of the nineteenth century, Rembrandt Peale, John Vanderlyn, and Washington Allston, among others, went to Italy to view the tourist sites and to sketch scenes made famous through historical associations. The more famous a location, the more noble a subject the site became. Primeval wilderness, as in the New World, was almost unknown, and the character of Italy had been shaped not only by the passage of

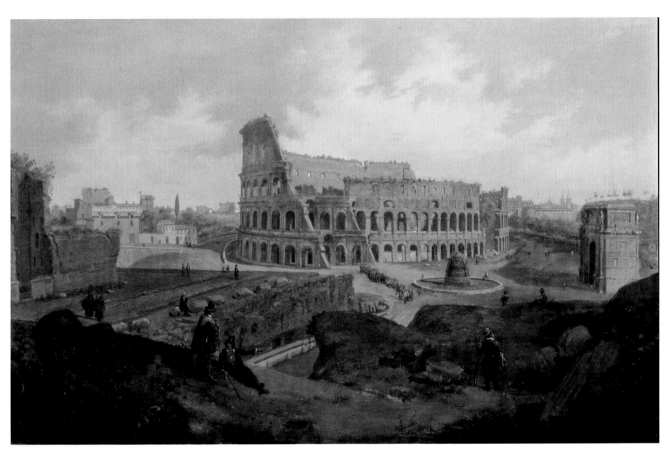

3 ✒ JASPER FRANCIS CROPSEY, The Colosseum (Coliseum), *n.d.*
Oil on canvas, 20 ½ x 32".
Collection of the Newington Cropsey Foundation.

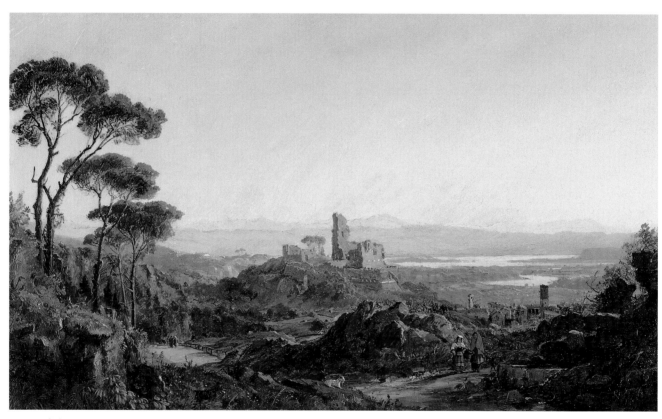

4 ✒ JASPER FRANCIS CROPSEY, Ruins at Narni, Italy, *1875*.
Oil on canvas, 11 ⅝ x 19 ½".
Georgia Museum of Art, University of Georgia;
extended loan from the West Foundation Collection, Atlanta.
GMOA 1997.101E

centuries but also the rise and fall of human civilizations. For Americans, the golden age of Italian travel, beginning with the 1840s, coincided with the age of romanticism and the vision of the United States as involved in a democratic experiment. Nathaniel Hawthorne, in the opening chapter to *The Marble Faun*, notes the vague intermingling of history, memory and texture that Italy impressed upon many American visitors: "Side by side with the massiveness of the Roman past, all matters that we handle or dream of nowadays look evanescent and visionary alike."[14] Thomas Cole's *Sunset on the Arno* (fig. 2) reflects Cole's belief that Italy was a "land evoking the classical ideals of harmony and prosperity," and in the Italian landscape "the pastoral state represents man existing in harmony with nature, and with himself."[15] For American artists of the generation after Cole, Italy was established not only as a great "museum" of the past with classic beauty but also as a site of beautiful light, interesting local people, and sublime and picturesque views.

THOMAS COLE SERVES AS A SEMINAL FIGURE in understanding American artistic approaches to Italy in the mid-nineteenth century. His death on 11 February 1848, just ten days after his forty-seventh birthday, precipitated an outpouring of printed and painted eulogies. The *New-York Evening Post* described Cole's passing as a "public and national calamity." William Cullen Bryant, in his *Funeral Oration*, compared it to a violent convulsion in the natural order that "amazes and alarms us." Concluding, Bryant asserted that "[Cole] will be reverenced in future years as a great master in art." Later that year the members of the American Art-Union, the National Academy of Design, and the New-York Gallery of the Fine Arts cooperated and displayed a memorial exhibition of Cole's paintings at the Art-Union building. This exhibition, which included many of Cole's Italy-inspired paintings, had a significant impact on a younger generation of landscape painters—many whose

works appear in this project—and their potential patrons.[16]

Several young American artists made the journey to Italy as a significant part of their ongoing artistic education. After a short-lived career as an architect, Jasper Francis Cropsey turned to landscape painting in the mid-1840s. He became famous for his landscapes of American autumns in the northeast. In 1847, Cropsey traveled to Europe on a honeymoon with his wife, Maria. They went to England, Scotland, France, and Switzerland before arriving in Italy that fall, and, while in Rome, visited the historic sites that had become a canonical part of any stay in the city. *The Colosseum (Coliseum)* (fig. 3) shows the ancient Flavian amphitheater and the Arch of Constantine in Rome as viewed by tourists from near the Arch of Titus. The following summer, the Cropseys shared a villa with sculptor and author William Wetmore Story and his wife in Sorrento. With the revolutionary events in Europe in spring 1849, the Cropseys left Italy for France and England, arriving back in the United States in mid-summer. Although Cropsey never returned to Italy, for the rest of his career he created oil paintings, including *Ruins at Narni, Italy* (fig. 4), recollected from the sketches he made during his sojourn in the late 1840s.

In 1856 and 1857, young American painter Albert Bierstadt, following study in Düsseldorf, traveled with fellow artists Worthington Whittredge, William Stanley Haseltine, and Sanford Robinson Gifford throughout Switzerland and Italy. Bierstadt spent the winter of 1856 and 1857 in Rome. That spring, Gifford and Bierstadt traveled together on foot, camping outdoors and sketching, throughout Lazio and Abruzzi, and on to Naples, Capri, and the Amalfi Coast. Bierstadt returned to Massachusetts in the summer of 1857 and created numerous oil paintings based upon his Swiss and Italian sketches over the next several years, including *View of Subiaco, Italy* (fig. 5). The Italian hill town of Subiaco, east of Rome, still serves as the headquarters of the Benedictine order where, in the fifth century, St. Benedict lived as a hermit in a cave (*Sacro Speco*) and wrote his famous "Rule"

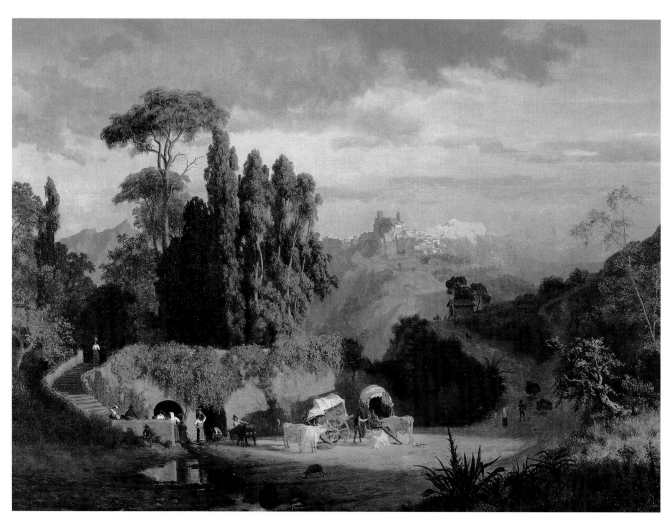

5 ❧ ALBERT BIERSTADT, View of Subiaco, Italy, *1859*.
Oil on canvas, 27 ⅛ x 37 ¼".
Georgia Museum of Art, University of Georgia;
extended loan from the West Foundation Collection, Atlanta
GMOA 1997.88E

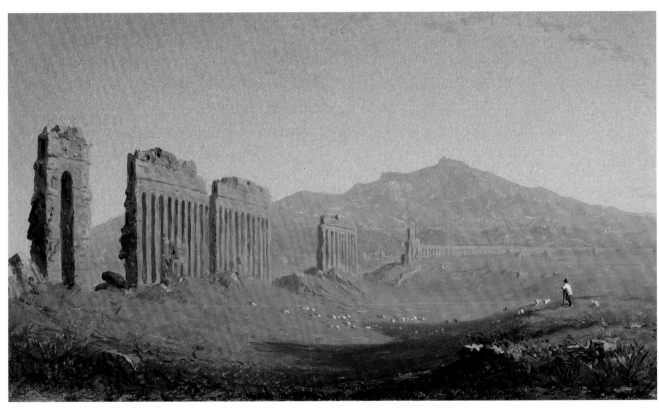

6 ❧ SANFORD ROBINSON GIFFORD, The Roman Campagna, *1859*.

Oil on canvas, 6 x 10 ⅛".

The Frances Lehman Loeb Art Center, Vassar College, Poughkeepsie, New York.

Gift of Matthew Vassar. 1864.1.34

for monasteries at Monte Cassino. Like Cropsey, Bierstadt would use his Italian sketchbooks as source material for paintings for several years after his tour.[17]

Some American artists, including Bierstadt's friend Sanford Robinson Gifford, made several trips to Italy during their lifetimes. Artists often used small oil sketches to assist them in translating compositional ideas and elements to larger canvases. Gifford's *The Roman Campagna* (fig. 6), featuring the Claudian aqueduct diminishing in perspective toward the mountains outside of Rome, served as the basis for other, larger exhibition pieces.[18]

OTHER AMERICAN PAINTERS BECAME EXPAtriates and lived in Italy for large portions of their careers. For example, the Philadelphiaborn William Stanley Haseltine visited and then lived in Italy in 1856 through 1858, 1865, 1867 through 1873, and again in 1874 through his death in Rome in 1900. Italian scenes of Capri, Venice, Sicily, Lago Maggiore, and Genoa thus dominate Haseltine's *oeuvre*. Although American artists like Haseltine spent years abroad, they never were removed completely from the political and cultural events in the United States. Haseltine's *Torre degli Schiavi, Campagna Romana* (fig. 7) features the Roman countryside from the site of an ancient mausoleum. The monument "became an architectural surrogate for Liberty, symbolic of [the artists'] optimistic faith in the American cause" prior to the Civil War.[19]

American painters were a solid constituency around the sites and scenery of Italy during the three decades following Thomas Cole's death. American newspapers and journals reported on the actions of artists abroad. Tourists served as art patrons and their guidebooks were quick to offer the addresses of artists' studios. *Murray's Handbook* mentions that the "intellectual traveller" in Rome should visit "the studios of the artists" because they afford a visit of "the highest interest" and fewer sites "possess a greater charm."

American artists in Rome became part of a larger fraternity of mostly young men. *Murray's Handbook* romanticizes the artists' community and notes that "it is an honourable circumstance that men speaking so many different languages meet at Rome upon common ground, as if there were no distinction of country among those whom Art has associated in her pursuit." American painters made up a significant proportion of that "honourable circumstance" and, in 1858, William Cullen Bryant estimated the number of American artists in Rome at "thirty or more."[20]

Several American painters became part of the tourist guide list of "the most celebrated of the artists of Rome" and their respective studios operated as tourist stops on the "Grand Tour." With a studio listed at 135 Via Babuino in Rome, John Gadsby Chapman, "landscape painter, and author of a good work on 'the Elementary Principles of Art,'" hosted "the intellectual visitor" looking to experience the great "charm" of a studio in Rome. Born in Alexandria, Virginia, in 1808, John Gadsby Chapman took his first trip to Europe, financed by friends and by commissions to copy the old masters (Chapman made a copy of Guido Reni's *Aurora* for James Fenimore Cooper), in 1828. In the spring of 1848, Chapman, with his wife, daughter, and two sons, relocated to Italy. Of Rome, he wrote in 1854: "I have every reason to be happy and contented.... In a professional point of view I have all that I could desire, facilities of study and production, quiet, profitable association with art and artists of every nation at all times, and ... [I am] free from the wearing toil that I formerly endured in New York."[21] Living in a top-floor studio apartment, with windows looking toward St. Peter's, Chapman and his family resided in Rome until 1884. He made his living painting small souvenir oils, including *Service of Mass on the Campagna* (fig. 8), and he received the occasional large commission from British and American tourists who traveled to Rome.

Among the American artists in Rome who also created numerous versions of the same Italian locale for the tourist

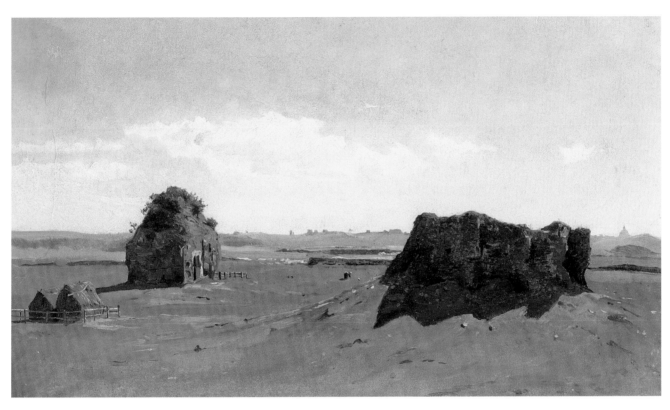

7 ❧ WILLIAM STANLEY HASELTINE, *Torre degli Schiavi, Campagna Romana, c. 1857-58,*
Oil on canvas, 13 ¾ x 19 ½".
North Carolina Museum of Art, Raleigh,
Gift of Helen Haseltine Plowden (Mrs. R.H. Plowden) in memory of W.R. Valentiner.

8 John Gadsby Chapman, Service of Mass on the Campagna, *1878*.

Oil on panel, 6 x 17 ½".

Georgia Museum of Art, University of Georgia;

extended loan from the West Foundation Collection, Atlanta.

GMOA 1997.98E

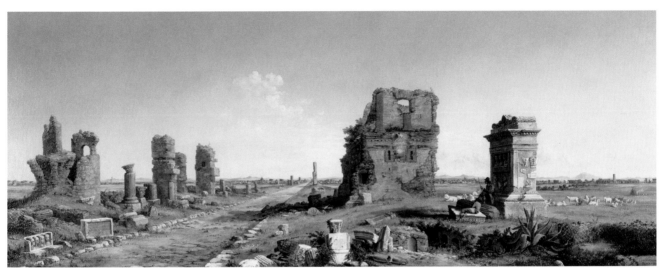

9 ❧ JOHN LINTON CHAPMAN, Via Appia, *1867.*
Oil on canvas, 27 ½ x 70".
Georgia Museum of Art, University of Georgia;
extended loan from the West Foundation Collection, Atlanta.
GMOA 1997.99E

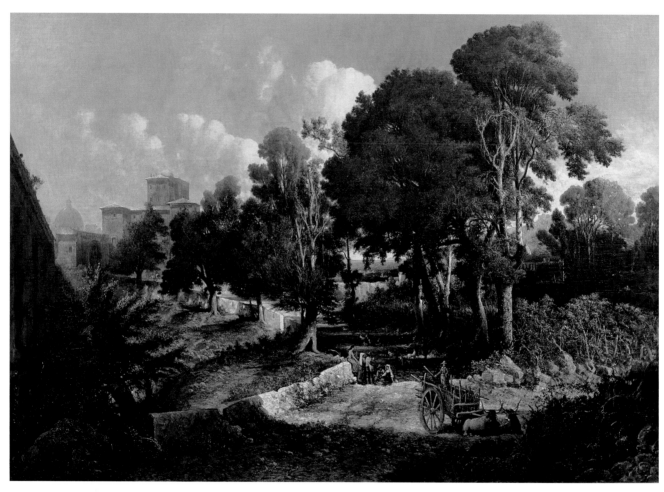

10 ❧ GEORGE LORING BROWN, Effect near Noon—Along the Appian Way, *1858.*

Oil on canvas, 68 ½ x 96".

Courtesy Spanierman Gallery, LLC, New York.

The Via Appia, its historical associations, and its ancient ruins of mausoleums resonated for nineteenth-century Americans as both a beautiful, picturesque site and as a tangible reminder of the cycle of human history.

trade was John Gadsby Chapman's elder son, John Linton Chapman. He moved with his expatriate family to Europe, settling in Rome as a child. Born in Washington, D.C., in 1839, John Linton Chapman lived in Rome until 1878, exhibiting paintings of Italian subjects at the National Academy of Design in the early 1880s. J. L. Chapman painted the *Via Appia* (fig. 9), the ancient section of the great Roman road that led to Southern Italy, several times over the course of his career.[22] "One of the most interesting excursions from Rome, and one of those most easily accomplished," a tour of the Via Appia not only served as a visit to "one of the most celebrated lines of communication which led from the capital of the Roman World" but as a chance to view the archaeological remains of the many ancient tombs and funerary monuments that lined the road.[23] In Chapman's paintings of the Via Appia, as in George Loring Brown's *Effect Near Noon—Along the Appian Way* (fig. 10), local peasants or shepherds with their goats inhabit the ancient road. In *Via Appia* and *Along the Appian Way*, Chapman and Brown, respectively, show the view looking back toward the city of Rome. The dome of St. Peter's, the most recognizable landmark for any American tourist approaching the city for the first time, stands at the distant horizon in Chapman's image but looms large at the left side of Brown's painting. The Via Appia, its historical associations, and its time-worn ruins of mausoleums resonated for nineteenth-century Americans as

both a beautiful, picturesque site and as a tangible reminder of the cycle of human history.

Largely because of its Catholic heritage, Rome often stirred contradictory or ambiguous feelings for mid-nineteenth-century American visitors, typically Protestants. In spite of fascination with the history of Rome, American tourists often noted Roman vices, especially beggary. William Wetmore Story observed that "begging, in Rome, is as much a profession as praying and shopkeeping. Happy is he who is born deformed, with a withered limb, or to whom Fortune sends the present of a hideous accident or malady; it is a stock to set up trade upon." Making connections between idleness and the Catholic Church, Story continued: "The splendid robes of ecclesiastical Rome have a draggled fringe of beggary and vice.... Industry is the only purification of a nation; and as the fertile and luxuriant Campagna stagnates into malaria, because of its want of ventilation and movement, so does this grand and noble people." For Story, "the restrictive policy of the [Roman Catholic] Church," in contrast to the "industrious" character of U.S. Protestantism, caused idleness, beggary, and vice; if only the church of the "grand and noble" Romans would promote freedom of thought and action, then beggary and other social ills would disappear. Americans in the mid-nineteenth century believed that the Italian people had been prevented, by the tradition and power of the Roman Catholic Church, from advancing

in science, art, and technology. Instead the church engendered superstition, poverty, and indolence, and, perhaps worst of all, was tyrannical and undemocratic.[24]

Most of the Americans who produced, commissioned, or collected paintings of Italy belonged, or aspired to belong, to a northern Protestant, urban professional and business culture. Typically, they held strong values centered in American republican, Protestant traditions. The patrons and painters established and utilized art organizations like the National Academy of Design, the Boston Athenaeum, and the Pennsylvania Academy of the Fine Arts. Richard L. Bushman has argued that "the culture of the educated elite in the eighteenth century had become by 1840 the primary stylistic vocabulary of the entire nation." The majority of American images of Italy reflect the perspective of those best able to travel to Europe—Protestant men and women representing a northeastern, upper- to middle-class. The preponderance of classical allusions in American civic culture exposes the nation's longing to fulfill greatness comparable to that of Periclean Athens or Republican Rome, under the leadership of men who personified the virtues of the ancients. Among the painters themselves, it was widely held that European subjects were more readily salable, a fact that sent more than one young American artist abroad with sketchbook in hand looking to store up a reservoir of scenes for future large canvas commissions. The paintings of Italian scenes reflect, encode, and encapsulate the issues and concerns that were forefront for the patrons, art associations, and museums of

the mid-nineteenth century. As the pictures and the essays in this book argue, these American images of Italy help us to understand questions of race, gender, immigration, politics, religion, history, and aesthetics in the years—1840s to 1870s—surrounding the Civil War in the United States.[25]

The United States after the Civil War differed in numerous ways from antebellum America. Emancipation and the effects of war revolutionized the social and economic order of the United States. During the Civil War and Reconstruction, a powerful national government, possessing greatly augmented authority and a new commitment to the ideal of national citizenship, came into being. The end of slavery in the United States produced extensive discussions over the role former slaves and their offspring would play in American life and freedom. Economic developments and changes brought new political issues to the foreground and re-determined concepts of race, class, and labor ideology in both North and South. But perhaps the most profound impact of the Civil War on American society was its human cost. As historian David M. Potter writes, "Slavery was dead; secession was dead; and six hundred thousand men were dead."[26] Many of the issues confronting American artists, writers, critics, and art patrons of the Reconstruction era differed greatly from pre-Civil War concerns. By the 1880s, Rome was no longer the primary pilgrimage site for young artists, overshadowed by the more poetic Venice or the more cosmopolitan and modern Paris. Paintings by mid-nineteenth-century Americans, either created in Italian studios or from numerous sketches made abroad, reflect the social, economic, religious, and artistic concerns of the Americans who created, purchased, disseminated, and displayed these images of Italy.

1 Van Wyck Brooks, *The Dream of Arcadia: American Writers and Artists in Italy 1760-1915* (New York: E. P. Dutton & Co., 1958), 85.

2 Jules David Prown and Kenneth Haltman, eds., *American Artifacts: Essays in Material Culture* (East Lansing: Michigan State University Press, 2000). See Prown, "The Truth of Material Culture: History or Fiction?," 11-27, and Haltman, introduction, 1-10. For a discussion of the material culture methodology within the context of art historical scholarship in the United States see Wanda Corn, "Coming of Age: Historical Scholarship in American Art," *Art Bulletin* 70 (June 1988): 203. The overall goal of *Classic Ground* involves synthesizing close textual readings of paintings about Italy created by

American artists with an understanding of the context of the paintings within the social and cultural history of the mid-nineteenth century United States. *Classic Ground* is also based upon the premise that paintings, like historical events, do not just happen; they are the results of causes. My approach to antebellum American paintings of Italy utilizes a material culture methodology. The method derives from the analysis recently outlined by Jules David Prown and Kenneth Haltman. The methodology involves a rigorously practical approach to understanding things, and analysis followed by interpretation. Prown and Haltman outline the basic approach: (1) choose an object; (2) thoroughly describe the object; (3) make clear intellectual and sensory responses to the object; (4) elucidate emotional responses; (5) entertain hypotheses concerning what the object signifies and the cultural work it might have accomplished; (6) think creatively about what research would be necessary to test the interpretive hypotheses; and (7) compose a polished interpretive analysis. My goal in using a material culture approach embraces a grounding of the social context of the paintings within the messages encoded in the works of art themselves.

3 Gordon S. Wood, *The Radicalism of the American Revolution* (New York: Vintage Books, 1991).

4 Some of the exhibitions and scholarship on American artists in Italy include E. P. Richardson and Otto Whittmann, Jr., introduction to *Travelers in Arcadia: American Artists in Italy, 1830-1875* (Detroit and Toledo: Detroit Institute of Arts and Toledo Museum of Art, 1951); Otto Whittman, "The Attraction of Italy for American Painters," Antiques 85, no. 5 (May 1964): 552-557; *The Arcadian Landscape: Nineteenth-Century American Painters in Italy* (Lawrence: University of Kansas Museum of Art, 1972); Barbara Novak, "Arcady Revisited: Americans in Italy," in *Nature and Culture: American Landscape Painting 1825-1875,* rev. ed. (New York: Oxford University Press, 1995); Regina Soria, *Dictionary of Nineteenth-Century American Artists in Italy, 1760-1914* (East Brunswick, NJ: Associated University Presses, 1982); Irma B. Jaffe, ed., *The Italian Presence in American Art 1760-1860* (New York and Rome: Fordham University Press and Instituto della Enciclopedia Italiana, 1989) and *The Italian Presence in American Art 1860-1920* (New York and Rome: Fordham University Press and Instituto della Enciclopedia Italiana, 1992). Also, see Wendy A. Cooper, *Classical Taste in America 1800-1840* (New York: The Baltimore Museum of Art and Abbeville Press, 1993); William L. Vance, *America's Rome* (New Haven: Yale University Press, 1989); and Theodore E. Stebbins, Jr., *The Lure of Italy: American Artists and The Italian Experience 1760-1914* (Boston: Museum of Fine Arts, Boston, 1992).

5 Jaffe, preface, *Italian Presence 1860-1920*, vii.

6 Paul Hazard, *The European Mind, 1680-1715* (New York: New American Library, 1963), 7. Jeremy Black, *The British Abroad: The Grand Tour in the Eighteenth Century* (Pheonix Mill: Sutton Publishing, 1992), 48. For the British origins of the Grand Tour, see Edward Chaney, *The Evolution of the Grand Tour* (London: Frank Cass, 1998) and Christopher Hibbert, *The Grand Tour* (London: Thames Methuen, 1987). The social and cultural impact of the Grand Tour and British tourism on Rome is detailed in the chapter "Letters, Art and Visitors" in Maurice Andrieux, *Daily Life in Papal Rome in the Eighteenth Century*, trans. Mary Fitton (London: George Allen and Unwin Ltd., 1968).

7 For more on George Inness's *A Bit of the Roman Aqueduct*, see Nicolai Cikovsky, Jr., and Michael Quick, *George Inness* (Los Angeles: Los Angeles County Museum of Art, 1985), 70; and *American Paintings at the High Museum of Art* (New York and Atlanta: Hudson Hills Press and the High Museum of Art, 1994), 68-69. The quotation about Inness's trip to Italy comes from George Inness, Jr., *Life, Art, and Letters of George Innes* (1917; repr., New York: Kennedy Galleries and Da Capo Press, 1969), 27.

8 For European artists on the Grand Tour in Italy, see Andrew Wilton, *The Art of Alexander and John Robert Cozens* (New Haven: Yale Center for British Art, 1980); Cecilia Powell, *Turner in the South: Rome, Naples, Florence* (New Haven and London: Yale University Press, 1987); Keith Andrews, *The Nazarenes: A Brotherhood of German Painters in Rome* (Oxford: Oxford University Press, 1964); and Peter Galassi, *Corot in Italy: Open Air Painting and the Classical-Landscape Tradition* (New Haven and London: Yale University Press, 1991); and Andrew Wilton and Ilaria Bignamini, eds., *Grand Tour: The Lure of Italy in the Eighteenth Century* (London: Tate Gallery Publishing, 1996).

9 See John Paul Driscoll, *John F. Kensett Drawings* (University Park: Museum of Art, The Pennsylvania State University, 1978); John K. Howat, *John Frederick Kensett 1816-1872* (New York: The American Federation of Arts, 1968); and *John Frederick Kensett: A Retrospective Exhibition* (Saratoga Springs: Hathorn Gallery, Skidmore College, 1967).

10 Nathaniel Hawthorne, *The Marble Faun or the Romance of Monte Beni* (New York: New American Library, 1980), 215.

11 See Novak, *Nature and Culture*, 203-225; Martin Christadler, "Romantic Landscape Painting in America: History as Nature, Nature as History," in Thomas W. Gaehtgens and Heinz Ickstadt, eds. *American Icons: Transatlantic Perspectives on Eighteenth- and Nineteenth-Century American Art* (Santa Monica and Chicago: Getty Center for the History of Art and Humanities and the University of Chicago Press, 1992), 93-117;

and J. Gray Sweeney, "The Nude of Landscape Painting: Emblematic Personification in the Art of the Hudson River School," *Smithsonian Studies in American Art* (Fall 1989): 43-65.

12 Wood, *Radicalism*, 101.

13 See Richard L. Bushman, introduction, *Classical Taste*.

14 Hawthorne, *The Marble Faun*, 14.

15 Eleanor L. Jones, catalogue entry for *Dream of Arcadia* in Stebbins, *Lure of Italy*, 178-179.

16 *New-York Evening Post*, 19 February 1848, 4. William Cullen Bryant, *Funeral Oration Occasioned by the Death of Thomas Cole* (New York: D. Appleton, 1848), 3 and 37. See J. Gray Sweeney, "The Advantages of Genius and Virtue: Thomas Cole's Influence, 1848-58," in William H. Truettner and Alan Wallach, eds., *Thomas Cole: Landscape into History* (New Haven, London, and Washington, DC: Yale University Press and National Museum of American Art, 1994), 113-135; and Mary Bartlett Cowdrey, *American Academy of Fine Arts and American Art-Union, Exhibition Record 1816-1852* (New York: New-York Historical Society, 1953).

17 For more on Cropsey's trip to Italy, see William S. Talbot, *Jasper Francis Cropsey 1823-1900* (Washington, DC: Smithsonian Institution Press, 1970). For some of the more detailed descriptions of Bierstadt's first European tour, see Nancy K. Anderson and Linda S. Ferber, *Albert Bierstadt: Art & Enterprise* (New York: Hudson Hills Press, 1990); Gordon Hendricks, *Albert Bierstadt: Painter of the American West* (New York: Harry N. Abrams, 1973); and Paul Manoguerra, "Anti-Catholicism in Albert Bierstadt's *Roman Fish Market, The Arch of Octavius*," *Nineteenth-Century Art Worldwide* 2, no. 1, Winter 2003, http://www.19thc-artworldwide.org/.

18 A discussion of Gifford's Italian sojourn is included in Ila Weiss, *Poetic Landscape: The Art and Experience of Sanford R. Gifford* (Newark: University of Delaware Press, 1987) and *America and the Grand Tour: Sanford Robinson Gifford at Home and Abroad* (Poughkeepsie, NY: Vassar College Art Gallery, 1991).

19 Charles C. Eldredge, "*Torre dei Schiavi*: Monument and Metaphor," *Smithsonian Studies in American Art* 1, no. 2 (Fall 1987): 32. For more on Haseltine, see Marc Simpson, Andrea Henderson, and Sally Mills, *Expressions of Place: The Art of William Stanley Haseltine* (San Francisco: The Fine Arts Museums of San Francisco, 1992).

20 *A Handbook for Travellers in Central Italy, Vol. 2: Rome and its Environs*, 3rd ed. (London: John Murray, 1853), 224 and 12. Letter to the *Evening Post*, 21 May 1858, from William Cullen Bryant II and Thomas G. Voss, eds., *The Letters of William Cullen Bryant*, vol. 4 (New York: Fordham University Press, 1984), 34.

21 *A Handbook of Rome and Its Environs; Forming Part II of the Handbook for Travellers in Central Italy*, 6th ed. (London: J. Murray, 1862), 284 and 286.

22 Chapman's known versions of *Via Appia* are dated between 1868 and 1879, and are in the collections of the Brooklyn Museum and the Denver Art Museum, among others. For more on John Gadsby Chapman, see William P. Campbell, *John Gadsby Chapman* (Washington, DC: National Gallery of Art, 1962). Quotation by Chapman taken from Stebbins, *Lure of Italy*, 304.

23 Murray, *A Handbook of Rome*, 337-338.

24 William Wetmore Story, *Roba di Roma*, 7th ed. (London: Chapman and Hall, 1876), 46. Story's chapter from *Roba di Roma* on "Beggars in Rome" also appeared in Boston's *Atlantic Monthly* 4, no. 12 (August 1859): 207-219. Essayists in Robert K. Martin and Leland S. Person, eds., *Roman Holidays: American Writers and Artists in Nineteenth-Century Italy* (Iowa City: University of Iowa Press, 2002) argue that Italy served American nineteenth-century writers and artists as "a kind of laboratory site for encountering Others and 'other' kinds of experience."

25 See Bushman, introduction, *Classical Taste*, 14.

26 See Eric Foner, *Reconstruction: America's Unfinished Revolution 1863-1877* (New York: Harper & Row, 1988) and David M. Potter, *The Impending Crisis 1848-1861,* comp. and ed. Don E. Fehrenbacher (New York: Harper & Row, 1976), 583.

As the pictures and the essays in this book argue, these American images of Italy help us to understand questions of race, gender, immigration, politics, religion, history, and aesthetics in the years—1840s to 1870s—surrounding the Civil War in the United States.

Paul A. Manoguerra ❧ *Georgia Museum of Art*

This Cause is Ours

MARTIN JOHNSON HEADE'S *ROMAN NEWSBOYS* AND AMERICAN REACTION TO THE ROMAN REPUBLIC OF 1848-1849

THE YEAR 1848 WITNESSED, IN THE UNITED STATES, THE concurrence of an extraordinary number of significant social, political, and natural events. In early 1849, a Baptist antislavery periodical noted the gravity of worldwide events during the previous year: "[This] has been an era in the annals of the world from which, in ages to come, the philosopher will draw lessons of instruction, the poet his most inspiring themes, the artist his noblest subjects for chisel or pencil, and the preacher some of the most striking proofs of God manifest in history." Some "proofs of God manifest in history," including American success in the Mexican War, had begun before that year. The United States had severed diplomatic relations with Mexico in March 1845, declared war in May 1846, and signed a peace treaty in July 1848, following military successes at Veracruz and Mexico City. The war with Mexico brought vast territory under American control but envenomed serious rivalries between North and South by intensifying antagonism over the spread of slavery into the newly acquired territories. News of the discovery of gold in California in 1848 brought thousands of migrants into the territory. At Seneca Falls, New York, in the summer of 1848, the call for rights of American women was announced in one of the most significant protest gatherings of the antebellum era. Modeling their "Declaration of Sentiments" on the Declaration of Independence, the women at Seneca Falls proclaimed that "all men and women are created equal" and that men had usurped the God-given freedom and dignity of women. At the end of 1848, cholera-infected sailors, entering New York and New Orleans, initiated a full-blown epidemic by the summer of 1849. 1848 was also a presidential election year, which saw Whig candidate Zachary Taylor, hero of the Mexican War, defeat Democrat Lewis Cass and Free-Soiler Martin Van Buren.[1]

Events outside the United States, however, were also fashioning changes within American society. By the end of 1848, the ongoing impact of the Irish Potato Famine facilitated the movement of thousands of poor, Catholic immigrants to American ports, especially the Northeast cities of Boston and New York. In 1848, and for several succeeding years, a series of liberal and nationalistic revolutions occurred in Europe. Italian, French, German, and Hungarian nationalism and republicanism stimulated American sympathies. American tourists and writers, both at home and abroad, commented upon the European revolutionary events. For

some Americans, the revolutionary upheavals in Europe indicated that the recent victory in Mexico did indeed mark a pivotal moment in the great contest between monarchism and republicanism—a contest that was now continuing throughout Europe. Yet events specific to Italy and Rome offered Protestant Americans an opportunity for providential conjecture, given Protestant antagonism to the pope. Anti-Catholicism was fundamental to a large section of American society, which viewed the progression of history as republicanism and Protestantism versus monarchy and Catholicism. Caroline Kirkland, author and editor of the *Union Magazine of Literature and Art*, noted that "visiting Europe in the Year of Revolutions, the aspect of things was naturally very interesting to Americans, and it seemed worth while [*sic*] to catch what one could of the flying picture."[2]

But not all Americans, including artists, remained passively curious in the ever-changing political atmosphere of 1848 in Europe. In particular, several American artists, tourists and writers in Rome during the short-lived Roman Republic of 1848 and 1849 became actively involved in Italian political events. Three individuals—Martin Johnson Heade, Thomas Hicks, and Margaret Fuller—were linked together by their acquaintance, nationality while abroad, and the events of the revolution in the Papal States. Fuller covered the revolution for the *New York Tribune*, edited by the reformer Horace Greeley, and became America's first ever war correspondent, male or female. While in Italy, she commissioned a portrait of herself from Hicks. Meanwhile, Hicks's fellow artist and Pennsylvanian, Martin Johnson Heade, "a highly political person," created *Roman Newsboys* (fig. 11) as one painting resulting from his stay in Rome during this tumultuous time period.

Fuller, Hicks, and Heade were among the Protestant Americans who supported the moderate reforms begun in 1846 in Italy by Pope Pius IX and other leaders. But with the flight of Pius IX from Rome at the end of 1848 and strong Austrian and French intervention in Italian affairs, some Americans, especially Fuller in her writings, placed their sympathies with a Roman Republic and favored radical revolution in Italy over moderate reform. Despite their fear of the inevitable failure of the revolution of 1848 in Italy, these Americans used their conviction in the providential nature of American governmental and intellectual forms to sustain their hope that the "childlike" Italians would eventually learn to be "good" republicans. By condensing "four phases of the political 'news' of Rome" into a single image, *Roman Newsboys* serves as a distinctly American, politically moderate interpretation of Italian events in 1848 and 1849. Through the use of highly-detailed compositional elements, Heade's painting reflects American exceptionalism and support for the notion of a fusion of "liberty" with "religion," of "freedom under God." Despite the overall sympathy among Protestant Americans for the Roman Republic, *Roman Newsboys* expresses the belief that the inability of the Italians to combine the spiritual with the secular, to overcome the machinations of anti-republican forces, and to comprehend the responsibilities of a democracy led to the failure, in 1849, of the movement to unite Italy politically under a liberal government.[3]

In Martin Johnson Heade's *Roman Newsboys*, two pre-teen boys sell their "penny" papers.[4] Standing on a crack-filled sidewalk in the glow of full sunlight, the first boy, at the left side of the composition, offers forth multiple copies of a short, one-page newspaper with his outstretched right arm. Wearing a white shirt, faded red pants, golden suspenders, and a tattered green jacket, he casually leans against the wall with his left knee bent and foot up. The fly of his pants is unbuttoned and a toe emerges from his right shoe. Generally disheveled in appearance, this newsboy wears a golden cap with the name of the pope, Pio IX, emblazoned across its front. The second newsboy, to the right of the composition, sits atop a post (designed to keep carriages and carts from hitting *palazzo* walls) along the sidewalk and higher than the other boy. He wears the tricolors

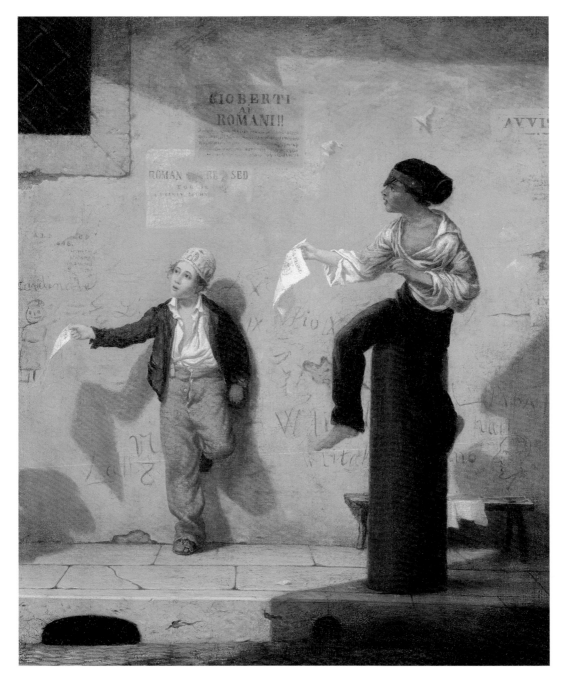

II ❧ Martin Johnson Heade, Roman Newsboys, *about 1848-49.*
Oil on canvas, 28 ½ x 24 ⁵⁄₁₆".
Toledo Museum of Art, purchased with funds from the
Florence Scott Libbey Bequest in memory of her father, Maurice A. Scott.
1953.68

of republican governments including a white shirt, blue pants, and a too-large blue and red military-style cap. Without shoes, the boy grasps an orange-glowing cigar in his left hand. With his face and torso almost entirely in shadow, he holds out a newspaper with his right hand. Strikingly readable in the sunlight, and at the center of Heade's composition, the paper's title clearly states "PIRLONE."

Through a faded poster with the number "48" at the head level of the standing boy, Heade dates the image, and its associated events, for the painting's viewers. The partially-decipherable posters and scrawled graffiti, decorating the palace wall behind the two newsboys, suggest the "flying picture," the rapid movement of Italian political events. A stick-figure caricature labeled "cardinale" appears on the wall to the far left of the composition, directly adjacent to the first boy's papers. On the wall behind the seated boy's "PIRLONE" paper, someone has scribbled "Pio IX." Behind the sidewalk post, other graffiti declares "Wlita," perhaps "Viva L'Italia" or "Viva libertá." The final, clearly-legible scrawling, above a small bench in the lower right of Heade's image, shows a profile caricature portrait labeled "PAPA." Two posters have been placed high on the wall. The lower of these broadsides reads "ROMAN—RE-SED /TUE—/A WEEKLY JOURN—." Overlapping and above that broadside, another poster, in blue, clearly reads "GIOBERTI AI ROMANI!!" Strong shadows play across the gutter, sidewalk, and the wall. Emblematic for Heade and American tourists of Rome's urban decay, small sections of the palace wall have had the plaster facade chipped away. One of those sections, shaped like an arrow or a dagger, visually pierces the right leg of the seated boy. At the far lower left of the painting, a figure, unseen except for the ominous shadow cast by the shoulders and quite broad hat, approaches the boys and draws their attention.

In its layering of symbols and text, Heade's *Roman Newsboys* established an American understanding of specific events within Italy during the late 1840s. In the first of these events,

liberal moderates in the College of Cardinals engineered the election of Cardinal Giovanni Maria Mastai-Ferretti, as Pope Pius IX on 16 June 1846. In central Italy the Pope ruled absolutely a large area stretching across the peninsula from Bologna and the Adriatic to Rome and the Tyrrhenian. The pope's temporal domain, divided by the Apennine Mountains, consisted of several disparate regions. Rome itself was important not as an economic center for the region but as the capital of the Catholic world. Unique in Italy, Rome and its surroundings were ruled by an elected sovereign. In his first official act, Pius IX appointed a commission to study the question of amnesty for political prisoners, demanded by popular opinion. The pope also promptly announced a package of reform proposals for his government in Rome. These reforms created great excitement, especially in liberal national circles all over Italy, Europe, and the United States.[5]

MARGARET FULLER AND LIKE-MINDED Americans saw the hope for a united and republican Italy in the 1847 reforms of Pius IX. Arguably one of the greatest female intellectuals of her day, Fuller (fig. 12) covered European events for the *New York Tribune*, edited by the Whig reformer Horace Greeley. Ralph Waldo Emerson called Fuller "quite an extraordinary person for her apprehensiveness, her acquisitions [and] her powers of conversation." In 1844, she published *Summer on the Lakes*, her observations on travels to Niagara Falls, Chicago, the Illinois prairies, Milwaukee, and the Great Lakes. That same year she accepted a position as the literary editor for the *New York Daily Tribune*, eventually publishing about 250 essays. In Europe from 1846 until 1850, she met William Wordsworth, Thomas Carlyle, Giuseppe Mazzini, Frédéric Chopin, and Robert and Elizabeth Barrett Browning, among others. Fuller believed that reform in institutions came about when a majority of those affected changed from within and insisted on external changes to accommodate the new reality.[6]

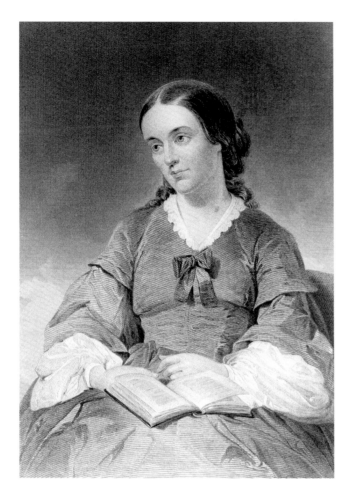

toward republican government in Italy. Fuller feared that the pope did not have "the means at his command to accomplish these ends." Instead, according to Fuller, Rome needed to renounce its history as an ecclesiastical capital and re-embrace its ancient history of republicanism. Expressing her view of American exceptionalism, she called upon Americans to support the democratic movements in Italy: "I earnestly hope for some expression of sympathy from my country toward Italy.... This cause is OURS, above all others; we ought to show that we feel it to be so."[7]

Yet Fuller still held tempered hopes for a new reality in Italy and for the positive effect of Pope Pius IX's late 1840s reforms. Fuller wrote to the readers of the *Tribune* that Rome mistakenly "seeks to reconcile reform and priestcraft." Echoing Fuller's appreciation of the difficulty of attuning years of Catholic traditions to American-style democracy, Heade shows "religion," in the guise of the newsboy to the left, and "liberty," embodied by the seated newsboy, as separate and disconnected. For Fuller, as for Heade and other Americans following Pius's reforms, the question was not whether liberal political changes were necessary in Italy but whether Pius IX could accomplish reform in a Catholic nation. In May 1847, Fuller called Pius IX "a man of noble and good aspect" and his reforms "something solid for the benefit of man." But she realized that Pius's political reforms should be only the beginning of a revolutionary movement

LIKE FULLER AND HEADE IN ROME, SOME Americans in the United States took a civic interest in the reforms within the Papal States. Interested citizens of Philadelphia, in Heade's native state, held a meeting at the Chinese Museum on 6 January 1848 for the purpose of "expressing their cordial approval of the wise and liberal policy" of Pius IX "to elevate and improve the condition of the people of Italy." Philadelphia Democrat John K. Kane called the meeting to order, and the attendees "unanimously adopted" (and later published) a public speech. The address began by pointing out the privileged position the United States held in the history of the world: "Blessed with a fertile territory of boundless extent and resources; enjoying free institutions, framed with wisdom and administered with moderation," the meeting attendees "acknowledge, with gratitude to God, that we experience a degree of individual and national prosperity not often vouchsafed to any people." The speaker

attributed the God-granted prosperity "to the wisdom which framed our institutions." In noting that the reforms of Pope Pius IX "tend to the melioration of the social, and the enfranchisement of the political condition," of the people "of a once great and powerful empire," the speaker praised the possibility of a united and free Italy.

The "liberal and enlightened" Philadelphians had invited a broad political spectrum of notable Americans to attend their public meeting. In the published version of the address, the citizens of Philadelphia also included the letters they received in response to their meeting. All of the letters, across political party lines, stated strong support for the goals of the Philadelphia meeting and the reforms of Pius IX. The published "regret" letters included statements of support from Senator Daniel Webster, Massachusetts Whig and former presidential candidate; John A. Dix, a Free Soil gubernatorial candidate in New York later that year; John Van Buren, son of the former president; John Tyler, James Buchanan, Polk's secretary of state; and eventual presidential candidate Lewis Cass of Ohio. One letter noted: "[Pope Pius IX] will place the Seven Hilled City next to Philadelphia, and the present Pontiff next to Washington upon the page of history, and in the grateful memory of mankind."

But the longest letter of response came from Philadelphia's three-term congressman, Joseph Ingersoll, who compared Pius IX to the apostle St. Peter and called Pius, "if [he] is sincere, the greatest reformer of intolerant exclusiveness since Luther." The congressman continued: "All [the Italians] need is what we enjoy, perfect union, national independence, and the blessings of liberty, to become again a great and happy nation." Then Ingersoll's thoughts moved from the philosophical to the practical: "The happier and richer all Italy is, the better and richer will be these United States." He noted that he had suggested that Congress should empower the president to appoint a special ambassador to Italy so that "the Declaration of American Independence proclaimed from Philadelphia to Rome, may be echoed from Rome to

Washington in a Declaration of Italian Independence." Ultimately, Ingersoll also put forth an argument, centered on trade, international commerce, and economic possibilities, for an active United States involvement in the foreign affairs of Europe.

TWO OTHER LETTERS LINKED THE CONCEPTS OF "Liberty" and "Religion"—symbolically embodied and separated by Heade through the trope of the two newsboys—to the idea of a rejuvenation of lost greatness among a people. The Boston patrician Robert C. Winthrop responded that "the establishment or advancement of free institutions in any part of the world, must always be a spectacle of the highest interest to an American eye." Winthrop then took notice of the special nature of "liberty" returning to a once great nation: "But when we witness such a movement on classic ground; when a spirit of Liberty is seen rising amid the ruins of Greece or Rome; when one of these mighty nations of antiquity seems about to start up from its slumber of centuries, and to re-assert its long-lost freedom and independence, we may well be excused for something of enthusiastic emotion." George M. Dallas of Pennsylvania, Polk's vice-president, noted the duality of "Religion" and "Liberty," calling them "sisters" that "delight in Union." He continued: "No exhibition can be more interesting and attractive than the Head of a Church laboring to surround his spiritual Faith with the institutions of temporal Freedom." These well-known and prominent Americans believed that combining faith in God with faith in republicanism brought about the best form of human government.[8]

As these public statements of the Philadelphians and Heade's *Roman Newsboys* attest, Pius IX was originally hailed on both sides of the Atlantic as an Italian patriot. Americans and moderate and liberal Italians hoped that Pius IX could combine religion with liberty in a new republican government. The pope's popularity soared among the

general Italian populace. American visitors to Italy in 1848 made note not only of the popularity of Pius IX and his reforms, but also of the ubiquitous graffiti supporting the pope. Margaret Fuller recorded the omnipresent scrawls acknowledging papal reforms and Pius's renown in a letter from Milan on 9 August 1947: "Tranquil as Assisi was, on every wall was read *Viva Pio IX.!* and we found the guides and workmen in the shop full of a vague hope of him."[9]

Pius IX's success or failure in leading a united Italy rested in his fulfillment of the ideas put forth by an exiled priest, Vincenzo Gioberti. Heade's first newsboy, wearing faded red, white, and green clothing, and a golden cap with "Pio IX" on its front, operates not only as a symbol of "religion" but also of the pro-Pius IX, moderate Italian view of unification, as articulated by Gioberti. Heade also expresses the significance of the pro-papal views of Vincenzo Gioberti to the events in Italy of 1848 and 1849 by including a broadside that clearly reads "GIOBERTI AI ROMANI!!," or "Gioberti to the Romans." From the election of Pius IX in 1846 until the spring of 1848, Italians hoped that the pope would unite Italy under his control. Americans in Italy were keenly aware of the powerful influence of Gioberti's writings on this hope. Charles Edwards Lester, a Democrat and great-grandson of preacher Jonathan Edwards, served as United States Consul at Genoa from 1842 to 1847. In 1853, Lester published *My Consulship*, in which he describes the history of Italy in the years leading up to the Roman Republic. Lester believed that "Gioberti wrote with a fearless pen." Calling Gioberti the "greatest" political writer "to prepare the way for Pius IX," he also notes that Gioberti prophesized of "some bold reformer" becoming pope. Margaret Fuller also commented upon the influence of Gioberti on the events of 1848: "The thought of Gioberti had been at first the popular one, as he, in fact, was the seer of the so-called Moderate party.... He assailed the Jesuits, and was of real use by embodying the distrust and

aversion that brooded in the minds of men against these most insidious and inveterate foes of liberty and progress."[10]

From the 1830s, Italian intellectuals and liberal politicians, including Vincenzo Gioberti, fiercely debated how Italian unification might take place and what its future would be. Most important, Gioberti reconciled Italy's political independence with its spiritual mission by envisioning a loose confederation of existing states under the pope's "presidency," ideas which directly influenced Pius IX. For some Italians who wished to be free of Austrian control, the goal of a national Italian federation under the presidency of the pope seemed within the range of possibility. For some Americans, including Lester and Fuller, the linking of Italian religion and liberty under a "presidential" pope seemed to offer a fulfillment of their desire to see Italy unified and republican.[11] But events in Italy would prevent that goal from being permanently achieved in 1848 and 1849.

The first European insurrection in 1848 took place in Sicily, as an anti-Bourbon revolution, some weeks before more substantial revolutions in Paris and Vienna. Sicily elected a parliament on restricted suffrage and sent a token force of a hundred soldiers to northern Italy to help defend a possible Austrian counter-revolution. The news from Sicily prompted citizens in Naples to call for their own representative parliament. On 10 February 1848, King Ferdinand II of Naples conceded a parliamentary constitution that maintained his royal prerogatives. In Milan, men boycotted, in a deliberate copy of the Boston Tea Party, the state lottery and the tobacco monopoly, two important sources of Austrian revenue. On March 14, Pope Pius IX published a constitution for the Papal States establishing two legislative houses but giving himself and the College of Cardinals supreme power over legislation; the constitution also banned the secular legislature from passing laws in areas of mixed secular-ecclesiastical concern, extremely difficult to define, and conferred political rights only on practicing Catholics. Other rulers of Italy, including those in Tuscany

*R*oman Newsboys *records the quick-changing fortunes of the papacy and the rise of the Roman Republic.*

(Leopold, an archduke of Austria) and Piedmont-Sardinia (King Charles Albert), also granted constitutions to their subjects early in 1848. At the end of March, spurred on by events in Vienna and the resignation of state chancellor Prince Klemens von Metternich, anti-Austrian insurrections took place in Venice, where a republic was proclaimed, and Milan. King Charles Albert declared war on Austria. After Austrian military victories over Piedmont at Custoza and Milan, Pius IX issued an allocution on 29 April 1848 declaring that, as leader of all Catholics, he would not endorse war on the Catholic Austrians, and affirming his neutrality. On November 15, a zealot stabbed Pius's appointment to head the Roman government, Pellegrino Rossi, to death. Demonstrations ensued, and the crowd imposed a cabinet committed to Italian independence and the removal of all papal temporal power. On November 24, Pope Pius IX fled (according to tradition, disguised as a groom on the box of the Bavarian ambassador's coach) to Gaeta, in the Kingdom of the Two Sicilies. On 9 February 1849, an elected assembly voted to make Rome an independent republic. The new Roman Republic entrusted its fate to Giuseppe Mazzini.

Roman Newsboys records the quick-changing fortunes of the papacy and the rise of the Roman Republic. Heade positions the second newsboy, an embodiment of "liberty" and of the Roman Republic under Mazzini, at a higher elevation than the "papal" newsboy, suggesting Heade's own sympathies. This second boy wears red, white and blue, including a "liberty" cap. Heade marks the contrast between this "republican" boy's age and his maturity by showing him holding a cigar in his left hand. During the revolution, English tourist Charles MacFarlane experienced children in Italy very similar to Heade's representation of the "republican" newsboy: "Nearly every man and boy wore some uniform or other. Even the little children were dressed up like national guardsmen; and here [in Ancona], as afterwards at Rome, Florence, and too many other cities, we saw urchins not ten years old strutting about with swords by their sides and cigars in their mouths. In the puerile affectation and miserable cant of the day, these children dressed as soldiers are called 'Le Speranze della Patria'—the hopes of the country." Margaret Fuller, in February 1849, also noticed that many Romans had donned the "liberty cap": "I passed into the Corso; there were men in the liberty cap,—of course the lowest and vilest had been the first to assume it; all the horrible beggars persecuting as impudently as usual." The liberty cap worn by Heade's republican newsboy became a symbol of the Mazzini-led Roman Republic.[12]

Heade marks the Mazzinian, "republican" phase of events in Rome through the "Wlita" graffiti behind the sidewalk post in *Roman Newsboys*. Giuseppe Mazzini renewed the republican movement in Italy following the flight of Pius IX from Rome. Margaret Fuller characterized the transition of popularity from the pro-papacy Vincenzo Gioberti to the pro-republic Mazzini with her 20 March 1849 letter to the *New York Tribune*: "The 'illustrious Gioberti' has fallen.... Now the name of Gioberti is erased from the corners of the

streets to which it was affixed a year ago.... Mazzini is the idol of the people." Mazzini believed that only republican institutions could enact the social legislation to make Italians "free, equal, and brothers." His slogans—"God and the People" and "Italy will do it by itself"—reflected his desire to liberate Italy from Austrian and papal control. Mazzini arrived in Rome in March 1849 and became the recognized leader of the new Republic.[13]

Margaret Fuller, as a friend to Mazzini and as an interested American, became actively involved in the short-lived Roman Republic. She remained the voice of the Roman Republic for Americans through Horace Greeley's *Tribune*. In comparing the plight of Rome to the American colonies, she pleaded with her fellow Americans to support and to recognize officially the Republic: "Some of the lowest people have asked me, 'Is it not true that your country had a war to become free?' 'Yes.' 'Then why do they not feel for us?'" In May 1849, she noted that the American community in Rome donated $250 to help support the Roman hospitals during the siege of the city by anti-republican forces. She called for the new presidential administration of Zachary Taylor to assist the Republic, even if just through words: "Send dear America! to thy ambassadors a talisman precious beyond all that boasted gold of California." Yet, even as Fuller continued working on a written history of the Roman Revolution, she knew that European forces had aligned themselves to ensure the failure of the Republic and the restoration of Pope Pius IX. Heade implies the ominous counter-revolutionary forces aligned against both moderate and radical reformers in Italy through the forbidding shadows closing in on the two young vendors in *Roman Newsboys*.[14]

By 1849, pro-monarchy reactionaries had regained political control in Austria and Germany and, in May and June 1848, French radicals who might have supported Italian liberty suffered defeat. Under the leadership of Mazzini and Giuseppe Garibaldi, the Roman republic held out, with a small army of volunteers, until July 1849, against armies sent from France, Spain, and Naples to destroy it. A heroic defense by the Roman Republic defeated Louis Napoleon's army at first, but the French commander violated an armistice and sneaked in reinforcements. French troops restored Pope Pius IX to his throne, and then remained in Rome for the next twenty years to defend the temporal power of the pope against another nationalistic, radical revolution. Margaret Fuller, with her Italian husband, Count Ossoli, and their son, fled Rome to Rieti in mid-July 1849, then to Florence in September. On 17 May 1850, she and her family sailed for New York on the SS *Elizabeth*; all three tragically drowned when the ship wrecked off the shore of Fire Island, near Long Island, New York, in a storm on July 19. The manuscript of her history of the Roman Revolution, on which she had been working, was also lost. The American public would never read Fuller's narrative or her assessments of the failure of the Republic.

However, American politicians and newspaper editors, along with the general public, had strong reactions to the failures of the revolutions not only in Rome but elsewhere in Europe. The first news in American papers of the February Revolution—having begun on George Washington's birthday—in Paris arrived on 20 March 1848. It had been two weeks since the United States Senate had ratified the Treaty of Guadalupe Hidalgo, ending a victorious war against Catholic, monarchical Mexico that brought huge territorial acquisitions. For some Americans it seemed that just when the United States had confirmed its supremacy over the North American continent news arrived of turmoil in reactionary Europe. America's greatness, ideological superiority, and providential destiny seemed to be confirmed. Different groups in American society seized upon different aspects of the revolutions to validate their own purposes and biases. American reception of events in Europe often hinged on domestic political allegiances since

"the year of revolution" was also a presidential election year in the United States. Ideologically, the Free Soil Party of 1848 celebrated equal opportunity and self-help, ideals that it saw exemplified in at least some aspects of the revolutions in Europe. The Democratic Party pointed with pride in its national party platform, adopted in May 1848, to "the sovereignty of the people." According to the Democrats, Europeans, in imitation of the United States, were building republics on the ruins of despotism in the Old World.[15]

Political ideologies mingled with religious ones in the American interest in the revolutions of 1848. Some evangelical preachers seized upon events as heralding the overthrow of the papacy, the long-deferred culmination of the Protestant Reformation. Revolutionary enthusiasm manifested itself in fashions of dress as well, such as the liberty cap of the French, the red attire of the Italian *carbonari*, or the fur hats and boots of Hungarian leader Louis Kossuth. But any direct impact on the United States of the European revolutions of 1848 involved international commerce. On 5 November 1849, the *New York Herald* aptly stated that although Americans could not condone the brutalities of either the revolutions or their suppression, "we can console ourselves with a rise in the cotton market, [creating] as great a sensation in Wall Street and in New Orleans as the recent revolutions did among speculators in the destiny of the human race." The immediate failure of the revolutions only strengthened and entrenched American ideological exceptionalism.[16]

HEADE EMPLOYS NEWSPAPERS IN *ROMAN NEWSBOYS* as a paragon not only of the immediacy of the revolutionary events in Italy but also of the significance of information to a democratic society. When the dissemination of information seems threatened, as with the powerful shadows of counter-revolution that surround Heade's young newsboys, the success of republican governments becomes endangered. Antebellum intellectuals like Heade viewed newspapers as vehicles that encouraged political debate and the spread of progressive, perhaps even subversive or revolutionary, ideas. The penny papers in the United States were inexpensive, manageable for readers, included more local and crime news, and more news of interest to women and laborers than the larger, often weekly, papers. These penny papers relied on distribution and not on subscriptions. Publishers sold their papers to vendors at two-thirds of a cent per copy. These vendors distributed the paper to newsboys, like Heade's subjects, who then hawked them to the urban public on the streets. In America, these affordable and accessible newspapers, often directly associated with a political party, reached the masses with news and with their respective political and social agendas. In Europe, including Italy, inexpensive papers in the 1840s were one aspect of a vast circulation of newspapers, illustrated papers, and placards which helped create "something of a revolutionary culture which was appreciated by a growing number of people."[17]

The "penny paper" *Il Don Pirlone*, placed in full sunlight at the center of Heade's composition and offered on the street by Heade's "republican" newsboy, operated as the satirical voice of Rome's revolutionary culture. That Roman satirical voice also found its way into the minds of Americans, both at home and abroad. Writing from Rome in December of 1848 and referencing a comparable British paper, Margaret Fuller took note of "*Don Tirlone* [*sic*], the *Punch* of Rome." Fuller continued by describing in detail one of the political cartoons parodying the pope as a parrot, held "captive" in a birdcage by the King of Naples. An abridged version of the complete *Il Don Pirlone* political cartoons was published in New Orleans about 1850. The Italian American editor of this abridged edition of fifty plates notes that the "principal object of these illustrations was to unmask all the political tricks of European diplomacy which, through its machinations, threatened the young [Roman] republic and greatly endangered the whole liberty of Europe." The editor made note of American exceptionalism by commenting that "the supreme condition of

liberty"—meaning republican governmental institutions—existed in modern times only in Switzerland and the United States. Arguing in English, Italian, and French that Pius IX was "obliged to submit to the will of Providence and the rights of the nation," the editor displays his strong support for Italian unification and democracy.[18] According to the editor of the American version of the plates, the failures and shortcomings of the Roman Revolution needed to be didactic tools for antebellum Americans in appreciating their own God-granted liberty.[19]

ONE GROUP OF CONTEMPORARY AMERICAN comments on the failure of the Roman Revolution of 1848 and 1849 blamed the Italians themselves. In April 1848, Margaret Fuller presaged the failure of the democratic unification movement. Aware that the question of Italian unification was potentially intractable, she believed that the problem "was one of such difficulty, that only one of those minds, the rare product of ages for the redemption of mankind, could be equal to its solution." Although Fuller would hope that Mazzini was "one of those minds," numerous other commentators hypothesized that the Italians were incapable of creating such a "rare product of ages." For some, the Italian "race" was simply incapable of "progressing" to republicanism. In *My Consulship*, despite his praise for Pius IX, Charles Edwards Lester states: "It will not be disputed, at least by American statesmen, that the ultimate cause of the failure of European nations, in the establishment and maintenance of liberal institutions, during and after the Revolution of 1848, was *the political incapacity of the people*.... Nor have I much confidence in the capacity of any race of men, to found and perpetuate even free Constitutional Governments, except the Anglo Saxon." Henry T. Tuckerman believed that the "the hope of [Italy's] state" lied not with its adults, who were "priests and beggars, spies and traitors," but "in the instinctive and characteristic

life of her children." The children of Italy could be instructed in the moral and civic responsibilities of republicanism.[20]

Other American commentators compared the political incapacity of Italians for understanding the responsibilities of republicanism with that of children. By employing two boys in his painting, Heade builds upon the comparison of mid-nineteenth-century Italians to children—perhaps ready to learn how to be "good" republicans—which appeared in many accounts of travels and events in Italy both before and after 1848. As American ideology assigned to mothers the moral instruction of the nation's future male citizens, Italians still needed to be instructed in the basics of republican institutions. The idea that the Italian nation was still "childish," not yet "grown up" and worthy of the responsibilities of democracy, penetrated into the writings on Italy by Americans during the late antebellum era. Nathaniel Hawthorne, through the allegory of the naive and emotional Donatello in *The Marble Faun*, compares his symbolic contemporary Italian to the Faun of Praxitiles, animals, and a child. Hawthorne's fellow writer, Margaret Fuller, in talking about the first Carnival of the new Roman Republic, likens the state of the post-revolution Italian people to adolescents, referring to the Italians as "after childhood." In one of her earlier letters, she used the trope of childhood to describe the readiness of the Italians to embrace republican reforms: "In the spring, when I came to Rome, the people were in the intoxication of joy at the first serious measures of reform taken by the Pope. I saw with pleasure their childlike joy and trust.... The Roman people, stigmatized by prejudice as so crafty and ferocious, showed themselves children, eager to learn, quick to obey, happy to confide." Fuller's positive yet patronizing view of the Romans defines them as "good children," ready to be educated in the responsibilities of republican political life. Lester, following the failure of the revolutions in Italy, comments that the majority of Italians had yet to be ready for democracy: "Men must be educated to democracy to make them democrats."[21] Likewise, Heade situates his

portrayal of the events in Rome in 1848 and 1849 within this discourse of Italians as "children." Heade's two boys, stand-ins for *Italia*, need to be educated in democracy in order for Italy to "grow up" a "good" republican nation.[22]

ALTHOUGH MANY CONTEMPORARY WRITERS did view the Italians as "children," not yet ready for, or racially incapable of, the responsibilities of republican government, many of these same Americans also blamed the Jesuits and their influence in Italy, France, and Austria for the failure of the Roman Revolution in 1848 and 1849. Heade includes the Jesuits, as threats to both the pro-papal, Gioberti-styled moderate reformers and the Mazzini-led republicans, in his narrative of the history of the Republic in *Roman Newsboys*. The powerful shadow, approaching both newsboys from the left, appears to have the broad hat of a Jesuit. The Jesuit ominously approaching as "shadow" adheres to contemporary American criticism of the Catholic society's role in the failure of the 1848 revolution and in the subversion and destruction of all liberal ideas. Charles Lester, in making Pope Pius IX the "hero" of his narrative in *My Consulship*, uses the Jesuits as a villain of his story. Lester opined that "from the first moment [Pius IX] made known his intentions of reforming the Pontifical Government, the Jesuits, and the leaders and instruments of the retrograde party, brought all machinery they could, to bear against him." He called the Jesuits the "most efficient and subtle spies... treacherous, wily... smooth, cool, [and] snaky." In the middle of his section discussing the reforms put forth by Pius IX, Lester foreshadows the revolutionary events and the "ruin" of Pius noting that the French soldier "has been the master-workman of the Society of Jesus." Margaret Fuller, in observing that "the influence of the Jesuits is still immense in France," feared that the "sly" Jesuits would influence opinion in France against the Roman Republic and for papal restoration.[23]

Like Heade's inclusion of a shadowy Jesuit in *Roman Newsboys*, the penny paper *Il Don Pirlone* often included the Jesuits, with large-brimmed hats, as evil scoundrels plotting against the Roman Republic and Italian unification. In a cartoon called "Impediments to Liberty," a poor, classically-garbed, "Cinderella" version of Liberty, straddling "the boot" of Italy, swings her broom and angrily attempts to strike at a military officer, already supine on the ground. The officer, almost defeated despite his chest covered in medals of victory, holds an open shackle and chain in his left hand. He desperately clings to "the boot." The head and arms of the pope emerge, from clouds at the horizon, preventing "Liberty" from taking her swing. Meanwhile, prepared for a surprise assault and lurking inside "the boot," a fiendish Jesuit, easily-identifiable by his large hat and dark robes, holds a stiletto in each hand. The note for the plate in the New Orleans version, in interpreting the image for its American viewers, implies the anti-Providential nature of Pius's actions: "The Pope, the Jesuits, and the generals are the jailers of liberty in Europe. That same Italy which so readily trampled under foot those very generals cannot divest herself of them, chained, as she is, by that ROMAN CATHOLIC SULTAN, whose JANIZARIES even threaten her at the point of dagger." Heade's inauspicious and potent shadows, including that of the unseen Jesuit, in *Roman Newsboys* foreshadow the eventual failure of the revolution at the hands of "the jailers of liberty in Europe."[24]

Heade designed *Roman Newsboys* both as a collapsed rendition of the revolutionary events in Rome in 1848 and 1849 and as a warning to Americans to be watchful of their freedoms. Ultimately, Heade created a second version of *Roman Newsboys* (now in a private collection), in which the barred window at the upper left looms larger, and many of the posters and graffiti no longer decorate the walls, except for a large cross at the right. The "republican" boy wears a regular street cap instead of his "Liberty" cap from the earlier version. Finally, the shadows have grown darker and the "republican boy" does not hand out *Il Don Pirlone*, but

a paper simply with "Roma" in its title. In this version, the military and political defeat of the Roman Republic, and the restoration of the papacy have apparently taken place. Yet the boys still offer forth the symbols of democratic information: their newspapers. Art historian Theodore Stebbins dates this later version to after 4 July 1849, following the return of Pope Pius IX to Rome and the fall of the Republic. In July 1849, Margaret Fuller expressed the idea that Americans needed to be watchful and contemplative about "freedom" around the world: "Friends, countrymen, and lovers of virtue, lovers of freedom, lovers of truth! be on the alert; rest not supine in your easier lives, but remember 'Mankind is one,/ And beats with one great heart.'"[25]

1 "The Past Year," *Christian Watchman and Reflector*, 4 January 1849, 2. See Timothy L. Smith, *Revivalism and Social Reform: American Protestantism on the Eve of the Civil War* (Baltimore: Johns Hopkins University Press, 1980), 152-153. On the Mexican War, see Carol and Thomas Christensen, *The U.S.-Mexican War* (San Francisco: Bay Books, 1998); Robert W. Johannsen, *To the Halls of the Montezumas: The Mexican War in the American Imagination* (New York: Oxford University Press, 1985); and David Pletcher, *The Diplomacy of Annexation: Texas, Oregon, and the Mexican War* (Columbia: University of Missouri Press, 1973). See Brian Roberts, *American Alchemy: The California Gold Rush and Middle-Class Culture* (Chapel Hill: University of North Carolina Press, 2000). Given the revolutionary climate of Europe, the *New York Herald* compared the changes taking place abroad to a place where the "political and social fabric of the world" was "crumbling": "By the intelligence, however, which we have lately received, the work of revolution is no longer confined to the Old World, nor to the masculine gender. The flag of independence has been hoisted, for the second time, on this side of the Atlantic, and a solemn league and covenant has just been entered into by a Convention of women at Seneca Falls." Quoted in Larry J. Reynolds, *European Revolutions and the American Literary Renaissance* (New Haven: Yale University Press, 1988), 55. On the Women's Rights Movement, see Ellen Carol DuBois, *Feminism and Suffrage: The Emergence of an Independent Women's Movement in America, 1848-1869* (Ithaca: Cornell University Press, 1999) and Keith E. Melder, *Beginnings of Sisterhood: The American Woman's Rights Movement, 1800-1850* (New York: Schocken Books, 1977). For more on the cholera epidemic, see Charles E. Rosenberg, *The Cholera Years: The United States in 1832, 1849, and 1866* (Chicago: University of Chicago Press, 1987). For the election of 1848, see Michael F. Holt, *The Rise and Fall of the American Whig Party: Jacksonian Politics and the Onset of the Civil War* (New York and Oxford: Oxford University Press, 1999), 284-382.

2 Arthur Gribben, ed., *The Great Famine and the Irish Diaspora in America* (Amherst: University of Massachusetts Press, 1999). J. Matthew Gallman, *Receiving Erin's Children: Philadelphia, Liverpool, and the Irish Famine Migration, 1845-1855* (Chapel Hill: University of North Carolina Press, 2000). Nathan O. Hatch, *The Democratization of American Christianity* (New Haven: Yale University Press, 1989), 184-189. Caroline M. Kirkland, *Holidays Abroad; Or Europe from the West* (New York: Baker and Scribner, 1849), vi.

3 Gail Husch argues that "an unusual concentration of paintings that depicted transformative moments of revelation and envisioned divine judgment or millenial promise was produced and exhibited in the United States in the years immediately following 1848." See Gail E. Husch, *Something Coming: Apocalyptic Expectation and Mid-Nineteenth-Century American Painting* (Hanover and London: University Press of New England, 2000), 3. In Italy during these tumultuous years, Pennsylvanian artist Thomas Hicks painted an *Italia*, described as "a half-length ideal female figure." Theodore E. Stebbins, Jr. argues that "Heade in [*Roman Newsboys*] clearly sides with the Risorgimento" [emphasis added]. See Stebbins's catalogue entry for *Roman Newsboys* in Theodore E. Stebbins, Jr., *The Lure of Italy: American Artists and the Italian Experience 1760-1941* (Boston: Museum of Fine Arts, Boston, 1992), 201. In calling *Roman Newsboys* "a history painting masquerading as a genre scene," Stebbins also observes that "Heade was a highly political person whose views blended social conservatism, economic populism, and a defiant individualism—libertarianism, in today's terms." See Theodore E. Stebbins, Jr., *The Life and Work of Martin Johnson Heade: A Critical Analysis and Catalogue Raisonné* (New Haven and London: Yale University Press, 2000), 10. As shown later in the essay, other American observers of the events of 1848 and 1849 believed that the intellectual and moral incapacity of the Italians would keep the Italian nation from "progressing" in the near future. Many Americans believed that God had ordained a special role to America through its unique combination of Protestant evangelical religion and democratic republican governmental structure. William Vance notes the compression of the four phases— the election of Pius IX and his initial reforms, the arrival of Gioberti in Rome in 1848, the flight of Pius from Rome, and the Republic. See William L. Vance, *America's Rome*, vol. 2 (New Haven: Yale University Press, 1989), 126. A basic premise of my argument here is that the American analysis of the failure of the revolution in 1848 says more about Americans than Italians.

4 *Roman Newsboys* resulted from Heade's trip to Italy in 1848 and 1849. Heade, born in 1819, in Lumberville, Pennsylvania, received his earliest training from Edward Hicks. Thomas Hicks, the young cousin of Edward Hicks, painted a portrait of Heade about 1841. For further interpretations and contextualization of *Roman Newsboys*, see Vance, 105-138; Husch, *Something's Coming*, 53-54; and Stebbins, *Martin Johnson Heade*, 7-12. Stebbins's catalogue lists

Roman Newsboys as no. 16. According to Stebbins, at least two other currently unlocated paintings resulted from Heade's trip to Italy—*Street Scene in Rome*, *The Roman Goat-Herd*, exhibited in Cincinnati in 1849 or 1850, and *Beatrice Cenci* (after Guido). It seems reasonable and likely that Heade's friend and fellow Pennsylvanian, Thomas Hicks, had a role in Heade's Italian soujourn during these years. The only mention of Heade in Rome, however, occurs in *The Literary Word*, whose Rome correspondent reported on 31 January 1848, "Heade of Philadelphia is here, but I know not what about." "Foreign Correspondence," from Rome, dated 31 January 1848, in *The Literary World* 60 (24 March 1848), 148, quoted in Stebbins, *Martin Johnson Heade*, 10.

5 My understanding of the revolutionary events in Italy in 1848 and 1849, as discussed at this point in the essay and later, comes from several secondary sources: Clara M. Lovett, *The Democratic Movement in Italy 1830-1876* (Cambridge and London: Harvard University Press, 1982); Lucy Riall, *The Italian Risorgimento: State, Society and National Unification* (London and New York: Routledge, 1994); Spencer M. Di Scala, *Italy: From Revolution to Republic 1700 to the Present* (Boulder: Westview Press, 1995); Denis Mack Smith, "The Revolutions of 1849-1849 in Italy," in *The Revolutions in Europe 1848-1849: From Reform to Reaction*, eds. R. J. W. Evans and Hartmut Pogge von Strandmann (Oxford and New York: Oxford University Press, 2000), 55-81; Jonathan Sperber, *The European Revolution, 1848-1851* (Cambridge: Cambridge University Press, 1984); David LoRomer, *Merchants and Reform in Livorno 1814-1868* (Berkeley: University of California Press, 1987); and Priscilla Robertson, *Revolutions of 1848: A Social History* (Princeton: Princeton University Press, 1971).

6 Quoting Ralph Waldo Emerson to William Emerson, 8 August 1836, in *The Letters of Ralph Waldo Emerson*, vol. 2, ed. Ralph L. Rusk, (New York, 1939), 32. For more on Margaret Fuller, her writings, and her cultural impact, see Donna Dickenson, *Margaret Fuller: Writing a Woman's Life* (New York: St. Martin's Press, 1993); Madeleine B. Stern, *The Life of Margaret Fuller*, 2nd ed. (New York: Greenwood Press, 1991); Joan von Mehren, *Minerva and the Muse: A Life of Margaret Fuller* (Amherst: University of Massachusetts Press, 1994); and Van Wyck Brooks, "The Risorgimento: Margaret Fuller" in *The Dream of Arcadia*. For an anthology of nineteenth- and twentieth-century responses to the works of Margaret Fuller, including essays by Orestes A. Brownson, Edgar Allan Poe, Matthew Arnold, and Henry James, see Joel Myerson, ed., *Critical Essays on Margaret Fuller* (Boston: G. K. Hall, 1980). William H. Gilman, ed., *The Journals and Miscellaneous Notebooks of Ralph Waldo Emerson*, vol. 11 (Cambridge: Harvard University Press, 1960-82), 445.

7 Margaret Fuller Ossoli, *At Home and Abroad; Or, Things and Thoughts in America and Europe*, ed. Arthur B. Fuller (Boston: Brown, Taggard and Chase, 1860), 224, 243, and 248. The New York editor Theodore Dwight, in his preface to *The Roman Republic of 1849; with Accounts of the Inquisition, and the Siege of Rome*, published in 1851, echoes Fuller by stating that the Italian "question" is "essentially our own." (New York: R. Van Dien, 1851), and pronounces that American Protestant principles and education were far superior to Rome's system of religion and government, 135-136.

8 *Proceedings of a Public Meeting of the Citizens of the City and County of Philadelphia, Held January 6, 1848, to Express Their Cordial Approval of the Liberal Policy of Pope Pius IX. in His Administration of the Temporal Government of Italy* (Philadelphia: Jos. Severns & Co., 1848).

9 Ossoli, *At Home and Abroad*, 230. In describing the perception of the reforms of the new pope by Italians living abroad in Constantinople, conservative Englishman (and eventual apologist for monarchy and the King of Naples in the events of 1848 and 1849) Charles MacFarlane wrote: "[A]ll the Italians were wondrously united by love and admiration of the reforming Pope; and while the enthusiasts were anticipating a perfect millennium, all looked forward to a greatly improved state of things in their native country. 'Long life to the Pope!' (*Viva Pio Nono!*) were words chalked upon the walls, written on paper, and placarded at the turning of nearly every street." Charles MacFarlane, *A Glance at Revolutionized Italy*, vol. 1 (London: Smith, Elder, and Co., 1849), 4-5. Harry W. Rudman calls MacFarlane "the most reactionary of Victorian publicists" in *Italian Nationalism and English Letters: Figures of the Risorgimento and Victorian Men of Letters* (London: George Allen & Unwin, 1940), 228. Ossoli, *At Home and Abroad*, 226.

10 C. Edwards Lester, *My Consulship*, vol. 2 (New York: Cornish, Lamport & Co., 1853), 5-79, and 169. Englishman Charles MacFarlane also comments, with irony, on the many pamphlets by Gioberti available, even in a small town like Foligno (which MacFarlane was visiting): "[T]here were the works of Vincenzo Gioberti, the great apostle of Italian Unitarianism, down to the last pamphlet which the post had brought from Turin (but this last pamphlet, though new in Foligno, would be old by to-day in Turin, for Gioberti—eternally scribbling—seems to publish a pamphlet as often and as regularly as he eats his daily dinner." MacFarlane, *Revolutionized Italy*, 322. Ossoli, *At Home and Abroad*, 355-356. In August 1847, Fuller made one other note of the popularity of Gioberti among Italians: "In Tuscany they are casting [a cannon] to be called the 'Gioberti,' from a writer who has given a great impulse to the present movement." Ossoli, *At Home and Abroad*, 249.

11 Vincenzo Gioberti was born at Turin in 1801, and studied theology at Turin University. He was ordained a priest in 1825, and appointed Piedmontese court chaplain and professor. Gioberti wrote articles under the pen-name "Demofilo" in Guiseppe Mazzini's "Young Italy." In 1833, Gioberti resigned as court chaplain and was arrested on suspicion of political intrigues. He was expelled from Turin and went to Paris and Brussels. Gioberti returned from exile to Turin with the events of 1848, and became a minister in Charles Albert's Piedmont government. For more on Vincenzo Gioberti, see G. F. H. Berkeley, *Italy in the Making 1815 to 1846* (Cambridge: Cambridge University Press, 1932). Orestes Brownson, in providing an American Catholic perspective on the events, argues that Gioberti's too-liberal actions in 1848 and 1849, which seem to contradict the intent of his philosophical and political writings,

are instead evidenced in Gioberti's philosophical errors. See *Brownson's Quarterly Review* 4, new series (October 1850): 409-447.

12 MacFarlane, *Revolutionized Italy*, 310-311. Ossoli, *At Home and Abroad*, 358.

13 Ossoli, *At Home and Abroad*, 364-365. For more on Mazzini, see Denis Mack Smith, *Mazzini* (New Haven: Yale University Press, 1994). L. Mariotti, *Italy in 1848* (London: Chapman and Hall, 1851) offers contemporary opinions on Mazzini and the Roman Republic. For the links between the ideology of the United States and Mazzini's thought, see Joseph Rossi, *The Image of America in Mazzini's Writings* (Madison: University of Wisconsin Press, 1954).

14 Martin Johnson Heade's friend, Thomas Hicks, painted a portrait of Margaret Fuller Ossoli in Rome in 1848. Ossoli, *At Home and Abroad*, 385 and 387. Later, American consulates and ships would provide safe haven for Italian political refugees.

15 See Timothy M. Roberts and Daniel W. Howe, "The United States and the Revolutions of 1848," in Evans, *Revolutions in Europe*, 157-179; and Holt, *Rise and Fall*, 284-382. The city of New York held a public demonstration of support for Pius IX on 29 November 1847. See the sixty-page pamphlet *Proceedings of the public demonstration of sympathy with Pope Pius IX and with Italy in the city of New York on Monday, November 29, A.D. 1847* (New York: W. Van Norden, 1847).

16 The *New York Herald*, 5 November 1848, quoted in Evans, *Revolutions in Europe*, 171.

17 Michael Schudson, *Discovering the News: A Social History of American Newspapers* (New York: Basic Books, 1978), 35-36. For the role of the newspaper within American politics and culture, see William E. Huntzicker, *The Popular Press, 1833-1865* (Westport, CT: Greenwood Press, 1999); and Menahem Blondheim, *News over the Wires: The Telegraph and the Flow of Public Information in America, 1844-1897* (Cambridge and London: Harvard University Press, 1994). The opinion of the role of newspapers in fostering a "revolutionary culture" in Europe comes from Hartmut Pogge von Strandmann, "1848-1849: A European Revolution" in Evans, *Revolutions in Europe*, 3.

18 Ossoli, *At Home and Abroad*, 345. G. Daelli, *A Relic of the Italian Revolution of 1849. Album of Fifty Line Engravings, Executed on Copper, By the Most Eminent Artists at Rome in 1849; Secreted from the Papal Police After the "Restoration of Order," And Just Imported into America* (New Orleans: Gabici's Music Stores, 1850?), 7-23. Daelli based his abbreviated, fifty plate American version of the engravings on the multi-volume work by Michelangelo Pinto, *Don Pirlone a Roma: memorie di un italiano dal 1 settembre 1848 al 31 dicembre 1850*, 3 vols. (Torino: Alessandro Fontana, 1850).

19 Daelli, *Relic of the Italian Revolution*, 7-23.

20 Ossoli, *At Home and Abroad*, 321. Lester, *My Consulship*, 226-227. Henry T. Tuckerman, *The Italian Sketchbook*, 3rd ed. rev. and enl. (New York: J.C. Riker, 1848), 408, quoted in Vance, *America's Rome*, 122.

21 For one example of an antebellum author expressing the concept of republican motherhood, see Protestant minister John S. C. Abbott's *The Mother at Home; or the Principles of Maternal Duty, Familiarly Illustrated* (New York: The American Tract Society, 1833), 159-161. Hawthorne consistently plays upon the idea of Donatello as "child" in the "pre-murder" chapters of the book. See Hawthorne, *The Marble Faun*, 19-65. Ossoli, *At Home and Abroad*, 346-347, 242. Lester, *My Consulship*, 254. In her essay "Fuller, Hawthorne, and Imagining Urban Spaces in Rome," Brigitte Bailey argues that both Fuller's newspaper accounts and Hawthorne's novel are "implicated in the related cultural effort of conceptualizing and representing the city, in developing an urban imaginary in antebellum American culture." See Bailey's essay in Robert K. Martin and Leland S. Person, eds., *Roman Holidays: American Writers and Artists in Nineteenth-Century Italy* (Iowa City: University of Iowa Press, 2002), 173-190.

22 Genre images of young boys were popular in the nineteenth century. Paintings of young newsboys and other urban boys from the late 1840s and 1850s often commented upon the issues of reform, social perfection, and politics. For a discussion of the meaning of nineteenth-century images of rural children, see Sarah Burns, "Barefoot Boys and Other Country Children" in *Pastoral Inventions: Rural Life in Nineteenth-Century American Art and Culture* (Philadelphia: Temple University Press, 1989), 297-332. Other images of young newsboys and other urban boys from the 1840s and 1850s include David Gilmour Blythe, *Street Urchins*, 1856-1860, oil/canvas, Butler Institute of American Art; Blythe, *The News Boys*, c.1846-1852, oil/canvas mounted on board, Carnegie Museum of Art; George Henry Yewell, *The Bootblack (Doing Nothing)*, 1852, oil/canvas, New-York Historical Society; and Thomas Le Clear, *Buffalo Newsboy*, 1853, oil/canvas, Albright-Knox Art Gallery; among many others. Both Elizabeth Johns and Gail Husch interpret some of these images of urban boys. See Elizabeth Johns, *American Genre Painting: The Paintings of Everyday Life* (New Haven: Yale University Press, 1991), 176-196, and Husch, *Something's Coming*, 34-80.

23 Lester, *My Consulship*, 20, 107, 177, and 231. Ossoli, *At Home and Abroad*, 19-20 and 382.

24 Daelli, *Relic of the Italian Revolution*, 19.

25 For the second version, in a private collection, see Stebbins, *Martin Johnson Heade*, 202. Ossoli, *At Home and Abroad*, 421.

Janice Simon ✒ *Universty of Georgia*

Impressed in Memory

JOHN FREDERICK KENSETT'S *ITALIAN SCENE*

The wonderful individuality of the painted rocks I saw at your studio has been an increasing source of admiration to me, as they remain impressed in memory, and I am more certain that "things of beauty are joys forever."

WITH THESE WORDS, ADAM R. SMITH EAGERLY ANTICIPATED his recent art purchase of 1859, a characteristic landscape scene from the brush of Connecticut-born John Frederick Kensett (1816-1872).[1] Smith was just one among many who found in Kensett's paintings of rocks and light-filled distances an idyllic repose conducive to stimulating a reverie of associations. On 19 November 1863, Juliet Campbell wrote to Kensett in appreciation of her recently arrived, "little gem of a landscape," a "dream of peace" such as "Tennyson imagined, in his Lotus eaters." She proceeded to describe where it hung, replacing a head of Shakespeare:

> [T]here it is, like a rift in the wall, revealing a new heaven and a new earth! Mr. Campbell calls it "the Better Land."... Yesterday, as I sat thus, receiving the sweet suggestions of the picture my thoughts wandering by "down dropping veils" of far cascades, and dreamy slopes of distant mountains, or, into its western heart of light; I wondered how I could thank him who had set this bit of beauty as an ornament, in my every day life.[2]

For her, not only did Kensett's landscape contain mountain rocks, but the painting itself acted as a rift in the wall's rock face, revealing a new vision.

On the eve of the Civil War, New York's foremost art periodical, *The Crayon*, similarly praised Kensett's "subtle and delicate ... perception of the poetry and harmony of nature." Indeed, *The Crayon*'s reviewer of the annual exhibition at the National Academy of Design proclaimed Kensett's reposeful pictures as the "highest expression of landscape art." Of particular interest was "the rocky bluff on the right," Newport, "the most beautiful piece of rock-painting we remember to have seen by him. The delicacy and the expression of solidity which characterizes this object, as well as its fine color, makes it a study for all landscape painters."[3] Such rhapsodies about Kensett's painted rocks were not unusual. In *Book of the Artists: American Artist Life* (1867), Henry T. Tuckerman frequently lauded Kensett's ability to delineate the "Flemish truth in the grain of that trap-rock," to so capture the local geological character of a place so that "his landscapes would charm even a man of science." Yet critics and patrons alike appreciated, as Tuckerman phrased it, that "Kensett does not merely imitate, or emphasize, or reflect nature—he interprets her—which we take to be the legitimate and holy task of the scenic limner."[4]

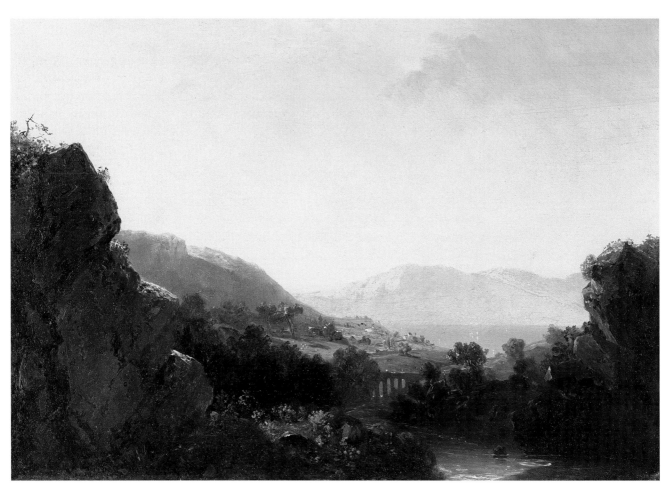

13 ❧ JOHN FREDERICK KENSETT, Italian Scene, *c. 1847.*

Oil on canvas, 13 ⅝ x 19 ⅝".

Georgia Museum of Art, University of Georgia;

Eva Underhill Holbrook Memorial Collection of American Art, gift of Alfred H. Holbrook.

GMOA 1945.56

K ENSETT'S SUDDEN DEATH IN DECEMBER 1872 from a heart attack brought on by pneumonia inspired numerous tributes to his genial character and to his tranquil art. Unitarian minister Samuel Osgood concluded memorial proceedings for the artist at the prestigious Century Association by celebrating the poetic power and distinctive meaning of Kensett's paintings. Like so many previous writers on Kensett's art, Osgood found his painted rocks mesmerizing. Referring to the many paintings Kensett produced of their shared neighborhood of the Connecticut shore on Long Island Sound (for example, *Study on Long Island Sound at Darien, CT*, 1870-72, Amon Carter Museum, Fort Worth, Texas), Osgood commented on how Kensett rendered the "frequent and characteristic ... rocks in our neighborhood ... in a wonderful way." Indeed, they so struck Osgood's eye as to stimulate his mind into an associationist reverie on time, creation, and the processes of nature:

> Under his touch we see the marvel of the Egyptian sands reappearing on the shore of our great Sound, and that stone looks upon you with the face of the Sphinx. That rock whispers to you the secret of earth, and sea, and sky. Its surface speaks out the mysterious life of nature which glows in that rich color like blood in the cheek; and those stains, and seams, and mosses are the impressions which ages have left upon that stony face under the changes of the air, and water and light. This Sphinx means more than we can understand, and her features and look so faithfully report her colloquy for thousands of years with the sea and the winds.[5]

Now anthropomorphized, the rocks in Kensett's paintings not only would "remain impressed in memory" but also embody the recollective, metonymic, and metaphorical processes of the mind.

No single rock prefigures more the imagery of Osgood's geological musings or the "wonderful individuality" impressed in Smith's memory than the left foreground rock face of Kensett's *Italian Scene* (fig. 13). This singular, large, and irregularly cut stone extends from the edge of the canvas. Its gray, chiseled edges catch the sunlight and distinctly compose the profile of a human face: an angular jutting block at the top creates the forehead; a shadowed crevice forms the eye socket and temple; a round strongly-lit protrubence complete with dashes of leafage imitates eyeball and lashes; a sharp diagonal break, dazzlingly highlighted along the edge, produces the extension of a prominent nose. Another deep angled crevice forms the mouth that seems open due to the sunlight on its "lip." A jutting chin completes the stern, masculine-looking countenance. Fissures on the side suggest the areas of the cheek and ear. As if to complete the anthropomorphic illusion, vegetation gathers at the top and "brow" of the rock. This severe visage literally faces into and figuratively gazes upon the panoramic scene beyond. With the highly irregular rocks situated across the stream, it creates a natural gateway to the mountains, ruins, and river extending into the distance. Of Kensett's extant works, this is the first and most blatantly anthropomorphic rock face in his *oeuvre*. Perhaps more than any other rock configuration by Kensett, this stern mountain face functions as a Sphinx-like presence, stimulating questions about the perception of nature and its transcription, and the processes of human memory and artistic imagination.

A NTHROPOMORPHIC ROCKS, TREES, CLOUDS, and objects appear throughout the history of art. American artists picked up where Renaissance and Baroque artists experimenting with the grotesque left off, incorporating prominent rock faces and gesturing trees in their landscape paintings.[6] Thomas Cole, the dean of American landscape painting at the time Kensett traveled to Europe and Italy in the 1840s, featured anthropomorphic faces in his mountains and cliffs, and wrote of trees as emulating human gestures.[7]

Whether wilderness views of American scenery, biblical allegories, or imagined Italian Arcadias, Cole repeatedly included in his paintings rock faces as witnesses and trees as human surrogates (*Sunny Morning on the Hudson River*, 1827, Museum of Fine Arts, Boston; *The Voyage of Life*, 1840, Munson-Williams-Proctor Institute, Utica, New York; *L'Allegro*, 1845, Los Angeles County Museum of Art). On the other hand, Kensett usually tempered his moderate anthropomorphic inclinations with a more scientific naturalism derived, in part, from the writings of English critic John Ruskin. Kensett's unusual incorporation of a blatant rock face in an image inspired by his Italian tour, and its virtual disappearance from his subsequent work, raises significant questions about the purposes of anthropomorphic imagery, Kensett's perceptions of Italy, Europe, and America, and the importance of Cole to Kensett's art.

The anthropomorphic impulse, pervasive in the literature and art of most cultures since the beginning of time, derives from an inborn disposition that compels the human race to discover patterns of meaning in all things perceived. As both Ludwig Wittgenstein and William James recognized, "we never merely see, but always 'see as.'"[8] Anthropomorphism especially satisfies the universal need to ascribe meaning to the complexity of the world. It does so by taking what has been traditionally assumed as the most familiar, most highly organized, and most intellectually powerful organism in our perceptual world—the human form—and affixing it onto a diversity of natural and artificial structures. By doing so, anthropomorphism attends to our need to see for better or worse what is most important to our biological survival, other human beings.[9] Eighteenth-century philosopher David Hume importantly theorized that anthropomorphism originated from perceptual and physical insecurities that stimulated the imagination to conceive familiar, analogical explanations of the unknown. His *Natural History of Religion*, published in 1757, the same year as Edmund Burke's *Enquiry into the Origin of our Ideas of the Sublime and Beautiful*,

addressed concerns regarding the perception of the world that were as fundamental for landscape painters as were Burke's seminal theories. Hume wrote:

> There is a universal tendency among mankind to conceive all beings like themselves, and to transfer to every object, those qualities, with which they are familiarly acquainted, of which they are intimately conscious. We find human faces in the moon, armies in the clouds; and by a natural propensity, if not corrected by experience and reflection, ascribe malice or good-will to every thing, that hurts or pleases us. Hence … trees, mountains and streams are personified, and the inanimate parts of nature acquire sentiment and passion.[10]

Other theorists read by nineteenth-century landscape painters like Cole and Kensett, most notably Archibald Alison, extended the importance of personification and anthropomorphism to creating a train of mental associations that evoke the emotions of sublimity and beauty. Through this process the mind ascribes moral meaning to the physical world. Alison concluded his highly influential *Essays on the Nature and Principles of Taste* (1790) by asserting that

> There is yet, however, a greater expression which the appearances of the material world are fitted to convey, and a more important influence which, in the design of nature, they are destined to produce upon us: their influence I mean in leading us directly to RELIGIOUS sentiment ... nature, in all its aspects around, ought only to be felt as signs of his providence, and as conducting us, by the universal language of these signs, to the throne of the DEITY.[11]

Alison's endowment of religious sentiments in the perception of nature was one shared by Cole, Kensett, and their landscape contemporaries, as well as by the majority of their patrons and viewers. Perhaps then, Kensett's overt anthropomorphism in *Italian Scene* can be understood as a

product of those religious, sublime, and beautiful emotions his mind associated with his experiences of pagan Rome and Catholic Italy.

INDEED, *ITALIAN SCENE* EVOKES KENSETT'S ASSIMIlation of his seven-and-a-half-year tour of England, France, Switzerland, and Italy. In June 1840, Kensett left his engraving job in Albany in order to join his artist friends Thomas Rossiter (1818-1871), John Casilear (1811-1893), and Asher B. Durand (1796-1886) on their passage to Europe.[12] By traveling through the celebrated cities and inspiring landscapes of the Old World, Kensett hoped to develop an artistic style that would reap him success in the New World. His initiation into the artistic circles of London, Paris, and Rome resulted in exposure to some of the most important European landscape artists of the past and present including Claude Lorrain, Salvator Rosa, Jacob van Ruisdael, Constant Troyon, John Constable, and J. M. W. Turner, with whom he probably conversed in 1840. As important as were such European contacts, Kensett's connection to the vast community of American artists and writers in Europe was even more influential. Rossiter's painting of *A Studio Reception, Paris* (fig. 14) has Kensett,

holding palette and mahl stick, standing directly between the seated Rossiter and Thomas Cole, whom Kensett and his comrades regarded as America's premier painter of the historical landscape. Durand (leaning against Kensett), Casilear, Benjamin Champney, and Daniel Huntington (against the mantel) are among the other painters featured in this group portrait. Cole functioned as an artistic barometer of sorts for Kensett. Cole's name crops up in Kensett's letters and diary while in Paris, with special mention of sketches produced and sites seen, including a joint excursion to Versailles. On 9 October 1841, Kensett noted with much delight his unexpected receipt of a landscape study from Cole as a souvenir of their sketching jaunt together around the environs of Paris, "one ... that [I] esteem and prize very highly."[13] Cole then left Paris with Kensett's friend Rossiter for extended travel through Switzerland to Italy, arriving in Neufchâtel on October 16, Rome on November 9. Cole stayed in Italy until late May 1843. This was Cole's second trip to Italy, his first conducted a decade earlier, May 1831 to August 1832, and inspiring his famous *Course of Empire* series (1834-36, New-York Historical Society).[14] Although Kensett would not encounter Cole again on his European travels, Cole remained in his thoughts through his friends Rossiter,

Durand, and Casilear. At the time of Kensett's death in 1872, he owned two of Cole's paintings, the aforementioned *Study*, and *Arch of Titus, Rome*, and had even painted a *Reminiscence of Cole* (seventeen by twenty-seven inches, now unlocated).[15]

In the summer of 1845, Kensett, whose travels had been restricted to England and France, acquired enough money to descend upon Rome. He departed from Paris with fellow artist Benjamin Champney, taking eleven weeks to arrive at "the First City of the World" via the Rhine and Switzerland. In Rome, Kensett attended costumed figure drawing classes with artist and transcendental follower, Christopher Pearse Cranch.[16] During the summer and fall of 1846, Kensett and painter Thomas Hicks (who would remain one of his closest friends) conducted a five-month sketching tour in the country-side south and east of Rome. From Albano and Genzano, they proceeded to the Sabine range of the Apennines, and the hill towns of Olevano, Palestrina, Subiaco, and Civitella, which is most likely perched between and west of Subiaco

and Olevano rather than that of Roveto on the Liri River or of Tronto farther northeast into the Abruzzi.[17] After a stop at Tivoli, Kensett returned to Rome for the winter. In April 1847, Brook Farm writer George William Curtis and his wife, who would become Kensett's lifelong friends, accompanied the artist to Naples, Pompeii, and Capri; all set sail for America in November.[18]

The overall image of *Italian Scene,* as well as its details, suggest that it is a pastiche of sights Kensett experienced on his trip to the Sabines and Apennines, an area in the nineteenth century replete with craggy rock faces, remnants of fortress walls and aqueducts, river valleys amidst grand mountains, medieval monasteries and convents, village churches and habitations. Pencil sketches extant from Kensett's trip confirm the location. Letters and exhibition records clearly indicate Kensett executed the majority of his Italian oil paintings upon his return to America from summarily outlined sketches and color studies.[19] Memory,

15 ⌁ JOHN FREDERICK KENSETT, *Civitella, 2 October 1846.* *Pencil on buff paper (bleached),* *12 ⅛ x 17 ¼".* *Courtesy of the Huntington Library,* *Art Collections, and Botanical* *Gardens, San Marino, California.*

16 ❧ WILLIAM GILPIN,

View from Observation on the River Wye and several parts of South Wales, &c. relative chiefly to picturesque beauty; made in the year 1770, 2nd ed. London: R. Blamire, 1782. Courtesy of Janice Simon.

association, convention, and expression played significant roles in their artistic construction. For example, the sketch of *Civitella* (fig. 15) shows that the foreground prospect rock certainly captivated Kensett's eye; his imagination transformed its irregular profile into the imposing rock face of *Italian Scene*. Even Kensett's more conventional Italian views like *The Shrine—a Scene In Italy* of 1847 (Katz Collection, Naples, Florida) seamlessly incorporate several sources: he took the figures directly from costume-study sessions; the foreground mullein plants he lifted from a previous oil study; he gleaned the roadside shrine and hilltop ruins from his travels; and he borrowed the landscape composition and lighting directly from Claude Lorrain. In fact, Kensett frequently emphasized the role of memory in his artistic representations of place by including "reminiscence," "recollection," and "souvenir" in his titles of Italian and American scenery.[20]

With its left foreground rock face literally gazing beyond an aqueduct into a valley that leads to distant water and a mountain range, *Italian Scene*'s composition suggests the very act of recollection or reminiscence. In the right foreground of the composition, a series of jagged rocks form additional profiles looking into the valley. From one of them, a thin, rocky extension juts out leftward, its flattened edge highlighted by sunlight, pointing like a finger to the painting's prominent geological visage. It alerts the viewer to the stony face's act of seeing, and serves to form with it a gateway into the scene. This stony curtain has a long tradition in scenic views. Kensett's craggy prominence juxtaposed with a tranquil river valley and gentle mountain range recalls the scene picturesque theorist William Gilpin provided to illustrate his travels through the English countryside (fig. 16). *Italian Scene*, however, amplifies the idea of a threshold from one

state of existence to another quite different in character.

Nineteenth-century viewers would readily see Kensett's Italian view as a juxtaposition of the Sublime with the Beautiful, of the wild crags of Salvator Rosa with the reposeful vales of Claude Lorrain, of what Burke categorized as the terrifying masculine with the tranquilizing feminine. Kensett's art, with its soothing, luminous distances, always reminded viewers of Claude's ideal landscapes. Critics and patrons linked Thomas Cole, however, with both Salvator Rosa and Claude Lorrain.[21] *Italian Scene* is unusual for Kensett in its blatant combination of these opposing aesthetics. Its wild, anthropomorphic foreground, which dramatically yields to a sweeping panoramic view of a relic-scattered middle ground and soft, distant mountains, has its origins in Cole's equally theatrical and anthropomorphic *Sunny Morning on the Hudson River* (1827; Boston Museum of Fine Arts) and his disjunctive *View from Mount Holyoke, Northampton, Massachusetts, After a Thunderstorm (The Oxbow)* (1836; Metropolitan Museum of Art).

Yet Cole's views of Italy avoid the stark juxtapositions he favored in his American scenes by including foreground picturesque figures and ruins that harmonize man and nature, civilization, and space (fig. 17). He envisions Italy as a pastoral, feminized space to be aesthetically appreciated. Cole's friend James Fenimore Cooper codified this American tourist approach to Italy in his *Gleanings in Europe: Italy* (1838) in which he described his view of Naples:

> That bewitching and almost indescribable softness of which
> I have so often spoken, a blending of all the parts in one
> harmonious whole, a mellowing of every tint and trait,...threw
> around the picture a seductive ideal, that blended with the
> known reality in a way I have never before witnessed, nor
> ever expect to witness again.[22]

This need to see Italy as a unified experience under a "sleepy haziness of the atmosphere" created an ideal in which the Sublime and the Beautiful blended into a picturesque poem or painting:

> There is an admixture of the savage and the refined in the
> ragged ravines of the hills, the villas, the polished town, the
> cultivated plain, the distant ...peaks, the costumes, the songs
> of the peasants, the Oriental olive, the monasteries and
> churches, that keeps the mind constantly attuned to poetry.[23]

C OOPER'S DESCRIPTION CAPTURES THE picturesque admixture of nature and culture, past and present, inviting "contemplation and repose" that Kensett portrays as "Italy" in the panoramic section of his *Italian Scene*. In fact, Kensett provides a "pathway" for his tourist/viewer to enter this feminine, idyllic world of the Beautiful: a shimmering stream flows from the right foreground, passing the Sublime gateway of rocks to flow underneath yet another threshold image, the manmade bridge-aqueduct. Spots of red and white atop the structure transform into travelers, marking it as a crossing from one side of the vale to the other. This image of human mobility across the landscape continues, as the stream itself does, into the distant blue water, where numerous white sails punctuate its broad expanse. Populated bridge and water recall Claude Lorrain's landscapes in which man moves through nature peacefully, and provide a hopeful continuity of past and present.[24] Travel and commerce, essential to Italy's past glory, still thrive. Kensett's attention to the historic remains of human habitation and worship in this Italian vale creates a correspondent movement forward in time as the viewer follows the stream back into space. Beginning with the rough-hewn primitive rock face, Kensett leads the viewer in a zigzag direction to the Roman aqueduct and over an old wall to a Romanesque monastery with its arch and dome and then farther back to a white-and-red-roofed Renaissance church;[25] rightward to this church, in a direct line back in space from the rock

face, is a more contemporary village habitation also in red and white, with sailboats just beyond. In one harmonic view, Kensett visually summarizes the civilization of the Italian countryside.

With his two thresholds—foreground anthropomorphic gateway and Roman aqueduct—Kensett thereby provides the viewer with an exit from and entrance into two separate realms: the wild sublimity of Nature and the civilized beauty of Italy. Such an opposition duplicates Kensett's own Grand Tour, one common to eighteenth- and nineteenth-century travelers, and notable for its trek over many bridges and aqueducts.[26] In letters to his family, Kensett describes his journey with phrases from Byron's *Manfred* and *Childe Harold's Pilgrimage* as he moves through the treacherous terrain of Switzerland, and "old Mt. Blanc," "the monarch of mountains" to the broad *campagna* of "sunny Italy," "this land of song," and on to Rome, "lone mother of dead Empires."[27]

17 ❧ THOMAS COLE, Italian Landscape, *1839.*
Oil on canvas, 35 x 53".
Courtesy of The Butler Institute of American Art,
Youngstown, Ohio.

By peppering his descriptions with poetic allusions, Kensett follows Archibald Alison's associationist theories of the Sublime and the Beautiful. According to Alison, an acquaintance with poetry enhanced the spectator's ability in "giving *character* to the different appearances of nature, in connecting them with various emotions and affections of our hearts, and in thus providing an almost inexhaustible source, either of solemn or of cheerful meditation." Poetry led the landscape viewer "to the remembrance of such associations, enable them to behold, with corresponding

dispositions, the scenes which are before them, and to feel from their prospect the same powerful influence, which the eloquence of poetry has ascribed to them."[28]

Kensett's written descriptions of the rocky gorges he passed along the Rhine and the glaciers of the Alps reveal his engagement in Alison's associationist Sublime in which poetic metaphor overtakes empirical perception. The constant rain encountered during his party's "pedestrian journey of the Rhine" was of "the most gloomy [and] disheartening character." Yet Kensett found the trip "one of surpassing beauty under the inhospitable circumstances." He recounted how they:

> Went through the gorge of the Jura mountains produced by some terrific convulsion of nature & extending a distance of 50 or 60 miles more or less thro' a series of narrow & rocky debris thro' which the river Bris takes it foaming way—the grandeur of the scenes which are constantly recurring at every step or turn of the circuitous road keeps the mind in a constant frame of excitement. Bare rocks overhang the road—rising in perpendicular height from 500 to a 1000 feet, covered sometimes from top to bottom with the dark fir trees again presenting a bare surface of grey rock of regular layers, like a gigantic wall thrown up by some herculean arm of another race—while the Bris dashes thro' its narrow aperture and sweeping over rocks, and pebble shores at times one mass of snowy foam and this water power setting in motion [indecipherable] swills.[29]

Despite his attempts to explain what he saw in a rational, descriptive manner, he was overwhelmed by the unattainable and the disruptive. Repeatedly, Kensett noted in his diary the physical challenges of ascending the Alps and their emotional effect upon his perception: the "painful reflection of bright sun on the snow," "blistering the lips," "amid the sublime woods of this icy region," and how they reached "the brink of fatigue" on the mountain side, viewing the "superb" valleys and the "deep gorges" of "perpendicular rock" that "drop 2000 feet into the valley" that all effected "truly the sublimity of mystery."

ONE PASSAGE, REPLETE WITH THE TERRIBLE Sublime, reads more from a Gothic novel than an objective description: Noting the "approaching gloom which awaited them in the dark world of spirits," Kensett wrote of how "dank skin is stretched grimly on the skeletons giving them a still more fearful expression which the few rays of light which struggle into this silent abode of death amid gloom and insanity adds strength to the overpowering solemnity of the scene." He continued this rumination on fateful death with most likely a reference to the Carthaginian General Hannibal, "him who sown of eternal hatred to Rome he saw there all obstacles conquering seemingly the fates & looking back upon his work with stern satisfaction and delight."[30] Hiking the precarious glaciers of the majestic Alps, Kensett converted his anxiety into Alison's associationist strategies of the metaphorical Sublime, imagining a race of giants, icy caverns of skeletal remains, and the heroic exploits of Hannibal. With the latter, Kensett took a literal page out of Alison's theory. In arguing that "the sublime is increased … by whatever tends to increase this exercise of imagination," Alison declared that "the majesty of the Alps, themselves, is increased by the remembrance of Hannibal's march over them; and who is there that could stand on the banks of the Rubicon, without feeling his imagination kindle, and his heart beat high?"[31] Kensett not only responded to the gorges, glaciers, and rocks of his Alpine journey in a heightened state of sublimity, but also transferred these emotions through his imagination to subsequent experiences and artistic creations.

Indeed, the gigantic carved face of *Italian Scene*, its immensity all the more apparent in contrast to the aqueduct with its tiny travelers, recalls the herculean race Kensett imagined as he hiked through the Alps. Its aged, stern profile

18 ☙ THOMAS COLE,

The Course of Empire: Desolation, *1836.*

Oil on canvas, 39 ¼ x 63".

accession number 1858.5, negative number 6049.

The New-York Historical Society.

literally visualizes Kensett's poetic allusions to "old Mt. Blanc," "the monarch of mountains." Bright sunlight strikes the eyeball, nose, and lower lip evoking Kensett's memories of the "painful reflection of bright sun on the snow," "blistering the lips." Even its panoramic gaze upon the Italian valley below calls to mind the words Kensett wrote regarding Hannibal's voyage to Rome: "he saw there all obstacles conquering seemingly the fates [and] looking back upon his work with stern satisfaction and delight." In short, the formidable visage of *Italian Scene*, along with the odd grimaces and profiles of the rocky gateway to its right, embody the sublime mystery, solemnity, grandeur,

triumph, and even pain, Kensett experienced in Switzerland.

The painting's progression from its startling uniqueness of anthropomorphic rocks to the tranquil unity of a luminous vista mirrors Kensett's reaction to yet another moment of the natural Sublime, the spectacle of Halley's comet in 1843. Although full of excitement, he could not rationally grasp what he had seen well enough to objectify it. Instead, he marveled at the world's mysterious unity: "[S]ummer will still follow winter, day follow night.... The sun rise[s] and sets, and all things move on in that beautiful harmony in which God has created the Universe, and touched with his immortal influence."[32] Alison's directive that engagement with the Sublime and Beautiful in nature leads to "the noblest convictions, and confidences of religion" is clearly voiced in Kensett's response.[33] As previously discussed, Kensett offers his own orderly flow of historical time in *Italian Scene* from primitive rocks to Roman aqueduct, Romanesque and Renaissance churches to contemporary habitations and sailboats. It suggests Kensett's own travels

through territory and time as he traversed from north to south, from natural spectacle to artistic wonder. In effect, the sublime stone face gazing upon this scene of reposeful order imitates Kensett's own reactions to his Grand Tour, and provides a model for the viewer: one is to engage in Alison's metaphorical Sublime — of which the rocky visage is an embodiment — summoning a series of remembered associations and religious sentiments that equate the extension of space and succession of ruins with divine "loops of time" and the moral lessons of "dead empires" familiar to the nineteenth-century traveler.

Kensett, enamored of Cole, created in *Italian Scene* an evocation of Cole's great cycle on the rise and fall of empire that itself incorporates the metaphorical Sublime. *The Course Of Empire* (1834-36; New-York Historical Society), on public exhibit in New York in 1836 while Kensett was in residence, uses natural and architectural elements to enact a drama from primitivism to civilization to obliteration. The last panel entitled *Desolation of Empire* (fig. 18) features a foreground threshold of Sublime, ominous ruins from which the

19 ❧ SKETCH BOX, USED BY THOMAS COLE.
Mahogany with brass fittings, c. 1840. 2 ½ x 17 x 13".
Bronck Museum, Greene County Historical Society,
Coxsackie, New York, gift of Edith Cole Silberstein.
64.11.4

20 ❧ JOHN FREDERICK KENSETT,
A Holiday in the Country, *1851.*
Oil on canvas.
Columbus Museum of Art, Ohio, gift of Mr. and Mrs.
Walker Knight Sturges and family.
1991.013.003

21 ⌗ John Frederick Kensett, Reminiscences of the Catskill Mountains, *1853*

Oil on canvas, 22 x 18".

Elliot Vessel Collection, Pennsylvania.

viewer passes to the quiet distance. There, gazing silently into an even more remote space is an old stone face in the mountain—time's witness of things past. This mountain outcropping appears in each of Cole's five panels, its anthropomorphic profile increasingly insistent as civilization overtakes nature, and in *Desolation* the human profile remains as a sublime testament to experience. Kensett's anthropomorphic rock closely resembles the rock by Cole, who frequently employed such faces in his art. Kensett may have had occasion when sketching with Cole in Europe to view the top lid of his sketch box (fig. 19) with its bulbous rock head framing the left foreground as scattered ruins crowd the scene. Cole's *Italian Landscape* (fig. 17) includes a prominent rock face commanding the view from the left foreground as an aqueduct arch counters it on the right. Kensett would have seen this painting at the Cole Memorial Exhibition of 1848.[34] So too, at that memorial exhibition, as well as earlier in the fall of 1847 at the American Art-Union, Cole's *Home in the Woods* (1847; Reynolda House, Winston-Salem N.C.) displayed in the left background a chiseled rock face with nose, lip, and chin starkly similar to what Kensett incorporates in the left foreground of *Italian Scene*.[35]

Kensett's appropriation of Cole's anthropomorphism is part associationist recollection, part tribute, and part sublime "rediscovery of the great": for as theorist Thomas Weiskel has summarized, the sublime moment allows a renewal, a freeing of the self from the burden of the "great" through creative imitation and acknowledgment of one's indebtedness.[36] As previously suggested, Kensett most likely painted *Italian Scene* upon his return to America as he seriously pursued his painting career. In it he paid tribute through sublime recollection to Cole, an artist he admired who was celebrated for his own Italian scenery, and whose death in 1848 inspired many artists to paint their own memorials. Through creative imitation of Cole with sublime anthropomorphic rocks, Kensett also freed his own voice: that of the

22 ❧ JOHN FREDERICK KENSETT, Mountain Peak, *c.1850s*.
Oil on canvas.
Jane Voorhees Zimmerli Art Museum, Rutgers,
the State University of New Jersey,
Mary Bartlett Cowdrey Bequest,
photograph by Jack Abraham.

eternal optimist permanently manifest in his art. In painting style, composition, coloring, and inclusion of the foreground rock face, *Italian Scene* corresponds to works like *A Holiday in the Country* of 1851 (fig. 20) and *Reminiscences of the Catskill Mountains* of 1853 (fig. 21) rather than to the darker coloring, constricted composition, and heavier paint application of Kensett's pre-1850 oils. In addition to the anthropomorphic cliff in the left foreground that preoccupied Kensett only upon his return to America, both *Italian Scene* and *A Holiday in the Country* incorporate a foreground gateway of rocks, a flowing stream that cuts between them, and a panoramic view from dale to light-filled distance. In effect, Old World history is replaced with a New World arcadia.[37]

Upon his return to the states, Kensett quickly re-encountered the sublimity he experienced in Switzerland, for

Benjamin Champney introduced him to the White Mountains in 1849 and 1850. Oil sketches like *Mountain Peak* (fig. 22), with its high anthropomorphic rocks peering into the vast distance and rushing waterfall cutting through the mountain gorge, visualize the sublimity Kensett felt in Franconia Notch and echo the masculine power portrayed in the foreground of *Italian Scene*. Writing to his sister, Kensett barely contains his excitement of finding an American version of alpine sublimity:

> [Saw] much that struck us with awe and wonder for is truly a grand and wild passage among the mountains with bold masses of precipitous rocks. Dashing torrents, primitive forests surrounding you on every side. In the recesses of these mountain fastnesses one cannot but be impressed with the gigantic magnitude of God's work. The whole journey up the Notch recalled vividly some of my excursions of Switzerland.[38]

In the White Mountains, Kensett not only experienced the "desolate character" and "savage gloom" that marked his excursion through the Rhine and Switzerland, but also he saw that very natural-made profile with which he framed

the foreground of *Italian Scene*: the Old Man of the Mountain of Profile Rock in Franconia Notch. Before Kensett's journey to the White Mountains, this most famous of all rock faces had been pictured for all to see in books on White Mountain scenery by Charles Jackson and William Oakes (fig. 23). Other profile rocks resembling Kensett's of *Italian Scene, Mountain Scene*, and *Holiday in the Country* appear in New England scenic guides, notably the *Profile Rock at Squantum* (fig. 24). By painting the anthropomorphic gateway of *Italian Scene*, Kensett united in one chiseled gaze the sublimity of the Old World with the New, the reminiscent vision of an American traveler who has witnessed the grandeur of nature and the beauty of civilization.

Kensett's continuing awe and wonder before "the gigantic magnitude of God's work" produced throughout his career that "wonderful individuality" of rocks that remained "impressed in memory," both in the artist and the viewer. His later coast scenes, filled with rocks possessing unique presences, reconcile the Sublime and the Beautiful, the disruptive and the familiar, the masculine and the feminine, into one unified, harmonic vision. *Beach at Beverly, Massachusetts* (fig. 25) is typical: one finds as in *Italian Scene* the signs of an amiable and civilized passage through nature, now represented by a row boat, a stroller with picnic basket, and many sailboats. A rocky gateway to a distant, peaceful horizon also dominates the left foreground as in *Italian Scene*. But now, the anthropomorphic profile only exists as a sunken remnant of its earlier, formidable presence as indicator of the metaphorical Sublime. Kensett, now under the influence of William Wordsworth and John Ruskin, adopts

23 ⊲ WILLIAM OAKES, Profile Rock (Plate 10)
from Scenery of the White Mountains, *Boston, 1848.*
Courtesy, the Winterthur Library:
Printed Book and Periodical Collection.

24 ❧ Profile Rock at Squantum, Plate 6 in the Fouth Series: New England Scenery, by various artists *(Boston: M. J. Whipple, 1852). Drawn on stone by Richard P. Mallory, and printed by Tappan & Bradford. American Antiquarian Society, photograph courtesy of Janice Simon.*

25 ❧ JOHN FREDERICK KENSETT, Beach at Beverly, Massachusetts, *1869/72. Oil on canvas, 22 x 34". National Gallery of Art, Washington, gift of Frederick Sturges, Jr. 1978.6.5*

a metonymical, "positive" Sublime that unites sensible nature and the transcendent. The Sublime, now ever immanent in Nature, becomes a daily habit. Metaphors and the overt power of the individual imagination they represent are no longer necessary. The object and the subject make "contact." No longer dissonant opposites, the "I" and nature, the Beautiful and the Sublime collapse into one.[39] Unitarian minister Samuel Osgood recognized such at the time of the artist's death: equating Kensett with Wordsworth, he eloquently praised how Kensett's art "shows the affinity between the universe and the eternal Spirit, and lift all things up towards the supreme mind."

Indeed, Kensett's paintings of rocks, sea, and sky "are a cycle of sonnets of nature; a string of precious poems of our common lot, and they help us in that great task of practical wisdom which finds blessings in our daily path, and sees God's love everywhere."[40] The overt anthropomorphic gaze dominating *Italian Scene* no longer became necessary in Kensett's art: settled in his New World arcadia, with memories of Old World sublimity and empire comfortably distant, Kensett's discordant experiences between the Sublime and Beautiful, the real and the ideal, the past and the present, the natural and the divine evaporated. ❧

A shorter version of this essay was first presented at the Southeastern College Art Conference, Washington D.C., October 1995. I am indebted to numerous individuals who have aided in the research of this project over the years including the superb staff at the American Antiquarian Society, Worcester, Massachusetts, Sandra Langer who most generously gave me all her files and photographs on John F. Kensett, and the curatorial and publications staff at the Georgia Museum of Art, especially Paul Manoguerra who invited me to write this essay for the exhibition and whose patience and kindness were seemingly unlimited. Lastly, I would be remiss if I did not thank my colleague in Italian art at the University of Georgia, Shelley E. Zuraw, for her vast knowledge about all things Italian, and her observant suggestions regarding Kensett's depiction of the Italian countryside. In appreciation for her love of Italy and her loyal friendship over the years, I dedicate this essay to her.

1 Adam R. Smith to John Frederick Kensett, 21 February 1859, Lansingburgh. Kensett Papers, Archives of American Art, microfilm roll 68-85. Smith bought Kensett's *Scene Among the Rocks of Paradise (Rhode Island)* for $200, Kensett Papers, "Register of Paintings Sold" since 1 January 1859. Archives of American Art, microfilm roll 68-85.

2 Juliet H. L. Campbell to John Frederick Kensett, 19 November 1863, Pittsville, Pennsylvania. Kensett Papers, Archives of American Art, microfilm roll 68-85. Because Kensett's "Register of Paintings Sold" has the pages torn out for years 1862-1864, the title or exact subject of the work is unknown.

3 [John Durand], "Sketchings. Exhibition of the National Academy of Design," *The Crayon* 5, no.5 (May 1858): 146-47.

4 Henry T. Tuckerman, *Book of the Artists: American Artist Life* (New York: G. P. Putnam,1867), 512-513. On the importance of geology in American nineteenth-century landscape painting and responses to the geological character of Kensett's paintings, especially their relationship to tourism in Niagara Falls and Newport, Rhode Island, see Rebecca Bedell, *The Anatomy of Nature: Geology and American Landscape Painting 1825-1875* (Princeton and Oxford: Princeton University Press, 2001), 85-107 and passim.

5 Reverend Samuel Osgood, *Proceedings At a Meeting of the Century Association, Held in Memory of John F. Kensett*, December 1872 (New York, 1872), 22-23.

6 Artists like Albrecht Dürer, Agostino Carracci, and Jacques De Gheyn among others, provided precedents for Romantic and twentieth-century artists' enthusiastic incorporation of anthropomorphic imagery in their work. Ovid's *Metamorphoses* (c. AD 8) provided such artists a rich literary tradition of transformation to draw upon, with stones turning into humans and humans becoming birds and plants throughout the recounted myths. For a theoretical overview of anthropomorphism throughout history, see Stewart Elliott Guthrie, *Faces in the Clouds: A New Theory of Religion* (New York and Oxford: Oxford University Press, 1993). For the use of anthropomorphism in American landscape painting see J. Gray Sweeney, "The Nude of Landscape Painting: Emblematic Personification in the Art of the Hudson River School," *Smithsonian Studies in American Art* 3, no.4 (Fall 1989): 42-65; J. Gray Sweeney, "A `Very Peculiar' Picture: Martin Johnson Heade's *Thunderstorm Over Narragansett Bay*," *Archives of American Art Journal*, 28, no. 4 (1988): 2-14. No scholar has previously noted the anthropomorphic rock in Kensett's *Italian Scene* of the Georgia Museum of Art; only J. Gray Sweeney has noted Kensett's periodic use of such imagery in *Bishop Berkeley's Rocks, Newport*, 1856 (Vassar Gallery of Art, NY) and *Rocky Landscape (White Mountain Scene)*, 1853 (Henry E. Huntington

Library and Art Gallery, San Marino, CA). See J. Gray Sweeney, "The Advantages of Genius and Virtue: Thomas Cole's Influence, 1848-58," *Thomas Cole: Landscape into History*, eds. William H. Truettner and Alan Wallach (New Haven & London: Yale University Press, 1994), 113-135.

7 Thomas Cole wrote how his "attention has often been attracted by the appearance of action and expression of surrounding objects, especially trees.... They spring from some resemblance to the human form. There is an expression of affection in intertwining branches,—of despondency in the drooping willow." Louis Legrand Noble, *The Life and Works of Thomas Cole*, ed. Elliot S. Vesell (1853; repr., Cambridge, MA: Harvard University Press, 1964), 41.

8 Guthrie, *Faces in the Clouds*, 42-43.

9 Guthrie, *Faces in the Clouds*, 90, 140-41.

10 David Hume, *Natural History of Religion* (1757; Stanford: Stanford University Press, 1957), 29-30, quoted in Guthrie, *Faces in the Clouds*, 69.

11 Archibald Alison, *Essays on the Nature and Principles of Taste* (1790; repr., New York: G.& C.& H Carvill, 1830), 414-415: On the universality of personification see 108-109. In fact, Guthrie's study is really an assertion that religion is anthropomorphism. See his final chapter, "Religion as Anthropomorphism," *Faces in the Clouds*, 177-204.

12 For a narrative overview of Kensett's European travels see, John K. Howatt, "Kensett's World," and John Paul Driscoll, "From Burin to Brush: The Development of a Painter," in *John Frederick Kensett, An American Master*, ed. Susan E. Strickler (Worcester Art Museum; New York: W. W. Norton & Co., 1985), 27-34, 49-61.

13 John Frederick Kensett, Diary 1840-1857, 9, 11, 12, 13 October 1841. Kensett Papers, Archives of American Art, microfilm roll N68-85. Kensett also notes in his entry for October 8, "took up an old landscape of mine to complete—forward state in hope of making something of it." This indicates an early precedent of an activity Kensett most likely engaged in throughout his career—the returning to earlier oils and sketches to complete them later thereby relying on his memory and imagination rather than *plein-air* experiences.

14 For a chronology of Cole's European travels see, Ellwood C. Parry III, *The Art of Thomas Cole: Ambition and Imagination* (Newark: University of Delaware Press, 1988), 363-375, 375-376, 377-378.

15 *Catalogue of the Executor's Sale of the Collection of over Five Hundred Paintings and Studies of the Late John F. Kensett,* (New York: 1972), collection of the American Antiquarian Society, Worcester, MA, 9, 45.

16 Lizzie Cranch, Journal, Rome, 1 November 1846 in *The Life and Letters of Christopher Pearse Cranch,* ed. Leonora Cranch Scott (Boston and New York: Houghton Mifflin Co., 1917), 107; Benjamin Champney, *Sixty Years' Memories of Art and Artists* (Woburn, MA: Wallace and Andrews, 1900), 74.

17 John F. Kensett to Sarah Kellogg (sister), Civitella, 5 October 1846; John F. Kensett to John R. Kensett (uncle), Venice, 20, August 1847. Kensett Papers, Archives of American Art, microfilm roll N68-84. See the drawn map for exhibition section 3, in Theodore E. Stebbins, Jr., *The Lure of Italy: American Artists and the Italian Experience 1760-1914* (Boston: Museum of Fine Arts, Boston, 1992), 189.

18 Howatt, "Kensett's World," 33-34.

19 The title given by Kensett to the Georgia Museum of Art's painting is unknown. Of the many recorded paintings of Italy listed in the Kensett sale at his death, only one is named *Italian Scenery*, #425, but its dimensions are too small, measuring 14 3/4 by 10 1/2". Indeed, the only painting with the approximately correct dimensions is #115 *In the Vale*, 14 x 20" purchased by J. K. Kellogg. The composition of GMOA's *Italian Scene* does incorporate a valley below rocks, coursed by a stream that leads down to a broader sheet of water. Photographs of the sale exhibition owned by the Metropolitan Museum of Art, however, do not show the GMOA picture, though not every painting of the sale is visible or easily identified. Many of the sale pictures were like the GMOA work: moderate or small in size, undated, and unsigned. Works listed at the sale with Italian titles are #72 *Entrance to the Chigo Villa, Mt. Albans, Italy*; #94 *Shrine near Subiaco, Italy*; #96 *Street Scene, Italy*; #158 *The River Arno, Italy*; #218 *Trees near Aricia, Italy*; #226 *An Ilex Tree on Lake Albano, Italy*; #243 *Italian Roadway*; #255 *Amalfi, Italy*; #269 *Study made at Subiaco, Italy*; #297 *Subiaco, Italian Boy*; #312 *Grand Canal, Venice 1847*; #380 *Italian Coast, Sunset*; #406 *Study of an Italian Woman*; #425 *Italian Scenery* (14 3/4 x 10 1/2); #482 *Bridge near Sabacco, Italy*; #580 *Terre di Schiavi, Campagna di Rome*; #593 *Bay of Naples*; #620 *View near Rome*; #622 *Entrance to the Sabine Mountains, Italy*; #649 *Ruins of the Baths of Caracelli, Rome*; #655 *Near Olivens, Italy*; #668 *Valley of Arno, in the Sabine Mountains, Italy*. From Kensett's Sales Record: From 1 January 1848: *The Shrine* and *La Galleria* to Mr. Ives, Providence for $150 each; *Scene on the Anio, Italy*, $250; *Campagna Scene* American Art Union, $25. Pictures Sold Since 1 January 1849: *Lake of Nemi* American Art Union, $200. Generic titles such as *The Streamlet*, $30; and *Landscape Composition*, $30, could also be Italian scenes like the one owned by GMOA. Since 1 January 1868: *Claudian Aqueducts, Rome to Waters*, $750. Since 1 January 1871: *Lake Como Reminscences* of, to Schaus, $205. From exhibitions at the National Academy of Design: 1847: #177 *Twilight View of Rome from the Borghese Garden* owned by Charles Parker; #248 *Scene in*

Upper Italy in the Middle Age owned by J. G. Chapman; 1848: *The Anio—Scene near Subiaco, Italy; The Shrine—A Scene in Italy*; The Gallery, Leading *from Castle Gondolfo to Albano;* 1849: *The Ravine, Italy.* From American Art Union exhibition records: 1846: #108 *Northern Italy—A Scene of the Middle Age* to J. G. Chapman, NY; 1848: #27 *The Anio—Scene near Subiaco Italy* to B.C. Berrian NY; #169 *Campagana Scene* to Mrs Sarah Henshaw, Middlebury, VT; 1849: #210 *View on Lake Nemi* (40 x 30) to Mrs. F. C. Eddy, Stillwater, NY. For other works exhibited see, William Gerdts and James Yarnell, *Index to American Art Exhibition Catalogues*, 6 vols. (Boston: G.K. Hall, 1986). The Neopolitan Coast for Auction NY Artist's Fund Soc. 1866; *A Reminiscence of Lake Como* cat. no. 29 for Auction NY Artist's Fund Society 6 Feb 1871; *Large Picture Scene in Sicily* ptg cat 24, owner Robert Hoe, NY, 1 April 1871 Century Assoc; *Souvneir* [*sic*] *of Italy* no. 135 William Norris, San Fran. CA 1873 San Francisco Art Assoc 3rd Exhibition; *A Reminiscence of Italy* owner Robert Hoe, New York 1875 Hoe's Collection (60 1/2 x 41 1/2).

20 One of Kensett's friends, Charles Alexander, wrote from Coventry Street, London, in September 1848 that "I fancied I saw a picture of yours at the Exhibition here this time `recollections of Italy'—by Mr. Kinsett—referring to the artist however it strikes me that it was your [illegible] hence my conclusion." This suggests another possible identity and title for the GMOA picture. Edwin D. Morgan Papers, New York State Library, Albany. Archives of American Art, microfilm roll no. 1537.

21 Parry, *Art of Thomas Cole*, 63, 188, 313.

22 James Fenimore Cooper, *Gleanings in Europe: Italy* (Philadelphia: Carey, Lea, and Blanchard, 1838), 111-112, quoted in Brigitte Bailey, "The Protected Witness: Cole, Cooper, and the Tourist's View of the Italian Landscape," in *American Iconology,* ed. David C. Miller (New Haven & London: Yale University Press, 1993), 104. Bailey's insightful article on how Cole, Cooper, and their followers perceived Italy as an idealized Other, a pastoral feminine to be appreciated through aesthetic experience versus the masculine northern countries of England, America, and Switzerland, in which language, history, intellect, and politics dominated, significantly informs my interpretation of Kensett's painting (see Bailey, "The Protected Witness," 92-111).

23 Cooper, *Gleanings in Europe*, 67-71, quoted in Bailey, "The Protected Witness," 107-108.

24 For a discussion of the symbolic importance of the bridge in English romantic landscape painting, see Adele M. Holcomb, "The Bridge in the Middle Distance: Symbolic Elements in Romantic Landscape," *The Art Quarterly* 37, no. 1 (1974): 31-58.

25 I am indebted to my colleague at the University of Georgia, Shelley E. Zuraw, for identifying these medieval and Renaissance structures and their import to my thesis.

26 John Sweetman, *The Artist and the Bridge 1700-1920* (Brookfield, VT: Ashgate, 1999), 24-25.

27 John F. Kensett to John R. Kensett (uncle), Geneva, 24 August 1845; John F. Kensett to Sarah Kellogg (sister), Civitella, 5 October 1846. Kensett Papers, Archives of American Art, microfilm roll N68-84. Lord Byron's dramatic poems *Manfred* (1817) and *Childe Harold's Pilgrimage* (1816-18) offered many memorable lines on the sublimity of the Alps and the rise and fall of Italy's empires for artists, writers, and tourists to quote. Kensett's reference to Mont Blanc as "the monarch of mountains" quotes line 60, the "Voice of the Second Spirit" from the first scene of *Manfred.* Canto IV, stanza 78 from *Childe Harold* provides Kensett with his most famous reference to Rome: "O Rome! my country! city of the soul!/ The orphans of the heart must turn to thee,/ Lone mother of dead empires! and control/ In their shut breasts their petty misery." J. M. W. Turner and Thomas Cole notably painted landscape allegories inspired by Cantos III and IV that poeticize both the Alps and Italy. Cole's *Course of Empire* series of 1834-1836, conceived during his first trip to Italy, borrowed its theme and imagery from Bryon's famous poem. See Alan Wallach, "Cole, Byron, and the Course of Empire," *The Art Bulletin* 50 (December 1968): 375-379; Parry, *Art of Thomas Cole*, 131-187; Wallach and Truettner, *Thomas Cole: Landscape into History*, 90-98; Joy S. Kasson, *Artistic Voyagers: Europe and the American Imagination in the Works of Irving, Allston, Cole, Cooper, and Hawthorne* (Westport, CT: Greenwood Press, 1982), 102-129. Kasson also discusses the importance of William Cullen Bryant's poem "The Ages" to Cole's series.

28 Alison, *Essays*, 50-51.

29 John F. Kensett to Thomas Kensett (brother), Lake of Neufchatel, 22 August 1845, Kensett Papers, Archives of American Art, microfilm roll N68-84.

30 John F. Kensett, Diary 1840-1857, 30 August, 1, 3, 5 September 1845. Kensett Papers, Archives of American Art, microfilm roll N68-85. Both Byron and Turner made well-known references to Hannibal's treacherous but victorious pass through the Alps towards his enemy Rome, where ultimately he was defeated.

31 Alison, *Essays*, 28-29.

32 John F. Kensett to Mother [Elizabeth Daggett Kensett], Paris, 30 March 1843. Kensett Papers, Archives of American Art, microfilm roll N68-85.

33 Alison, *Essays*, 415.

34 Parry, *Art of Thomas Cole*, p. 218.

35 I am indebted to J. Gray Sweeney for suggesting to me Cole's face in *Home in the Woods* as a possible precedent for Kensett's.

36 Thomas Weiskel, *The Romantic Sublime: Studies in the Structure and Psychology of Transcendence* (Baltimore and London: Johns Hopkins University Press, 1976, 1986), 8-12, 28-33, 62. Weiskel's brilliant study informs much of my reading of Kensett's incorporation of the sublime and its movement in his art from the metaphorical (associationist) to the egotistical sublime Weiskel associates with William Wordsworth.

37 As early as 16 December 1844, Kensett wrote to his mother from London his longing for American scenery: "I long to get amid the scenery of my own country for it abounds with the picturesque, the grand, and the beautiful—to [illegible] among the striking scenes to which a bountiful hand has spread over its wide-extended and almost boundless territory—comprising as it no doubt does all the rareties [*sic*] and beauties which revel in European scenery famous in History and Song and yet unfortunately without its associations ... the moment I have completed my journey to Italy I shall take off my hat and wish the European states a `bon jour' and `final adieu.'" Kensett Papers, Archives of American Art, microfilm roll N68-84.

38 John F. Kensett to Sarah Kellogg [sister] North Conway, New Hampshire, 16 September 1850. Kensett Papers, Archives of American Art, microfilm roll N68-84.

39 Weiskel, *The Romantic Sublime*, 48-62, 195-204.

40 Osgood, *Proceedings*, 21-22.

Every stone has a voice, every grain of dust seems instinct with spirit from the Past, every step recalls some line, some legend of long-neglected yore. —MARGARET FULLER, 1847

Paul A. Manoguerra ⌖ Georgia Museum of Art

A Felicity of Taste or Nature

AMERICAN REPRESENTATIONS OF THE WATERFALL AT TIVOLI

IN 1853, NATHANIEL WILLIS PARKER, IN *Pencillings by the Way: Written During Some Years of Residence and Travel in Europe*, spent a few pages describing his visit to Tivoli, one of the more popular tourist sites in Italy. Tivoli, a small town about twenty miles east of Rome and perched high on one of the lower slopes of the Apennines, was an essential stop on a one-day, mid-nineteenth-century carriage trip from Rome or during an extended stay in the Roman countryside. At Tivoli, the Anio River plunges in cascades into the Roman *campagna* before joining the Tiber and flowing through Rome to the Mediterranean. Parker first compares the falls at Tivoli to the many falls he has seen in Europe and America: "I have seen many finer falls than Tivoli; that is, more water, and falling farther; but I do not think there is so pretty a place in the world." He continues his description of the cascades and the landscape, marking their nature with hackneyed picturesque diction, including "broken," "crag," and "twisted": "We passed through a broken gate, and with a step, were in a glen of fairy-land; the lightest and loveliest of antique temples on a crag above, a snowy waterfall of some hundred and fifty feet below, grottoes mossed to the mouth at the river's outlet, and all up and down the cleft valley vines twisted in the crevices of rock and shrubbery hanging on every ledge, with a felicity of taste

or nature, or both, that is uncommon even in Italy."[1] For Parker and the many other American tourists who visited Tivoli beginning in the 1830s, the cascades and the respective scenery offered a prime example of the Beautiful and the Picturesque in Italy. Late antebellum Americans continued an ongoing European tradition of visiting Tivoli and experiencing its numerous picturesque features. A visit to the sights of Tivoli, including the Villa of Maecenas, the Villa Gregoriana, the Temple of the Sybil, and the Villa d'Este, was a required component of any authentic Grand Tour. Antebellum artists, including George Loring Brown in *Tivoli (The Falls of Tivoli)* (fig. 26), built upon the classical, idyllic tradition of portraying Tivoli in the works of Claude Lorrain, Hubert Robert, Honoré Fragonard, Richard Wilson, Samuel Palmer, and various other European artists who toured the site.[2] But American tourists and painters defined and discussed the falls at Tivoli in specific contrast with North American scenery. As part of a mid-nineteenth-century tourist discourse, the cascades at Tivoli served as symbols of the Italian civilization of the past while waterfalls in North America, including Niagara, stood as emblems of unblemished and powerful wilderness. Adapting eighteenth-century British definitions of landscape traits — the Beautiful, the Sublime, and the Picturesque — and the work of

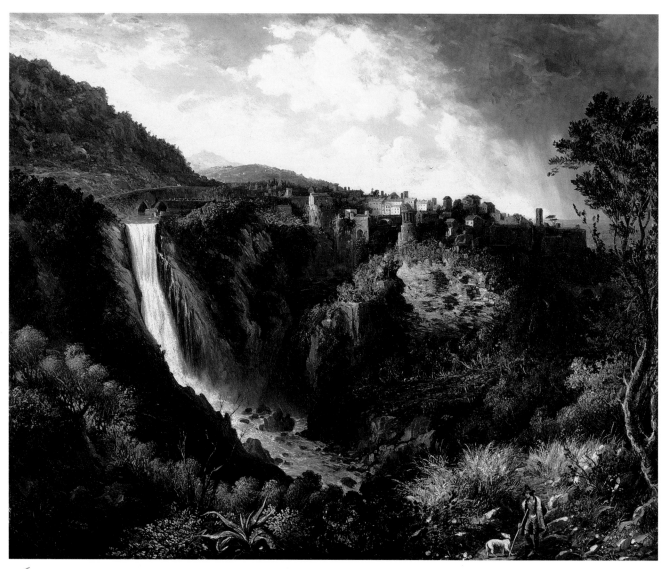

26 ❧ GEORGE LORING BROWN, Tivoli (The Falls of Tivoli), *1850.*

Oil on canvas, 25 ½ x 32 ½".

Collection of The Newark Museum, Purchase 1957, The G.L. Brown Fund.

Thomas Cole, mid-nineteenth-century American painters and writers, including Brown and Parker, constructed an Italian landscape of the picturesque past while associating the American landscape with a sublime present and future.

GEORGE LORING BROWN'S *Tivoli (The Falls of Tivoli)* exemplifies the American picturesque image of the tourist site. Brown, born in Boston in 1814, left for his second trip to Italy in 1840, and remained nineteen years. During the 1850s in Rome, Brown had a studio (visited by Nathaniel Hawthorne in 1858), and was part of the American artists' community that included Worthington Whittredge, Thomas Crawford, and Randolph Rogers. His paintings of Italian scenes were often directly commissioned as Grand Tour souvenirs by American tourists. Between 1847 and 1855, Brown painted numerous views of Tivoli. In *Tivoli (The Falls of Tivoli)*, the artist includes the craggy cliffs, steep waterfalls, and primeval vegetation of the landscape around Tivoli. Brown combines intimacy with vastness. He details the foliage, architecture, and sky while observing the enormous scale of the site. His use of a framing tree at the right of the composition, the scattered contrasts of shadow and sunlight, and the sketchy quality of the rocky hillside recall the syntax of the eighteenth-century Picturesque. He employs rich impasto and texture to accentuate the picturesque qualities of the landscape. He emphasizes the manmade nature of the largest of the falls, the Cascata Grande, created when a double tunnel was cut in the mountain to divert the oft-flooded Anio River from the center of the ancient town. Brown positions the nineteenth-century engineering feat, meant to control these natural floods, adjacent to the medieval and ancient architecture, including the Temple of the Sibyl at Tivoli. His emphasis on the human altering of the flow of the cascades insinuates that the entire natural order, in spite of any apparent external beauty, has also been retailored.[3]

American tourists made note of the human altering of the falls at Tivoli. Nathaniel Parker describes his tourist experience of the cascade: "From beneath [Tivoli's] walls, as if its foundations were laid upon a river's fountains, bursts foaming water in some thirty different falls; and it seems to you as if the long declivities were that moment for the first time overflowed, for the currents go dashing under trees, and overleaping vines and shrubs, appearing and disappearing continually, till they all meet in the quiet bed of the river below." Then, referencing one of the many historical associations made at Tivoli, Parker continues, '*It was made by Bernini,*' said the guide, as we stood gazing at it; and, odd as this information sounded, while wondering at a spectacle worthy of the happiest accident of nature, it will explain the phenomena of the place to you—the artist having turned a mountain river from its course, and leading it under the town of Tivoli, threw it over the sides of the precipitous hill upon which it stands." For mid-nineteenth-century Americans like Parker, the guide's invoking of Bernini only further marked Tivoli's falls as pure decorative fiction and artifice. Few Americans admired the work of the seventeenth-century architect and sculptor. For example, Charles Eliot Norton wrote to James Russell Lowell in 1857: "I love Rome more and more ... [in] spite of Berninis and Borromonis, of priests and forestieri [foreigners]." American visitors attributed the topographic chaos of contemporary Rome to the Baroque architects and designers. Protestant American artists tended to downplay Catholic references in their images and primarily ignored the great basilicas and palaces, with the notable exception of the dome of St. Peter's, of the Counter Reformation. George Stillman Hillard even argued that "[i]t would have been well if architecture could have stopped in the middle of the sixteenth century." Baroque art represented decadence and regression to most antebellum American viewers. The fact that Bernini, the master artist of Baroque Rome, had attributed to him the alterations of the falls at Tivoli only reaffirmed the American, Neo-classical

standards of taste. To many American visitors, the cascades at Tivoli were interesting but unsober, artificial, and sensual. The Italians had altered the landscape, compromising the natural order.[4]

LANDSCAPE PAINTINGS SHOWING THE INTRU- sion of technology into the landscape of the New World, unlike those of Italy, occasionally stressed that the natural order in the New World continued in spite of the encroachment of economic advancement. In Jasper Francis Cropsey's *Starrucca Viaduct, Pennsylvania* (fig. 27) from 1865, the artist paints the stone bridge, carrying the tracks of the New York and Erie Railroad, as it spans the wide valley near the Susquehanna River at Lanesboro in northeast Pennsylvania. Cropsey originally sketched the manmade wonder, following his European trip of 1847 and 1849, in October 1853. He

27 JASPER FRANCIS CROPSEY,

Starrucca Viaduct, Pennsylvania, *1865.*

Oil on canvas, 22 ⅜ x 36 ⅜".

Toledo Museum of Art, purchased with funds from the

Florence Scott Libbey Bequest in memory of her father,

Maurice A. Scott.

painted his scene from the site of a train stop that allowed passengers to get off the train and enjoy the view. A train, moving out of the misty mountains in the background, emits white smoke while two young boys in the foreground look out over the valley. Cropsey de-emphasizes the train, a symbol of progress and civilization, in the midst of the autumnal pastoral setting of the valley. Art historians often have compared Cropsey's picture to those of the environs of Rome, calling *Starrucca* "an echo of Italy in the American landscape." The structure of the viaduct recalls the ruins of ancient aqueducts in the Roman *campagna*. Cropsey associ- ates the technological advancements of the ancient Romans to the engineering feats of his contemporary American rail- road magnates. He also succeeds, by extension, in linking the civilization and achievements of ancient, republican Rome with nineteenth-century, democratic America.[5]

Brown's *Tivoli* juxtaposes the immensity of the falls and the modern Italian engineering feats with the tiny, round Sibyl's Temple. Also known as the Temple of Vesta due to its round nature, the Sybil's Temple at Tivoli dates from the late republican era of ancient Rome. Built of travertine, the exquisite structure makes use of the Corinthian order. Brown's inclusion of the round temple in his painting of Tivoli reflected the compulsory nature of image-making— as painted by numerous European and American artists for decades—at the historic locale. In his *Course of Empire* series, Thomas Cole makes use of a structure similar to Tivoli's Temple of the Sybil. A pastoral Republic has turned into an urban Empire in the third painting of the series, *Consummation* of 1836. The round temple, in glorious mar- ble splendor, sits atop the city's heights and overlooks the pomp and decadence recalling imperial Rome. In Cole's *Desolation* (fig. 18), the final image of the series, he returns the cycle of history to its end and its beginning.[6] The ruins of the past Empire, with a giant single column in the fore- ground, the remains of great bridges and temples in the middle ground, and a setting sun in the distance, mark the

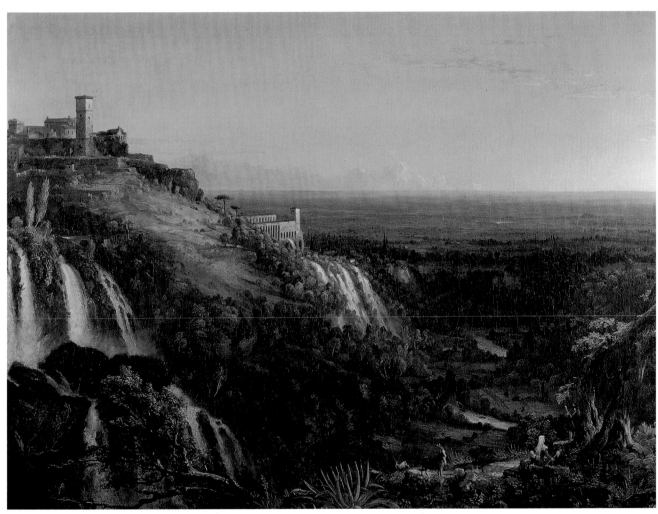

28 ✒ THOMAS COLE, The Cascatelli, Tivoli, Looking Towards Rome, *c.1832.*
Oil on canvas, 32 ¾ x 44 ½".
Columbus Museum of Art, Ohio; gift of Mr. and Mrs. Walker Knight
Sturges and Family.
1991.013.001

American paintings of Tivoli fit within the eighteenth-century tradition of the veduta and its standard series of views for the famous place.

scene as one of wildness. Cole places the ruins of Tivoli's round temple atop a hill in the far left background. Alan Wallach argues that Cole "set forth in allegorical form his pessimistic philosophy of history and his essentially agrarian-republican critique of Jacksonian democracy."[7] The small round temple in Brown's painting operates as a symbol of republicanism, while the ruined temple in Cole's *Desolation* serves as an emblem of decay.

Brown's inclusion of the round temple at Tivoli reflected its moral claim on American tourists: the trip to and around the falls at Tivoli operated as a ritualistic experience and the recollections of the sojourn among American tourists are strikingly similar. Travelers associated the countryside around Rome, the extensive plain of the *campagna* bounded by the Sabine hills to the east and by the Alban hills to the south, with the ancient civilization of Republican Rome. The remains of tombs, villas, monuments, and temples filled this landscape, and elated foreign tourists looking for tangible evidence and remembrances of the ancient past. Nineteenth-century Americans also found in the *campagna* an evocation of the pastoral ideal given visual form by European artists of the previous century. Tivoli, called Tibur in ancient Roman times, had been a favorite retreat from the city for emperors like Hadrian and for poets like Horace. These classical associations expressed themselves through the ruins of architecture left behind by the ancients.

American paintings of Tivoli fit within the eighteenth-century tradition of the *veduta* and its standard series of views for the famous place. Through repetition, the viewpoint looking up at the hillside town but out across the Roman plain acquired an iconic status. Brown, like his European and American predecessors to the site, chose a viewpoint that juxtaposed ancient ruins and modern buildings, invoking the living, tangible past of Italy in a visual equivalent of the layers of historical associations provided by the guidebooks and travel writers. The land in the Italian landscape paintings rarely appears cultivated and its figures are often the pastoral shepherds or peasants of an Arcadia. American painters valued the pastorals of Claude Lorrain for associations with the classical, and more especially their relationship to the late republican Rome of Virgil.

American landscape painters, in depicting the scenery of Tivoli and its historical associations, showed the influence of the eighteenth-century British landscape aesthetics associated with the Beautiful, the Picturesque, and the Sublime. Based on the writings of Sir Joshua Reynolds and others, the concept of the "beautiful" drew upon the ideal qualities of nature and involved close observation and study. An orderly, balanced, and harmonious design, evoking a pastoral ideal, often characterized the Beautiful. The "picturesque" customarily involved the use of irregularity and variety, of light and shadow, of a roughness in texture and, on a philosophical level, the capacity to affect the imagination. The mood of a picturesque landscape, in contrast to the more classical, beautiful landscape, becomes one of wild neglect instead of

idyllic repose. Craggy trees, medieval towers, rustic peasants, animals, rolling hills, cottages and farms fill picturesque landscapes. The "sublime," the third category of British aesthetic response to landscape, draws upon the spiritually and emotionally stimulating elements of nature.[8]

Tourist reactions to Tivoli were remarkably similar to each other and followed the nineteenth-century discourse of the "picturesque." The physical setting of Tivoli provided a space for symbolic, ritualized activity. The literature of American accounts of travel to Tivoli tends to be repetitious, a rehashing of hackneyed picturesque landscape motifs. Reverend John E. Edwards described his 1856 trip to the falls at Tivoli:

> We were standing under the shadow of, what passes for an old temple of Vesta, overlooking the vast chasm into which the foaming waters of the cascade of Tivoli are poured over a rocky bed, dashed into feathery spray that rose up like the smoke from an iron forge in some of the mining districts of our mountains in Virginia. The sun was shining in full, unclouded, noonday splendor, and the bold, glorious arches of two great rainbows were spanning the deep, dark ravine, and mingling their beautiful tints with the diamond spray, that rose, mist-like, from the hidden depths below. [9]

Reverend Edwards illustrated a particular event rooted in a tradition of confronting a panoramic, picturesque tourist landscape.

Yale geologist and naturalist, Benjamin Silliman, began a written representation of the environment around Tivoli using the visual vocabulary of the Picturesque: "The town itself is mean, with narrow and dirty streets, and a squalid population of 6300 people meanly representing its former grandeur." The dirt and squalor of Tivoli becomes the backdrop for the natural beauties of the tourist site. In spite of the "squalid" people and the "mean" streets, Silliman noted that the renown of the views accorded by the falls

was not undeserved: "The whole world have heard of the beauties of Tivoli. Have they been exaggerated? I think not." His words move the reader from visual foreground to background: "Down the side of the mountain nearest to us, a delicate ribbonlike cataract was precipitated, with a gentle movement, and lost itself in the abyss, hundreds of feet below. A little farther off, a much larger stream rushed down the mountain-side, in a splendid river, snowlike, resounding as it fell, while a cloud of spray glittered in the sunbeams, and revealed a brilliant rainbow." Silliman then lapsed into a typical aesthetic response, using the vocabulary of the Picturesque, to the scenery of the falls at Tivoli: "At every step, the view was unfolded more and more beautifully. Tivoli, perched upon the top of the opposite mountain, appeared like a castellated fortress, and in its numerous wars it has often sustained that character. As we proceeded, cataract after cataract was disclosed,—larger and smaller,—threading their way down the mountain from the Tivoli side." Ultimately, Silliman references two millennia of historical associations made perceptible in the visual experience of the waterfall:

> Seven cataracts were in view at one glance. They were beautifully contrasted with the rude rocks above, and the intense verdure below: the entire scene formed a delightful panoramic view, and it added no small interest to the prospect, that it had been seen and admired for more than 2000 years, by illustrious men and women, whose names glitter in these ever passing and ever renovated streams, and are inscribed by memory upon the everlasting mountains.

Silliman delights in the falls at Tivoli because he recognizes the scene as a spatially unified picture and he appreciates the interconnectedness and contrast of the visual elements that comprise the experience of seeing the location. For Silliman, the categorization of the landscape of Italy as "picturesque" allows him to pass through the "squalor" of

the town, to encounter the "everlasting" truths of God's nature, and to sense the "illustrious" historical associations of "more than 2000 years." Even a scientific book like Sir William Gell's *Topography of Rome* recorded the picturesque nature of the scenery at Tivoli: "All these glens, and especially the ruins of the ancient aqueducts, are worthy of a visit, if only on account of their picturesque beauties." [10]

Numerous American travel writers noted the many opportunities the scenery and historical associations at Tivoli provided to the artist. Long-time resident in Rome, William Wetmore Story, described the countryside around the falls:

> All around Tivoli wherever you go are massive remains of these Roman [aqueducts].… Most travellers who go to Tivoli content themselves with making the tour of the falls and cascatelle, visiting the villa of Maecenas, and the romantic villa D'Este, and luncheon in the Temple of Vesta; but few ever see… the adjacent country, so rich in picturesque ruins of the ancient time. Yet here an artist might fill his portfolio with new and characteristic sketches of great beauty, and the antiquarian might spend weeks of purest pleasure. [11]

NATHANIEL PARKER COMPARED THE VIEW of the scenery around Tivoli to one of Thomas Cole's images, meshing the picturesque travel account and the picturesque landscape painting together: "A mile farther on I began to recognize the features of the scene, at a most lovely point of view." Parker then connects the "lovely" scenery to an artistic one: "It was the subject of one of Cole's landscapes, which I had seen in Florence; and I need not say to any one who knows of this admirable artist, that it was done with truth and taste." Parker comments in a footnote: "On my way to Rome … we passed an old man, whose picturesque figure, enveloped in his brown cloak and slouched hat, arrested the attention of all my companions.

I had seen him before. From a five minutes' sketch in passing, Mr. Cole had made one of the most spirited heads I ever saw, admirably like, and worthy of Caravaggio for force and expression." [12] American tourists expected the landscape and people of Tivoli to fulfill their pre-determined understanding of the picturesque nature of Italy. American tourists were following a scenic path that had been well worn by European tourists for generations. In Italy, romantic writers and artists had transformed the landscape into "sublime" and "picturesque" scenery. Indeed, scenery, as described in the written word and as painted on canvases, was a marketable commodity. From this perspective, artists like Brown and writers like Parker were scenic entrepreneurs. They hoped to create and sustain careers for themselves out of their mediation between the landscape and its viewers or readers. American art patrons anticipated that images of the landscape around Tivoli would satisfy their desires for images of the European Picturesque.

Cole provided images for American collectors looking for the historical associations provided by the landscape of the Old World. His *The Cascatelli, Tivoli, Looking towards Rome* (fig. 28) includes an Italian peasant family and sylvan goats amid primeval vegetation in the right foreground. Across the valley, the ancient waterfalls flow from a hillside topped by ancient and medieval vestiges of human civilization. The painting's viewers followed the flow of the waterfalls and the river into the distant plain and "towards Rome." European scenes, like Cole's painting of the falls at Tivoli, stood for history and the past. But Cole's several images of American waterfalls revealed the present and the future: "The painter of American scenery has indeed privileges superior to any other; all nature here is new to Art. No Tivoli's[,] Terni's[,] Mount Blanc's, Plinlimmons, hackneyed & worn by the daily pencils of hundreds, but virgin forests, lakes & waterfalls feast his eye with new delights, fill his portfolio with their features of beauty & magnificence and hallowed to his soul because they had been preserved

untouched from the time of creation for his heaven-favoured pencil." Unlike the "hackneyed" and well-worn tourist paths of European sites like Tivoli, Cole believed that American scenery remained relatively "untouched" by human civilization and its historical associations. In his views of American waterfalls (for example, *The Falls of Kaaterskill*, 1826; Westervelt-Warner Museum, Tuscaloosa, Alabama), Cole shows the scenic and tumultuous beauty of the American locale long before they were visited by European and American settlers and tourists. Cole's figures, occasionally Native Americans or white pioneers shown dwarfed by the immensity of nature, define his New World landscapes as savage wilderness yet to be touched by civilization.[13]

MANY AMERICAN LANDSCAPE PAINTERS of the mid-nineteenth century believed that the ideas of religion, nature, and art were intertwined in the landscape category of the Sublime. In his famous "Essay on American Scenery," Thomas Cole expressed the belief that nature was both sublime and sanctified. Revelation could be experienced through the Sublime. American artist Asher B. Durand, Cole's friend, published nine "Letters" on landscape painting in *The Crayon* from January to July of 1855. In these letters, Durand argued that the first principle of landscape painting was the individual study of nature, rather than the study of art. A close study of a single nature object would influence the heart and the mind, as well as the painter's eye and hand. Durand declared that landscape art should embody a religious integrity through the sensing of transcendent beauty and significance. He stressed that an artist should limit artistic license to the variety found in nature itself: "One should modify nature only in the degree which Nature herself includes variety." An accurate depiction of a natural site operated as a metaphor for the divinity of God's creation.[14]

The Home Book of the Picturesque, a presentation book published by George P. Putnam and Son in the early 1850s,

embodied the link between God and nature for American intellectuals. Featuring steel engravings after American landscape paintings and numerous essays, the volume featured two tracts that confronted the role of religion in relation to the individual and the landscape. The collector Reverend Elias Magoon, in his "Scenery and Mind," writes that man's perception of beauty and his ability to feel the Sublime served as proofs of mankind's inherent immortality. A confrontation with magnificent scenery fed the capacity to feel sublimity and to experience God's presence in the viewer's life. In attempting to convince the reader of the deep psychological and philosophical effects of scenery on the human mind, Magoon argues that the great thinkers of history were close observers and admirers of nature.[15]

James Fenimore Cooper's essay "American and European Scenery" in *The Home Book of the Picturesque* divulges his attitude about the relative moral and philosophical values of different types of landscapes and locales. Cooper argues that American scenery lacked evidence of man's manipulation or construction as evidence of civilization and past heroic deeds. These civilized elements—castles, fortresses, medieval towers, ancient ruins, fields tilled for generations—made the scenery meaningful and picturesque. Unlike Europe, American towns could claim only a few "ill-shaped and yet pretending cupolas, and other ambitious objects, half of them in painted wood ... while the most aspiring roof is almost invariably that of the tavern." American artists needed to dwell on the scenic magnificence and emphasize the rough crudity of the native North American landscape.[16]

The lack of an American iconography of ruins, castles, and olive groves meant that American artists looking to depict the New World landscape needed to rely on objective naturalism and a sense of moral importance through conveying the grandeur of the American scenery. By mid-century in New York, the National Academy of Design, the American Art-Union, *The Crayon*, and other art organizations promoted a national artistic culture allied in evoking the

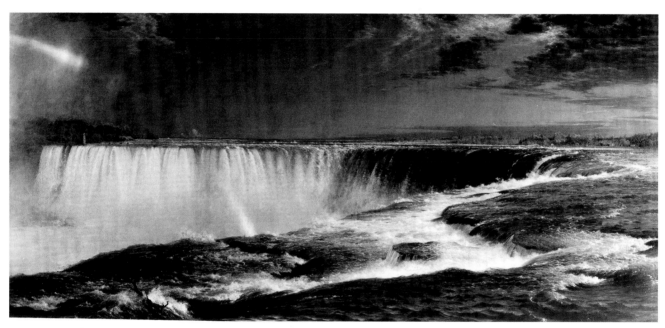

29 ❧ FREDERIC EDWIN CHURCH, *Niagara Falls, 1857.*
Oil on canvas, 42 ¼ x 90 ½".
In the Collection of the Corcoran Gallery of Art, Washington, D.C.
Museum Purchase, Gallery Fund.

deeper meanings of nature. Most leading landscape painters were associated with the so-called Hudson River school and looked to define their nation's landscape by capturing the essential quality of nature, utilizing new scientific awareness regarding creation, and incorporating evolving ideas of the Sublime. Late antebellum painters employed bigger, Romantic-style canvases—the "great pictures" of Frederic Church, Albert Bierstadt and others—to support their widening thoughts of the American landscape.

George Stillman Hillard, and other American visitors to the falls, compared the cascades at Tivoli to those at Niagara, Lowell, Trenton, Rochester, and other sites in the northeast

of the United States. Niagara Falls had been sketched and described by numerous eighteenth-century travelers; artists including John Vanderlyn, John Trumbell, Edward Hicks, and Thomas Cole painted the falls during the early nineteenth century. In popular art, from inexpensive engravings to miniatures, the sublime Niagara Falls had become the most widely circulated and best-known image of American nature. In the new American tradition of landscape painting in the nineteenth century, the primitive New World wilderness, with its grandeur and immensity, and its untamed and savage elements, evoked the Sublime. While the cascades at Tivoli were arguably the European falls most commonly

depicted in nineteenth-century art, Niagara Falls was the most frequently depicted North American natural wonder in the nineteenth century. Tourism and image-making at Niagara performed a potent role in America's creation of its own culture. It granted a way of illuminating America as a place and of taking pride in the unique features of the New World landscape. Niagara aided American intellectuals seeking European standards of culture while developing a distinct national image.[17]

Nineteenth-century American tourists departed from their everyday lives as they set out on their sojourn to places like Niagara Falls. Niagara Falls served as the major stop on any American "Grand Tour" and "visiting the Falls became one of the primary rituals of democratic life in nineteenth-century America." Niagara suggested transcendent meanings and functioned as a sacred place in a nation where God's plan would be fulfilled. Margaret Fuller, writing from Niagara on 10 June 1843, noted the sublime power of the falls: "Yet I, like others, have little to say, where the spectacle is, for once, great enough to fill the whole life, and supersede thought, giving us only its own presence." Viewing the spectacle of Niagara as a reflection of boundless divinity, Fuller remarks: "[T]here is no escape from the weight of a perpetual creation; all other forms and motions come and go, the tide rises and recedes, the wind, at its mightiest, moves in gales and gusts, but here is really an incessant, an indefatigable motion.... It is in this way I have most felt the grandeur,—somewhat eternal, if not infinite." But that grandeur was also dangerous in Fuller's interpretation. In commenting on the many complaints of visitors that the natural scenery of Niagara was being ruined by the buildings and collateral of the tourist industry, she states, "[T]he spectacle is capable of swallowing up all such objects." By 1871, Henry James would complain that at Niagara the "hackmen and photographers and vendors" made the experience "simply hideous and infamous." For Thomas Cole, water in motion over cataracts or waterfalls became

the sublime "voice of the landscape" and the "silent energy of nature." Cole asserted that Niagara Falls was "that wonder of the world!—where the sublime and the beautiful are bound together in an indissoluble chain."[18]

Frederic Church's *Niagara Falls* became one of the iconic mid-nineteenth century images of "that wonder of the world." An "epiphanic, apocalyptic landscape of Romanticism," Church's *Niagara Falls* (fig. 29) presents the famous tourist attraction as a symbol of the power and energy of the New World. As a grand-scale painting, over ninety inches in width, the panoramic *Niagara Falls* overemphasizes the breadth of the waterfall. Church brings the water all the way to the bottom edge of the canvas, eliminating any ground for the viewer to "stand on," tending to cause uneasiness in the viewer through a sense of vertigo. Church's *Niagara Falls* functions as a picture about power, the relentless kinetic energy of the blue-green water flowing toward the brink of the precipice and then plunging to the depths below. He leaves out any suggestion of a foreground upon which a person could stand forcing the viewer to be confronted by God's creation. In commenting on Church's painting, one viewer stated: "[I]t is grand and sublime; it is natural to the nation, since nature herself, has given the type; it is wild and ungovernable, mad at times, but all power is terrible at times. It is the effect of various causes; it is a true development of the American mind; the result of democracy, of individuality, of the expansion of each, of the liberty allowed to all; of ineradicable and lofty qualities in human nature."[19] Church provides the viewer every sense of the "wild and ungovernable" falls through the power of the flowing, dark emerald water, the sense of mistiness provided by the spray, and the precipitous drop. The critic quoted above links the American wilderness, symbolized by Niagara, with an "American mind" and an ideology of democracy, individuality, and liberty. Gordon Wood has argued that "forces unleashed" by

the American Revolution brought about a "reconstitution of American society" and made the United States as wild and powerful as Niagara Falls. Niagara was viewed as a sign from God of the millennial promise of America. Church painted the rainbow, a Biblical symbol of God's covenant with Noah and of rejuvenation and redemption. But the sublimity and awe created by Niagara Falls, and by extension Church's iconic image, also provoke fear, not calmed by the broken rainbow in the painting's left half. The falls were an American icon representing the strength and potential of the New World, the United States in particular. James Fenimore Cooper, in his essay "American and European Scenery Compared," stated that "Americans may well boast of their water-falls" and considered statements denigrating Niagara Falls for lacking nearby Alpine terrain as "hypercritical." Calling Niagara Falls a singular example of nature "the wild, the terrific, and the grand," Cooper continued: "The Alps, the Andes, and the Himmalaya [sic], would scarcely suffice to furnish materials necessary to produce the contrast, on any measurement now known to the world." The size and grandeur of Niagara Falls operated as a symbol of national strength in comparison with European nature. Niagara's association with the Deluge, and the rejuvenating and purifying floods of the Bible, resonates within the democratic, provi-

dential promise of America. However, Church's *Niagara Falls* suggests the millennial promise not yet fulfilled by the American experiment in republican government.[20]

American artists and tourists to Tivoli made aesthetic use of its nature and historical associations. They looked at the scenery and understood the landscape in its totality—for its hills and mountains, the Roman plain, and the distant coastline. They also noticed its striking landmarks: the ancient ruins, grotesque rock formations, unusual vegetation, caves, old trees, and waterfalls. American tourists and painters delineated the falls at Tivoli in specific contrast with North American waterfalls. As part of a mid-nineteenth-century tourist discourse, the cascades at Tivoli, performing as symbols of the Italian civilization of the past and marked by human achievements, were a long-standing part of tourist and artistic discourse dating back to the eighteenth century. Meanwhile, waterfalls in North America often functioned as emblems of unsullied and commanding wilderness. George Loring Brown created works of Tivoli for American patrons interested in "hackneyed" picturesque European associations. In contrast to the sublime images of the American landscape, associated with the present and future, Cole and Brown created Italian landscapes of the past to fulfill centuries-old understandings of European nature and civilization. ❧

1 Nathaniel Willis Parker, *Pencillings by the Way: Written During Some Years of Residence and Travel in Europe* (Detroit: Kerr, Doughty & Lapham, 1853), 307-308.

2 For European artists at Tivoli as part of a Grand Tour, see Andrew Wilton and Ilaria Bignamini, eds. *Grand Tour: The Lure of Italy in the Eighteenth Century* (London: Tate Gallery Publishing, 1996), 120-122, 141-143.

3 Brown traveled to Italy due to the support and recommendation of Washington Allston. He painted at least nine views of Tivoli and created a series of etchings in 1853 and 1854. Brown returned to the United States in 1860. See Thomas A. Leavitt, "The Life, Work, and Significance of George Loring Brown, American Painter" (PhD diss., Harvard University, 1957); John W. Coffey, *Twilight of Arcadia: American Landscape Painters in Rome, 1830-1880* (Brunswick, ME: Bowdoin College Museum of Art, 1987), 81-82; and K. Mathews Hohlstein, catalogue entry for *Tivoli (The Falls of Tivoli)* in Theodore E. Stebbins, Jr., *The Lure of Italy: American Artists and the Italian Experience, 1760-1914* (Boston: Museum of Fine Arts, Boston, 1992), 288-290. Sir William Gell mentioned one of the many floods: "The walls of Tibur [the ancient name for Tivoli] were much damaged by one of those extraordinary floods by which the Anio is not unfrequently swollen.... The great flood of November 1826, carried away the church of Santa Lucia, and thirty-six houses situated not more than two hundred yards from the temple of Vesta." See William Gell, *The Topography of Rome and Its Vicinity* (London: Henry G. Bohn, 1846), 418.

4 Parker, *Pencillings by the Way*, 309, emphasis about Bernini in original. Charles Eliot Norton, *Notes of Travel and Study in Italy* (Boston: Ticknor and Fields,

1855), 161, 144, and George Stillman Hillard, *Six Months in Italy*, vol. 1 (Boston: Ticknor, Reed, and Fields, 1853), 281, quoted in William L. Vance, *American's Rome*, vol. 2 (New Haven and London: Yale University Press, 1989), 77-102.

5 The version in the Toledo Museum of Art is a smaller composition, perhaps an "engraver's copy," probably similar to a much larger painting, destroyed in the Chicago fire of 1871. The comment on the painting's Italian "echoes" comes from E. P. Richardson and Otto Whittman, Jr., *Travelers in Arcadia: American Artists in Italy, 1830-1875* (Detroit and Toledo: Detroit Institute of Arts and Toledo Museum of Art, 1951). See William S. Talbot, *Jasper F. Cropsey 1823-1900* (Washington, DC: Smithsonian Institution Press, 1970), 180-185, and 428-431. For Cropsey's sketches of the viaduct, see the exhibition catalogue *An Unprejudiced Eye: The Drawings of Jasper F. Cropsey* (Yonkers, NY: The Hudson River Museum, 1979), 44-45. Carrie Rebora argues that "Cropsey was in sympathy with the concerns of railroad magnates" and had several as patrons. See her catalogue entry for *Starrucca Viaduct, Pennsylvania* in *American Paradise: The World of the Hudson River School* (Metropolitan Museum of Art, 1987), 210-213. Also see William S. Talbot, *Jasper F. Cropsey 1823-1900* (Washington: Smithsonian Institution Press, 1970), 90-92.

6 Thomas Cole's five paintings — *The Savage State, The Pastoral or Arcadian State, The Consummation of Empire, Destruction*, and *Desolation*— in the *Course of Empire* series are in the collection of the New-York Historical Society.

7 Alan Wallach, "Thomas Cole: Landscape and the Course of American Empire," in William H. Truettner and Alan Wallach, *Thomas Cole: Landscape into History* (New Haven and Washington, DC: Yale University Press and National Museum Of American Art, Smithsonian Institution, 1994), 90.

8 For primary source material on eighteenth-century landscape aesthetics see Henry William Beechey, ed., *The Literary Works of Sir Joshua Reynolds, First President of the Royal Academy*, 2 vols. (London: T. Cadell, 1835); Richard Payne Knight, *An Analytical Inquiry into the Principles of Taste*, 4th ed. (London: T. Payne, 1808); and John Sunderland, "Uvedale Price and the Picturesque," *Apollo* 93 (March 1971): 197-203. On the semiotic and political nature of landscape painting, see Ann Bermingham, *Landscape and Ideology: The English Rustic Tradition, 1740-1860* (Berkeley: University of California Press, 1986). For connections between British and American landscape aesthetics, see Joseph D. Ketner II and Michael J. Tammenga, *The Beautiful, The Sublime, and The Picturesque: British Influences on American Landscape Painting* (St. Louis: Washington University Gallery of Art, 1984).

9 John E. Edwards, *Random Sketches and Notes of European Travel in 1856* (New York: Harper & Brothers, 1857), 163.

10 Benjamin Silliman, *A Visit to Europe in 1851*, vol. 1 (New York: G.P. Putnam, 1854), 281-284. Gell, *Topography of Rome*, 420.

11 William Wetmore Story, *Roba di Roma*, vol. 2 (Boston and New York: Houghton, Mifflin and Company, 1889), 491.

12 Parker, *Pencillings by the Way*, 308.

13 Marshall Tynn, ed., *Thomas Cole: The Collected Essays and Prose Sketches* (St. Paul: John Colet Press, 1980), 131; quoted in Truettner and Wallach, *Landscape into History*, 51.

14 Asher B. Durand, "Letter from a Landscape Painter," *The Crayon*, 11 July 1855. Roger Stein has argued that this American attitude toward art and nature was influenced by the writings of English critic John Ruskin. Stein states that "the fundamental importance of Ruskin's writing in America in these years before the Civil War was his identification of the interest in art with morality and religion as well as with the love of nature." He writes that Ruskin proposed a "convincing system where art, religion, and nature were inextricably intertwined." See Roger Stein, *John Ruskin and Aesthetic Thought in America 1840-1900* (Cambridge: Harvard University Press, 1967), 41. Also see Barbara Novak, "Sound and Silence: Changing Concepts of the Sublime," in *Nature and Culture: American Landscape Painting 1825-1875*, rev. ed. (New York and Oxford: Oxford University Press, 1995), 34-44.

15 See *The Home Book of the Picturesque, Or American Scenery, Art and Literature* (New York: G. P. Putnam, 1851).

16 James Fenimore Cooper, "American and European Scenery" in *The Home Book of the Picturesque, Or American Scenery, Art and Literature* (New York: G.P. Putnam, 1851), 69.

17 Hillard, *Six Months in Italy*, vol. 2 (Boston: Ticknor, Reed, and Fields, 1853), 214. Jeremy Elwell Adamson et al., *Niagara: Two Centuries of Changing Attitudes, 1697-1901* (Washington, DC: The Corcoran Gallery of Art, 1985), 11. For more on tourism, Niagara Falls, and its nationalistic meanings, see Elizabeth McKinsey, *Niagara Falls: Icon of the American Sublime* (New York: Cambridge University Press, 1985); John F. Sears, *Sacred Places: American Tourist Attractions in the Nineteenth Century* (Amherst: University of Massachusetts Press, 1998), especially 12, for the quotation of the ritual nature of Niagara tourism; and William Irwin, *The New Niagara: Tourism, Technology, and the Landscape of Niagara Falls, 1776-1917* (University Park: Pennsylvania State University Press, 1996).

18 Henry James, "Niagara," in *The Art of Travel* (Garden City, NY: Doubleday Anchor, 1958), 90-91. Thomas Cole, "Essay on American Scenery,"

The New England Monthly Magazine, n.s., 1 (January 1836): 1-12; quoted in John W. McCourbey, ed., *American Art 1700-1960: Sources and Documents* (Englewood Cliffs, NJ: Prentice-Hall, 1965), 103 and 105. Margaret Fuller Ossoli, "Summer on the Lakes" in *At Home and Abroad; Or Things and Thoughts in America and Europe*, ed. Arthur B. Fuller (Boston: Brown, Taggard and Chase, 1860), 3-6.

19 Adam Budeau, *The Vagabond* (New York: Rudd and Carleton, 1859), as quoted in David Carew Huntington, *The Landscapes of Frederic Edwin Church: Vision of an American Era* (New York: Braziller, 1966), 67-68.

20 Gordon S. Wood, *The Radicalism of the American Revolution* (New York: Vintage Books, 1991), 229. Martin Christadler categorizes Church's Niagara as "heroic wilderness sublime." See "Romantic Landscape Painting in America: History as Nature, Nature as History," in Thomas W. Gaehtgens and Heinz Ickstadt, eds. *American Icons: Transatlantic Perspectives on Eighteenth- and Nineteenth-Century American Art* (Santa Monica and Chicago: Getty Center for the History of Art and Humanities and the University of Chicago Press, 1992), 93-117. The quotation in the text is from page 105. David Huntington sees in Church's image a consummate imagining of the young American nation. Bryan Wolf calls Church's images a "melodrama of pigment and impasto" which speak "more to the God of Armageddon… than to the transparent eyeball of Emerson." See Bryan Jay Wolf, *Romantic Re-Vision: Culture and Consciousness in Nineteenth-Century American Painting and Literature* (Chicago: University of Chicago Press, 1982), 247. Also, see Amy Ellis's catalogue entry for Church's *Niagara Falls* in Elizabeth Johns et al., *New Worlds from Old: 19th Century Australian & American Landscapes* (Canberra and Hartford: National Gallery of Australia and Wadsworth Athenaeum, 1998), 165. Cooper in *Home authors and home artists; or, American scenery, art, and literature* (New York: Leavitt and Allen, 1852), 56-57.

Italy was classic ground and this is not so much by association with great events as with great men.... [T]o the American Italy gave cheaply what gold cannot buy for him at home, a past at once legendary and authentic...

—JAMES RUSSELL LOWELL, 1864

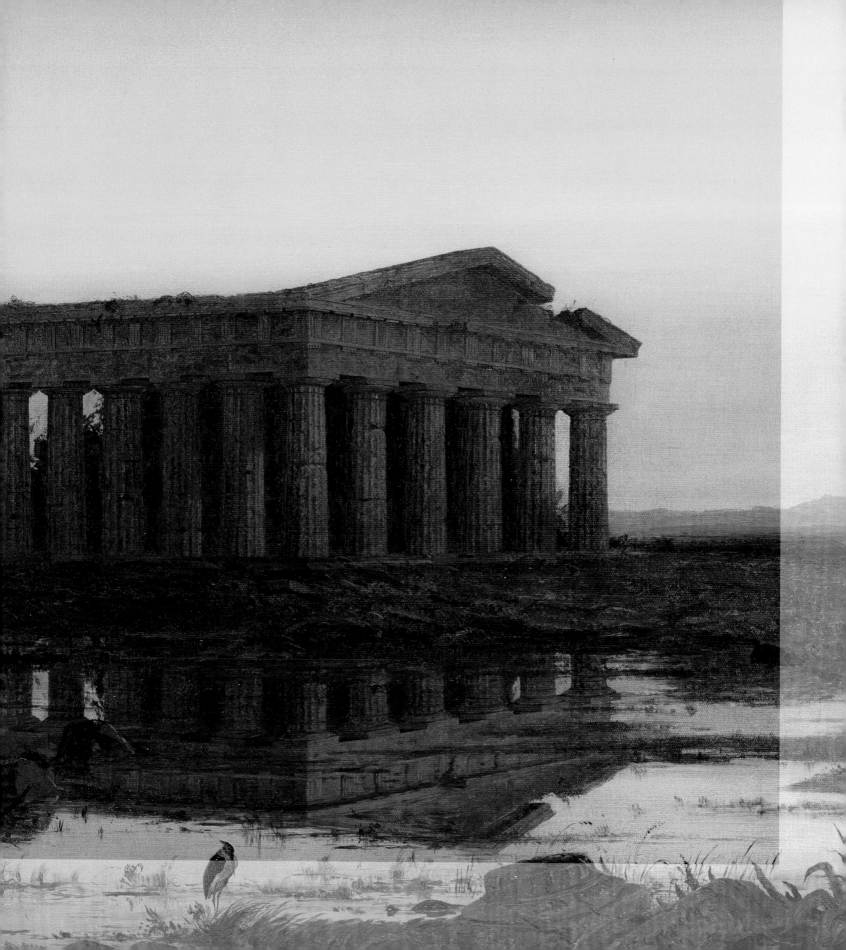

Paul A. Manoguerra ❧ Georgia Museum of Art

Like Going to Greece

AMERICAN PAINTERS AND PAESTUM

N 1847, THE YOUNG AMERICAN ARTIST JASPER FRANCIS Cropsey traveled to Europe on a honeymoon with his wife, Maria. They went to England, Scotland, France, and Switzerland before arriving in Italy in the fall. The following summer, the Cropseys shared a villa with sculptor William Wetmore Story and his wife in Sorrento. With the political and military turmoil in Italy during the spring of 1849, the Cropseys left Italy for France and England. They arrived back in the United States in mid-summer. While on this extended honeymoon, however, Cropsey, Story, and poet Christopher Cranch traveled by boat in southern Italy from Amalfi to Salerno, and then took a carriage across a swampy plain to Paestum, the ancient Greek colonial town. Cranch later described his reactions to the magnificent Greek ruins at the site:

> As we approached them we could none of us resist the most enthusiastic exclamations of delight. Never had I seen anything more perfect, such exquisite proportions, such warm, rich coloring, such picturesquely broken columns; flowers and briers growing in and around, and sometimes over fallen capitals. Right through the columns gleamed the sea, and beyond, the blue, misty mountains. And over all brooded such a silence and solitude. Nothing stood between us and the Past,

to mar the impression. Mysterious, beautiful temples! Far in the desert, by the sea-sands, in a country cursed by malaria, the only unblighted and perfect things—standing there for over two thousand years. It was almost like going to Greece.[1]

Through a tourist adventure that other American travelers and artists also would complete in the 1840s and 1850s, Cranch, Story, and Cropsey came face to face with "the Past." Cropsey's sketches, based upon his encounter with the temple ruins at Paestum, would lead to the painting of numerous canvases of the ancient site over his painting career. Prior to the Civil War, Albert Bierstadt and John Frederick Kensett, among other American painters, created images of Paestum for an American art market. The ancient Greek "past" met the American "present" through paintings displayed in exhibitions at the National Academy of Design and in the homes of American art patrons in the 1850s. Images of Paestum sought to remind Americans that they were heirs to a Greco-Roman tradition and to encourage their viewers to build a civilization as noble as that of the ancient Greeks. For these artists and the paintings' viewers, the American images of the ruins at Paestum represented a solid link between the democratic traditions of the ancients and the new democratic promise of the United States.

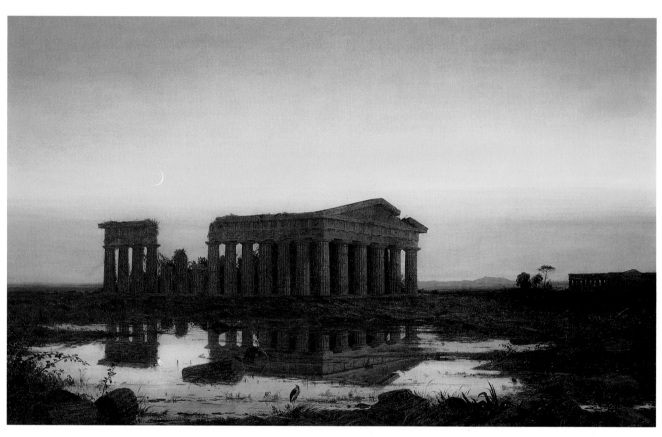

30 ❧ Jasper Francis Cropsey, Temple of Neptune, Paestum, *1859.*
Oil on canvas, 31 ½ x 51".
Collection of the Newington Cropsey Foundation.

The temples, having stood the test of time, symbolized the importance and strength of democracy while the surrounding swamp, "cursed by malaria," operated as a metaphor of degeneration. The paintings, *Temple of Neptune, Paestum* by Cropsey (fig. 30) and *Ruins of Paestum* by Bierstadt (fig. 33), linked the past and present in a historical cycle, but also warned Americans of the dangers of decadence and moral decay presented by the issue of slavery.[2]

THE ANCIENT GREEK TOWN OF POSEIDONIA, better known by its Roman name of Paestum, is located near the western coastline of southern Italy, towards the southern end of the Bay of Salerno, about fifty miles south of Naples. A thriving commercial city founded around 600 BC, Paestum had little modern archaeological work done until the twentieth century. Although not unknown, Paestum's temples went almost unvisited as a tourist locale until the 1700s, perhaps due to the malaria-breeding swamps at the site. Paestum appeared on maps of the eighteenth century and functioned as a landmark for sailors. But it was not until about the middle of the century that a dignitary and architect of the Neapolitan court announced the "discovery" of that town's temples. A number of scholars and travelers visited at about the same time, including the French architect J. G. Soufflot and Thomas Major, whose *The Ruins of Paestum otherwise Poseidonia in Magna Graecia* was published in London in 1768. From the 1760s onward, interest in Paestum coincided with the Doric Revival in Europe. Goethe visited in 1777, while Hubert Robert, Giovanni Battista Piranesi, Antonio Joli, and other continental artists created views of Paestum during the last half of the century. American painter John Singleton Copley visited Paestum in 1775, while Thomas Cole sketched there in 1832. John Frederick Kensett sojourned in Paestum in 1847, a year before Cropsey, Cranch, and Story made the trip, and created a small oil sketch, *The Temple of Neptune, Paestum* (fig. 31). Tourism, especially by mid-nineteenth-

century English and American travelers, at Paestum flourished with the improvement of roads from Salerno and the arrival of the railway. By the 1850s, *Murray's Handbook* for southern Italy stated that "of all the objects that lie within the compass of an Excursion from Naples, Paestum is perhaps the most interesting.... A journey to the South of Italy can hardly be considered complete if Paestum has not been visited."[3]

Cropsey's large canvas of the so-called "Temple of Neptune" at Paestum, resulting from his journey to southern Italy in the late 1840s, shows the Greek ruins reflected in a swampy pond. Dominating the foreground, the marsh includes a wading bird and broken columns amid the mirrored reflection of the temple. Full of overgrown vegetation, the temple looms on the flat plain. Cropsey painted the *Temple of Neptune* with a broken pediment and three ruined columns. Over the broken section of the ruins, a thin crescent moon and an evening star emerge from the twilight sky. The orange-red light of the setting sun catches the facade of the temple, allowing for numerous details—metopes, triglyphs, and the fluting of the Doric columns—to become visible to the painting's viewers. Cropsey painted Paestum's other Greek temples in the distance at the horizon line on the right side of his composition. The Reverend Elias Magoon, the purchaser of a small oil sketch by Cropsey of the ancient ruins, wrote to Cropsey about his *Paestum* image: "Our Father in Heaven has endowed you with fine capabilities, and may you long be spared to use them well in the cultivation of sacred beauty." Cropsey would paint other versions, including the small picture *Temple of Ceres, Paestum* (fig. 32), over the course of his artistic career.[4]

Temple of Neptune, Paestum portrays, with notable attention, the Doric nature of this partially ruined temple. Cropsey presents his viewers all the details necessary to recognize the lack of a base, as the columns rise straight from the stylobate, and the echinus and abacus which mark the temple columns as Doric. As a young man, he held an apprenticeship with

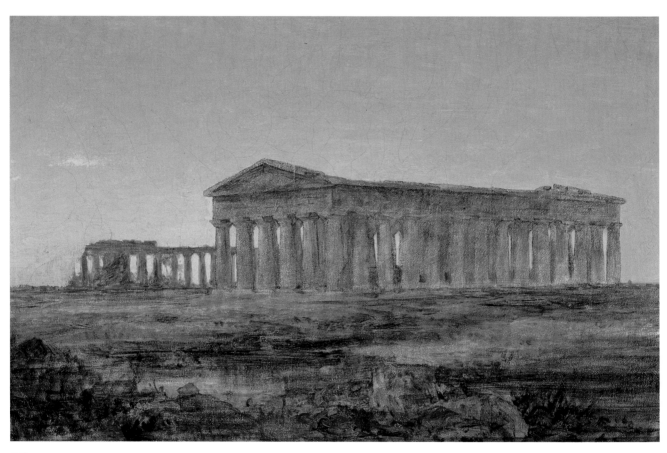

31 ❧ JOHN FREDERICK KENSETT, The Temple of Neptune, Paestum, *n.d.*

Oil on canvas, 9 ⅜ x 14 ⁵⁄₁₆".

Allen Memorial Art Museum, Oberlin College, Ohio;

Gift of Charles F. Olney, 1904

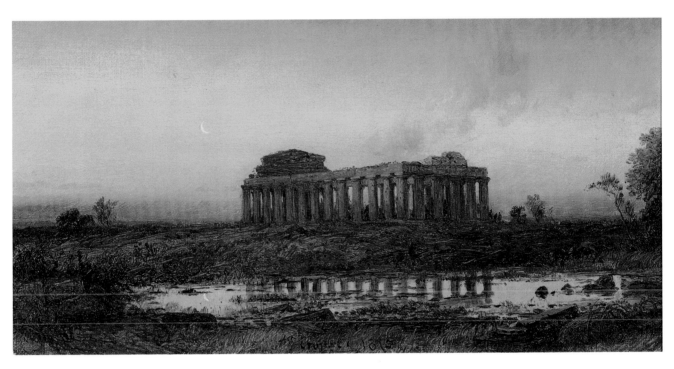

32 ❧ Jasper Francis Cropsey, Temple of Ceres at Paestum, *1875*.

Oil on canvas, 6 x 12".

Collection of the Newington Cropsey Foundation.

the New York architect Joseph Trench and eventually set up an architectural office, in the Granite Building on Broadway and Chambers Street in New York, at the age of twenty. Cropsey's interest in rendering a detailed image of the temple at Paestum likely reflects his early training but also announces the Doric significance and history of the temple. Using the common diction of magnificence and antiquity, Sir William Smith, in *A New Classical Dictionary of Greek and Roman Biography, Mythology and Geography*, observes that "The ruins of Paestum are striking and magnificent…. The two temples are in the Doric style, and are some of the most remarkable ruins of antiquity." For Cropsey and other American visitors to the site, Paestum's temples represented the greatness of Greek civilization. James Fenimore Cooper, visiting Paestum about a decade before Cropsey, noted the antiquity of the temple Cropsey paints: "Comparing the temple of Neptune with anything else of the sort, in Italy, would seem quite out of the question. Its history and its style prove it to be one of the most venerable specimens of human art of which we have any knowledge." Thomas Cole, Cooper's contemporary, remarked that his traveling party "came within sight of the temples of Paestum, just as the first beams of the sun were breaking upon them … as it had done for two thousand years." *Murray's Handbook* notes the dignified nature of the temples: "These magnificent ruins are, with the exception of those of Athens, the most striking existing records of the genius and taste which inspired the architects of Greece…. [T]hey are doubtless the most venerable examples of classical architecture in Italy." E. K. Washington, visiting in the late 1850s, echoed *Murray's Handbook*: "They are in the earliest Grecian style, and are reckoned the most remarkable existing of the genius and taste which inspired the architects of Greece, with the single exception of one building at Athens." All of these writers, in commenting on their visits to the Doric ruins at Paestum, noted the inspiring ancientness and majesty of the temples.[5]

THE DISCUSSION OF THE HISTORY OF PAESTUM in travel accounts and guidebooks appears remarkably uniform among the many authors. *Murray's Handbook* in the 1850s mentions that commentators remain unsettled about the historical origins of the site: "[t]he origin of PAESTUM, or POSEIDONIA as it was called previous to the Roman conquest, has been attributed by some antiquaries to the Phoenicians, and to the Etruscans by others; while many have endeavored to assign it to a more remote origin still." James Fenimore Cooper noted that "The history of Paestum is not very well settled." Misdating either the temples or the pyramids at Giza by about two thousand years, Cooper expressed his fascination with the ancientness of the ruins: "The temples that remain are certainly of very remote antiquity; probably little less ancient, if any, than the Pyramids of Egypt." He then re-emphasized their antiquity by observing that "[The Roman Emperor] Augustus is said to have visited the very temples that are now standing, as specimens of ancient architecture!" In the light of the past at Paestum, the very new democratic traditions in the United States become "a speck" in the "long vista of events — what a point the life and adventures of a single man!" Cooper also linked the history of Paestum to Biblical history in noting that, from "about the time of the Deluge," the temples represented "one of the best specimens of architecture that succeeded the new civilization." For Cooper and other Americans, Paestum represented solid evidence of the ancient nature of civilization, including democracy.[6]

For many antebellum American architects and thinkers, the Doric style of places like Paestum represented not just the remote origin of democracy but also order and simplicity. Like other images of Paestum, John Frederick Kensett's oil sketch *The Temple of Neptune, Paestum* (fig. 31) stresses the harmony and austerity of the ruins.[7] In his 1843 text delineating how to build "classic dwellings" in "rural" America, Edward Shaw outlined his interpretation of the short history

For many antebellum American architects and thinkers, the Doric style of places like Paestum represented not just the remote origin of democracy but also order and simplicity.

of American architecture. Unlike in Europe, where the Catholic and Protestant hierarchies have supported great architectural achievements, the Puritans, through "the simple severity of their architecture…appear to have been desirous of entirely obliterating the memory of the magnificent churches, and pompous ceremonials, attendant on the worship of their oppressors." But in recent times, Shaw argues, "the spirit of this new age is an enterprising spirit… the spirit of the age is locomotive." The more modern enterprising spirit, fueled by greater economic and political equality—democracy—for white male citizens, Shaw argues, permits the United States to create extraordinary and imposing architectural structures, in the Doric style. Shaw provides one example: "In Philadelphia we have the United States Bank, a faultless specimen of the pure Doric; classic, chaste, and simple in its proportions, it is a building of which we may well be proud." But Philadelphia was not alone in erecting "pure Doric" structures: "Among [Boston's] specimens of Doric, worthy of mention, are the new Custom House, the United States Branch Bank, the Hospital at Rainsford Island, the Washington Bank, and Quincy Market, a plain but noble structure of hewn granite, about five hundred feet in length, constructed by, and an honor to, our city." For Shaw and other American architects, creating grand Doric city and public buildings or Greek-style porches on vernacular architecture mirrored the original Doric style at Paestum

and in Greece. Recalling the admired virtues of the great ancient republican orators like Cicero and Cato, E. K. Washington calls the temples at Paestum "mute, impressive, stern, and eloquent." The Doric style in America also reflected the democratic ideals of the nation, passed on from the republican Romans and the ancient Greeks.[8]

The reflection of the ancient temple in the stagnant pool in the foreground of Cropsey's image functions as a metaphysical impression of the past. Although many American tourists to Paestum in the antebellum years would evince the antiquity of the Doric temples, those same tourists would remark on the supernatural and sublime qualities of the same temples. *Murray's Handbook* announces that the temples, with "their huge dusky masses standing alone amidst their mountain wilderness, without a vestige nigh of any power that could have reared them…look absolutely supernatural." E. K. Washington paraphrases and references *Murray's Handbook*: "It has been remarked that they look supernatural—they are so lofty and grand, and so stern and noble in their proportions, of such unquestioned antiquity— and yet there is nothing in character with them around, nothing that could have erected them." But Washington adds his own observation of the immortality of the temples: "The columns of these temples stand firmly on their bases, not having moved a particle. Time, with respect to them, would seem to be almost a mere illusion."[9] In a very Romantic

and spiritual vein, he continues: "I have been in places, and Paestum is one, where you feel the past—could read it, and write its history. Is it because it is all there yet—though in the shadow land? Is there *any thing* past? Are not all things haunted? The refined, subtle, enjoying Greek seems here with his genius, and the ruination around seems the phantasm. Is not the phantasm of one world the real of the other? and the desolation here now, the mere shadow of the unseen world?"[10] The powerful historical associations of the site became tangible for Washington and blurred the lines between the past and the present, and between reflection and reality. The learned, astute, pleasured American tourist replaces the "refined, subtle, enjoying Greek" as "genius." The American, democratic present had resurrected the "unseen phantasm" of the Greek past.

CROPSEY, UTILIZING THE SUPERNATURAL AND sublime qualities felt by American tourists at Paestum, employs a crescent moon, looming over the temple, as a symbol of renewal and resurrection. The moon appears in each of his small oil sketches of *Evening at Paestum* (1856; 9 x 15 ½ in.; Frances Lehman Loeb Art Center, Vassar College), *Temple of Ceres, Paestum*, and the full-sized canvas, *Temple of Neptune, Paestum*. Often "female" in European cultural discourse because of its passivity as a receiver of the sun's light, of its ever-changing nature, and of the similarity of the lunar month and the menstrual cycle, the moon contrasts greatly with the structural, sturdy masculinity of the Greek temple. The temple, through its aesthetics, embodies the rational, and very "male," elements of the past. The waxing and waning of the moon, and the inevitable return of the same lunar form, combine the ideas of death and rebirth. Ancient Christian writers viewed the sun and the moon as dualistic symbols: the sun as God; the moon as humanity, a reflection of God. Other theologians interpreted the moon as a symbol of the Church, which receives illumination from God and then transmits it to all believers. Cropsey's crescent moon signifies the God-granted regeneration of republican traditions, once "full" in the ancient Greek and Roman world but long since waned and as broken as the temple's columns. The waxing crescent moon decorating the sky over his painted Paestum communicates the recent re-emergence of republican institutions in the United States. That natural and inevitable re-emergence of republicanism in America, following the thread of Christian thought, receives its illumination from a divine source. The Greek sense of harmony and proportion, a celebration of the faculties and knowledge of humankind, represented the mirroring of the order of the universe. The sense of sublime natural beauty reflected God's order.[11]

The sublimity of the Greek ruins at Paestum, however, were significant yet secondary to Albert Bierstadt in his painting *Ruins of Paestum* (fig. 33). Traveling with fellow artist Sanford Robinson Gifford during the late spring and early summer of 1857, Bierstadt sketched at Paestum. In mid-May 1857, Gifford and Bierstadt left Rome on a six-week tour of the Abruzzi, Naples, and the Amalfi coast. They climbed Vesuvius in late May, and sketched at Capri for a month. Then, on 29 June 1857, Gifford and Bierstadt took a carriage to Paestum to see its imposing Greek ruins. On the plains nearby, where they were collecting marble fragments, Gifford sketched a pastoral scene with a column fragment and travertine slabs in the foreground. According to Gifford's letters, Bierstadt accidentally left his sketchbook behind at Paestum and walked back from several miles away to retrieve his sketches from the temple ruins. Most likely painted in New Bedford, Massachusetts, in early 1858, *Ruins of Paestum* went on display at the Boston Athenaeum in September 1858 and at the National Academy of Design's annual exhibition in spring 1859.[12]

Bierstadt's medium-sized canvas of the ruins at Paestum de-emphasizes the majesty of the ancient temples and highlights the desolation of the ruins' location. The swamp dominates the right foreground of Bierstadt's image. With

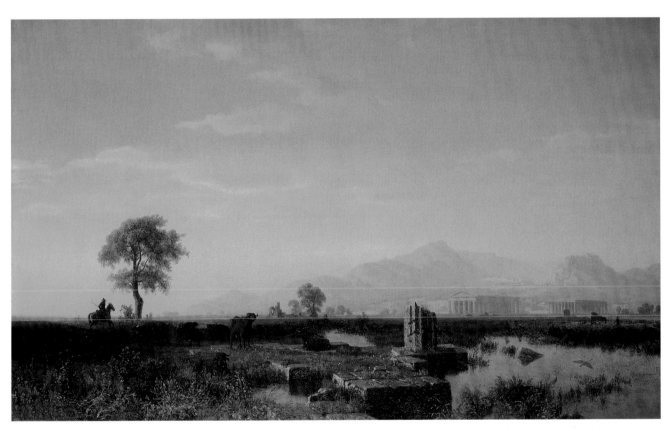

33 ☞ ALBERT BIERSTADT, Ruins of Paestum, *1858.*

Oil on canvas, 22 x 36".

The Minneapolis Institute of Arts, the Putnam Dana McMillan Fund.

its two wading birds, one taking flight, the marsh consumes one massive column while another, long and broken, survives, a fragment still rising from a stylobate. Adjacent to this lone column on the picture plane, but at the horizon line of the painting, Bierstadt paints the ruins of two temples. In the far left background, the distant ruins of the "Temple of Neptune" become visible. In the right background, an Italian town and mountains rise from the plain. In the left foreground and middle ground, Bierstadt places lush vegetation, a picturesque tree, and several roaming European buffalo. *Murray's Handbook* comments upon the roaming buffalo amid the ruins: "The plain extending…to Paestum is tenanted by wild horses, buffaloes, swine and sheep, guarded by fierce dogs." The handbook continues: "The Salso, which formerly flowed by the walls of the city, is now choked with sand and calcareous deposits, and it overflows the plain, forming stagnant pools, the resort of herds of buffaloes." Bierstadt also includes a solitary man on horseback.[13]

Bierstadt's lone man on horseback generally recalls Salvator Rosa's seventeenth-century landscape paintings, depicting Italian bandits, an alarming and all-too-common reality for travelers in Italy in the nineteenth century. American visitors to Paestum and southern Italy were familiar with the stories of ambush and murder of tourists by *banditi* on horseback. *Murray's Handbook* relates the story of a famous murder in 1824 at the ruins of Paestum:

> The spot where Mr. Hunt and his wife were murdered … is on the road to Eboli. They had slept at that town, and his servant had placed on a table near the window the contents of a dressing-case, which were mounted in silver, and Mrs. Hunt's jewels. A girl belonging to the inn saw them, and spread the report that an Englishman, carrying with him enormous treasures, was going to Paestum, upon which 18 men set out from Eboli, to intercept the spoil. Mr. and Mrs. Hunt, after visiting the Temples, were returning … when they were stopped …. Mr.

Hunt at first showed some resistance, but his wife having implored of him to surrender at once, he stooped to take the dressing-case lying at the bottom of the carriage. One of the brigands, who was at the window of the carriage, fancying that Mr. Hunt was going to seize the pistols, instantly fired; the ball mortally wounded Mr. Hunt and his wife. Another of the brigands exclaimed, 'What have you done?' and the murderer coolly answered, '*Ciò ch' è fatto è fatto.*' These facts were brought out by the judicial investigation, the result of which was that 17 out of the 18 robbers were identified by a shepherd boy, who witnessed the whole affair while concealed in a thicket. These men were executed, and the 18th confessed on his death-bed.

James Fenimore Cooper mentions the Hunt murder in his tale of his visit to Paestum: "The coachman stopped the carriage by a copse of bushes, and told us the spot was the scene of a recent robbery and murder." The gothic story of the cold-blooded murder and robbery, set against the backdrop of the ennobling ancient Greek temples, emphatically expressed not only the mid-nineteenth-century Anglo-American view of contemporary Italians but also the lost greatness of the ancient republican past. Paestum, for all its historical associations, history of republican democracy, and sublime beauty, remained in the mid-nineteenth century a site also exemplifying the degradation of civilization into chaos, death, and turmoil.[14]

The sublime beauty of the Doric temples, symbols of civilization and democracy, exists within a landscape of decay, sin, and wildness. Both Cropsey, in his *Temple of Neptune, Paestum*, and Bierstadt, in his *Ruins of Paestum*, depict a swamp in the foreground. The "swamp," as a specific landscape type, held ambiguous metaphorical meaning for mid-nineteenth-century Americans. The discourse on "swamps," and their related landscapes, "deserts," centered in the basic theological symbolism of these places as regions of evil, of temptation, and of death. These designations recall the "wilderness" of both the Old and New

Testaments, with the most apparent suggestion that of the Israelites in the wilderness. The encircling swamp performs, in one sense, as a relic of the hardship endured by those who struggled for a better and righteous life. The Greek temples, tangible relics of a democratic past, have survived amid the wilderness of Paestum's swamp.[15]

AMERICAN TOURISTS TO THE PLAIN AT Paestum often referred to the discourse of "swamp" places, connoting the area as a desert or wasteland. In the 1830s, James Fenimore Cooper blamed the Italians for "the appearance of neglect rather than of barrenness." The landscape at Paestum, in Cooper's estimation, was not an Old Testament desert allied with "that of solitude," but instead one associated with "the idea of wildness." In contrast, E. K. Washington, two decades later, poetically alludes not only to an Old Testament-type desert but also to death by asphyxiation as he comments on the landscape, "desolated by the miasma," around the Doric ruins: "[T]he once flourishing, commercial, and elegant Greek city has been a desert for one thousand years.... The desert, time-cursed plain, whence death exhales, is all around.... Beyond [the temples] stretched a suffocated river, lost and choked in a swamp, as it attempts to find its way to the sea—being obstructed by the fallen ruins of the city. The dismal croaking of a frog seemed a proper accompaniment of the scene." For Washington, and many other American visitors, a "flourishing, commercial, and elegant" city required the progressive use of a river for commerce, trade, and travel. Paestum, as a civic entity, had long since ceased to thrive. Bierstadt and Cropsey both evince the uncultivated nature of Paestum's landscape through the inclusion of wildflowers, briers, and other overgrown plants. Washington, Cooper, and other tourists would often include the ongoing threat posed by malaria in their descriptions of Paestum's choked river. Many visitors would also contrast the contemporary swamp—

a place of "briers, and weeds"— with Paestum's ancient renown as a site for beautiful flowers, especially roses.[16]

Numerous legends and stories exist in the Euro-American tradition about the rose and its origins. Noting the "rose of Paestum," Charles Fraser, in a July 1858 essay on gardening, comments that the rose in America had become the subject of innocuous adoration: "The offerings of taste and genius, of beauty and innocence, have diffused an atmosphere of joy around [the rose], and made it the object of universal but harmless idolatry." Fraser continues: "No doubt the celebrated rose of Paestum ... is to be found among the varieties that adorn our own gardens." But most of the traditions deal with the rose as a metaphor of earthly values and as a symbol of love, death, sensuality, or sin. One myth says that a white rose turned red with the kiss of Eve in the Garden of Eden. Another traditional ancient tale claims that the Roman goddess of flowers, Flora, created the rose, with the assistance of other deities, from the corpse of a favorite nymph. According to traditional accounts, Cleopatra used red rose petals as a carpet so that the flowers' scent would encompass and bewitch the approaching Marc Antony. In ancient Rome, the rose operated as a symbol of death and heaven. It became a custom to place roses on graves and on the foreheads of the dead as tokens of enduring love. During the Roman Empire, roses became associated with the degeneracy of the emperors; according to one legend, a number of virtuous Romans were suffocated under tons of rose petals dropped on them during an imperial orgy.[17]

Mid-nineteenth-century American and British tourists to Paestum were cognizant of its history as the ancient site for seeing and experiencing beautiful roses. *Murray's Handbook* mentions that "Paestum was celebrated by the Latin poets for the beauty and fragrance of its roses.... These roses have disappeared." E. K. Washington notes that "the poets have celebrated its roses, which bloomed twice a year," while Sir William Smith's textbook records that "in the time of Augustus[, Paestum] is only mentioned on account of the

beautiful roses grown in the neighborhood." American intellectuals and landscape architects were also familiar with the "rosebeds of Paestum" from Virgil and other ancient Roman poets. In a paper given at the dedication of a building in 1857, New Englander George Lunt commented that Paestum's roses "ages ago stirred and mingled with the sublimest of human emotions" yet now no longer reside "amidst the ruin's of man's less durable achievements." American visitors to Paestum, in Margaret Fuller's words, were "thinking American[s] … anxious to gather and carry back [from the Old World] with [them] every plant that will bear a new climate and new culture." Continuing the horticultural metaphor, Fuller wrote that such an American hoped to gather his "plants … free from noxious insects" yet did "not neglect to study their history in [the Old World]." The beautiful roses of Paestum, flowering during the age of republican Rome, had long since succumbed to the swampy, choked river encountered at the locale by mid-nineteenth-century American tourists to the ancient temples.[18]

T HE SWAMP AT PAESTUM FUNCTIONS AS A paradoxical emblem, as a place of both death and renewal. Cropsey and Bierstadt utilize a common motif of swamp images — a lone bird or a few wading birds — in their paintings of Paestum. Eighteenth-century naturalist William Bartram described "the solitary bird" in a "pensive posture" as looking "extremely grave, sorrowful, and melancholy, as if in deepest thought." Images of American swamps, including Flavius Fischer's painting of Virginia's *The Dismal Swamp* (fig. 34), utilize the "solitary bird" and, in Fischer's image in particular, the symbolic crescent moon as symbols of personal reflection and regeneration, respectively. Paestum's swamp manifests the concept of the wild, savage, and pre-civilized, operates as a site of both death and renewal, and becomes a place for personal thought and inner reflection. As David Miller writes, "The universe falls into proper moral perspec-

34 ☞ FLAVIUS FISCHER, The Dismal Swamp, *n.d.*
Oil on canvas, 30 x 50".
Collection of the Maier Museum of Art,
Randolph-Macon Woman's College, Lynchburg, Virginia.

tive along this axis: light, life and [God] are embodied in flowing water; darkness, death, and the withdrawal of the divine presence are exemplified in stagnant water." The Doric ruins at Paestum, metaphors of past democratic greatness, exist amid an uncertain landscape of decay, pensiveness, and renewal.[19]

Besides the majesty of the temple ruins and the wildness of the swamp, many American tourists to Paestum noted that on the plain near the temples Crassus defeated the army of Spartacus.[20] For many northerners in the United States, the ancient civilizations of Greece and Rome degenerated due to moral excess and slavery, with the legend of Spartacus as the most famous example of slave revolt in ancient history. In his 1857 work *Connexion of Sacred and Profane History*, David Davidson describes the ancient event: "In the centre of that country, Spartacus, a Thracian, and famous gladiator, raised an alarming insurrection among the slaves. His army, at one time, amounted to one hundred

and twenty thousand men. They laid waste the greater part of Italy, and were not conquered by Crassus till many thousands of them were slain in battle." The revolt began in 73 BC, at a training school in Capua, near Paestum, and the gladiators and slaves defeated the armies of two Roman praetors. Eventually, Spartacus fell in battle and six thousand of his followers were crucified. Many mid-nineteenth-century authors of ancient historical accounts argued that the defeat of Spartacus marked the moment Rome began to degenerate from republican government into despotism. In an 1855 chapter titled "The Fall of Rome," Thomas Bangs Thorpe maintains that "[t]he defeat of Spartacus took place... [when] the haughty tyranny of [Rome's] nobles was at its greatest height, and when the degradation of its industrial classes was most insupportable." Ultimately, Thorpe notes, "It was at this juncture, when the last glimmering light of liberty had vanished, that the dark reign of despotism began."[21]

Northern and anti-slavery writers were quick to link the ancient historical figure and story of Spartacus to the American situation in the 1850s. Noting that "[n]o such broad political freedom was ever heard of before, either in Greece or Rome," Thorpe attests that the American "mighty empire" faces a moment of crisis over the issue of slavery.[22] Using "the followers of Spartacus" as an example, the Reverend Charles Eliot, not hiding his contempt for the "peculiar institution," expresses one opinion of what slavery does to civic virtue: "But [slavery], while it binds the body, corrupts the mind. The outrages which men commit when they first regain their freedom, furnish the strongest argument against the condition which can render human nature capable of such crimes. Idleness, and treachery, and theft are the vices of slavery." In an 1850 speech delivered in the U.S. House of Representatives, Horace Mann longed for a "Spartacus ... with ... lofty heroism," or another Nat Turner, to serve as a leader among slaves in the South, which "fosters within its homes three millions of latent rebellions."[23] American anti-slavery politicians and writers viewed the revolt under Spartacus in ancient Rome as having derived from intolerable conditions on the ancient *latifundia* and from the desire of the slaves to be free. Abolitionists connected the ancient slave conditions with those of the plantation South.

MANY AMERICAN ABOLITIONISTS, both black and white, linked the "swamp" and the "desert" with the issue of slavery. Whig politician Daniel Webster, in speaking about the possibility of Civil War over the slavery issue and states' rights in 1851, employed the diction of mid-nineteenth-century swamp discourse in a statement that reads much like American tourist descriptions of the landscape at Paestum: "But secession and disunion are a region of gloom, and morass and swamp; no cheerful breezes fan it, no spirit of health visits it; it is all malaria.... [T]he traveller through it breathes miasma, and treads among all things unwholesome and loathsome." Others often used the metaphor of the "children of Israel" making "a grand exodus" from "the land of bondage" and traveling through the desert wasteland to a promised land of redemption. During the years prior to and during the Civil War, northerners often saw the swamp as an emblem of the depredations of slavery on southern society.

In the minds of northern abolitionists, escaping into the woods or swamps of the great plantation districts of Louisiana, South Carolina, or Virginia became one way in which a slave could resist the hegemonic and corrupt economic structure of the South. A powerful form of resistance, hiding out in a nearby wood or swamp fulfilled the need to experience a period of freedom away from the restraints and discipline of slave life. The so-called Compromise of 1850 and the federal enforcement of the Fugitive Slave Act of 1793 brought the popular image of the runaway slave in the midst of the swamp into the Northern lexicon and imagination.

35 ◈ Thomas Moran,

Slave Hunt, Dismal Swamp, Virginia, *1862*.

Oil on canvas, 32 ½ x 43".

Gift of Laura A. Clubb, the Philbrook Museum of Art,

Tulsa, Oklahoma. 1947.8.44

Images of the escaped or escaping slave hiding in the swamp were prevalent in both literature and art. For example, Thomas Moran's 1862 painting *Slave Hunt, Dismal Swamp, Virginia* (fig. 35) makes use of the swamp as a dangerous spot of anxiety, fear, and death. The runaway slaves, being pursued, fearing for their lives, and longing for their freedom, pass through a dusky, desolate swamp. Harriet Beecher Stowe, in her novel *Dred, A Tale of the Dismal Swamp* (1856), used the swamp image, according to David Miller, "as the metaphor for a 'grotesque' social condition," like that of late republican Rome, "festering" with the "revolutionary potential" that could be taken advantage of by a Spartacus (or, three years after the publishing of her novel, a John Brown). Stowe exploits "the popular image of the fugitive slave in the swamp, an image perhaps pivotal in focusing and dramatizing Northern attitudes to the South's peculiar institution." [24]

In Cropsey's *Temple of Neptune, Paestum*, and Bierstadt's *Ruins of Paestum*, the swamp and the history of Spartacus's slave insurrection allegorize the contemporary issue of slavery in the United States. Although the United States was the heir to the noble democratic traditions of the Greeks, the country risked degenerating into a malarial "swamp" over the moral issue of slavery. James Fenimore Cooper compared the setting of the plain at Paestum, formed by the "blue Mediterranean" and the Apennines, to a "beautiful amphitheatre" upon which humans had "performed" the "play" of history for centuries.[25] *Temple of Neptune, Paestum* and *Ruins of Paestum* reminded their mid-nineteenth-century American viewers that, linked closely with the republican past in a historical cycle of death and rebirth, the United States would need to face and withstand its own moral, historical challenges. The images of Paestum, created by Bierstadt and Cropsey for upper- and middle-class patrons and institutions in the Northeast, resonate with an anxious question for their American viewers: Would the new democratic experiment, the United States, created as a natural and divinely-inspired re-emergence of republican institutions "like Greece," also disintegrate into ruins over the role of slavery in American society? ◈

1 Lenora Cranch Scott, *The Life and Letters of Christopher Pearse Cranch* (Boston: Houghton, Mifflin Company, 1917), 147.

2 For more on Cropsey's travels to Paestum, see William S. Talbot, "Jasper F. Cropsey 1823-1900" (PhD diss., New York University, 1972). Talbot mentions Cropsey's Paestum images on pages 105, 387-388, and 412-413. Also see William S. Talbot, *Jasper F. Cropsey 1823-1900* (Washington, DC: Smithsonian Institution Press, 1970), 19-22, and 78. Cropsey painted numerous scenes of Paestum. Some of those recorded during his career include *Temple of Ceres, Paestum*, sold to a Mr. Hawks, February 1853; two *Temple of Paestum* images sold to E. L. Magoon (one of which is now in the collection at Vassar College); and *Evening at Paestum*, exhibited at the National Academy of Design in 1856. See the object research file for *Temple of Neptune, Paestum* at the Newington-Cropsey Foundation, and for *Evening at Paestum* at the Frances Lehman Loeb Art Center, Vassar College. Also, see K. Mathews Hohlstein,

catalogue entries for *Evening at Paestum* and *Temple of Paestum by Moonlight* in Theodore E. Stebbins, Jr., *The Lure of Italy: American Artists and the Italian Experience 1760-1914*, 267-269. For Albert Bierstadt's *Ruins of Paestum*, see its object record at the Minneapolis Institute of Arts; and Nancy K. Anderson and Linda S. Ferber's chronology in *Albert Bierstadt: Art & Enterprise* (New York: The Brooklyn Museum and Hudson Hills, 1990), 122-124.

3 For the history of Paestum from 600 BC to the present, see John Griffiths Pedley, *Paestum: Greeks and Romans in Southern Italy* (London: Thames and Hudson, 1990). For Europeans at Paestum, see Andrew Wilton and Ilaria Bignamini, eds. *Grand Tour: The Lure of Italy in the Eighteenth Century* (London: Tate Gallery Publishing, 1996). Mark Sullivan argues that images of Paestum "provided mid-century Americans with what Henry James called a 'sense of the past,' a feeling of belonging to something larger and more venerable then the American experiment.... [Later,] Americans no longer felt the same pressing need to connect with their Greco-Roman heritage." See Mark Sullivan, "American Artists at Paestum," *American Arts Quarterly* 11, nos. 2 and 3 (Summer/Fall 1994): 27-31. *A handbook for travellers in Southern Italy: being a guide for the continental portion of the kingdom of the two Sicilies; with a travelling map and plans* (London: J. Murray, 1858), 267. I will hereafter list the *Handbook* in these notes as Murray, *Southern Italy*. There are several examples of the popularity of *Murray's Handbook* among American tourists to Italy, including Caroline M. Kirkland, *Holidays Abroad; Or, Europe from the West* (New York: Baker and Scribner, 1849). Kirkland writes that "a faithful reading of *Murray's Guide Books* will give more [information] than one can use," vi; and, in commenting on the "interesting objects" that "thicken upon us as we approach Rome" she mentions that "they are of a kind of which our good friend Murray discourses at full length," 278. The Reverend John E. Edwards notes that his touring party "followed the suggestion of Murray's most excellent guide-book" in John E. Edwards, *Random Sketches and Notes of European Travel in 1856* (New York: Harper & Brothers, 1857), 99. Ohioan Samuel S. Cox mentions that "Not only guides in the human shape become essential, but Murray himself began to compensate us for lugging him about," in Samuel S. Cox, *A Buckeye Abroad; Or, Wanderings in Europe, and the Orient* (Cincinnati: Anderson & Company, 1854), 109.

4 Cropsey was not alone in misidentifying the deities for whom the temples at Paestum were dedicated. Murray notes the "Large Temple of Neptune," the "Basilica," and the "Supposed Temple of Peace" in the map in *Southern Italy*, 268. Modern archaeology knows these ruins as the *Temple of Hera II*, the *Temple of Hera I* (sometimes erroneously still called the Basilica), and the *Temple of Athena*, respectively. See Pedley, *Paestum*. Elias L. Magoon to Cropsey, 17 October 1856, Newington-Cropsey Foundation, quoted in James F. Cooper, *Knights of the Brush: The Hudson River School and the Moral Landscape* (New York: Hudson Hills Press, 1999), 30. A painting by Cropsey, listed as *The Temples of Paestum*, was exhibited at the Royal Academy in 1859 and was mentioned in the *Cosmopolitan Art Journal*. See "Foreign Art Gossip," *Cosmopolitan Art Journal* 3 (June 1859): 131.

5 See Talbot, PhD diss., 18-26. William Smith, ed., *Dictionary of Greek and Roman Biography and Mythology* (London: Taylor and Walton, 1844-49), 591. James Fenimore Cooper, *Gleanings in Europe: Italy* (Albany: State University of New York Press, 1981), 163. Originally receiving a commission from a Miss Douglass, Thomas Cole painted (now in a private collection) *Ruins of the Temples at Paestum*, a pastoral and sublime view of the site with the rising sun shining through the columns of the "Temple of Neptune," in 1832, and exhibited the painting at the National Academy of Design in 1833. In commenting on the painting upon Cole's death in 1848, William Cullen Bryant called Paestum "the grandest and most perfect remains of the architecture of Greece." See *An Exhibition of Paintings by Thomas Cole N.A. from the Artist's Studio, Catskill, New York* (New York: Kennedy Galleries, 1964), 8, quoted in Wendy A. Cooper, *Classical Taste in America 1800-1840* (New York: The Baltimore Museum of Art and Abbeville Press, 1993), 91-92. E. K. Washington, *Echoes of Europe; or, Word Pictures of Travel* (Philadelphia: J. Challen and Son, 1860),610. Murray, *Southern Italy*, 270.

6 Murray, *Southern Italy*, 269. Cooper, *Knights of the Brush*, 161-164.

7 See Wolfgang Stechow, *Catalogue of European and American Paintings and Sculpture in the Allen Memorial Art Museum* (Oberlin: Oberlin College, 1967), 92.

8 Edward Shaw, *Rural Architecture: Consisting of Classic Dwellings, Doric, Ionic, Corinthian, and Gothic, and Details Connected with Each of the Orders* (Boston: James B. Dow, 1843), especially 60-63. Washington, *Echoes of Europe*, 610. Patrick Lee Lucas argues that "a common democratic language emerged in the Old Northwest and the Frontier South in the decades leading toward the Civil War. The Grecian style, based on the architecture of Ancient Greece, provided Americans a means to express their nationality in built form. Cutting across building types and class lines, architecture demonstrated the ability to create a democratic image for individuals, communities, and landscapes in the trans-Appalachian West." See Patrick Lee Lucas, "Realized Ideals: Grecian-Style Buildings as Metaphors for Democracy on the Trans-Appalachian Frontier" (PhD diss., Michigan State University, 2002).

9 Murray, *Southern Italy*, 271. Washington, *Echoes of Europe*, 610 and 612.

10 Washington, *Echoes of Europe*, 613-614, emphasis in original.

11 Hans Biedermann, *Dictionary of Symbolism*, trans. James Hulbert (New York and Oxford: Facts On File, 1992), 224-226.

12 For Gifford and Bierstadt's Southern Italy sojourn, see Ila Weiss, *Poetic Landscape: The Art and Experience of Sanford R. Gifford* (Newark: University of

Delaware Press, 1987), 76-80; Gordon Hendricks, *Albert Bierstadt: Painter of the American West* (New York: Harry N. Abrams, 1974), 44; and Anderson and Ferber, *Albert Bierstadt*, 122-124, and 143.

13 Murray, *Southern Italy*, 269.

14 For Rosa's banditti, see Jonathan Scott, *Salvator Rosa: His Life and Times* (New Haven and London: Yale University Press, 1995), especially 22-23, and 226-227. Murray, *Southern Italy*, 272. Cooper, *Classical Taste*, 161. E. K. Washington also relates the story of the murder, Washington, *Echoes of Europe,* 614.

15 See David C. Miller, *Dark Eden: The Swamp in Nineteenth-Century American Culture* (Cambridge: Cambridge University Press, 1989). For Miller, the transformation of the swamp as "both image and symbol" occurs in the years around the Civil War and involves a change from the swamp as "moral emblem" to "object of aesthetic delight." The paintings by Cropsey and Bierstadt of the swamp at Paestum merge both the moral symbolism and aesthetic enchantment alluded to by Miller.

16 Cooper, *Knights of the Brush*, 161 and 165. Washington, *Echoes of Europe*, 611. For one example, among many, of the mention of malaria and Paestum as "briers, and weeds," see Washington, *Echoes of Europe*, 609-610.

17 Charles Fraser, "Gardening—Its History, Attractiveness, Etc.," *Debow's Review* 25, no. 1 (July 1858): 64. For more on the rose, see Barbara Seward, *The Symbolic Rose* (New York: Columbia University Press, 1960); and the entry for "rose" in Robert Hendrickson, *The Facts on File Encyclopedia of Word and Phrase Origins*, rev. and exp. (New York: Facts on File, 1997), 578-579. I appreciate the Most Rev. James Murray, bishop of the Roman Catholic Diocese of Kalamazoo, for alerting me to the symbolic meaning of the rose in the Roman Empire during his homily, "Pro-Life Sunday," on 22 January 2002, at St. Augustine Cathedral, Kalamazoo, Michigan.

18 Murray, *Southern Italy*, 271-272. Washington, *Echoes of Europe*, 610. Smith, *Dictionary*, 591. George Lunt, *Three Eras of New England, and Other Addresses, with Papers Critical and Biographical* (Boston: Ticknor and Fields, 1857), 192. Margaret Fuller Ossoli, *At Home and Abroad; Or, Things and Thoughts in American and Europe*, ed. Arthur B. Fulller (Boston: Brown, Taggard and Chase, 1860), 250-252. Margaret Fuller defines three types of Americans abroad: the "servile," the "conceited," and the "thinking."

19 William Bartram, *Travels of William Bartram*, ed., Mark Van Doren (New York: Dover, 1955), 138, quoted in Miller, *Dark Eden*, 6. Miller argues that the cultural interest in and the use of the swamp became "an exhilarating and self-renewing experience" and "a metaphor of newly awakened unconscious mental processes," 3. Miller, *Dark Eden*, 81.

20 Paestum was not the only set of ruins in Italy which Americans associated with the institution of slavery. Charles C. Eldredge argues that American images of the Torre dei Schiavi in the Roman Campagna were "readily tied" to "legendary slave battles" of ancient times. See Charles C. Eldredge, "Torre dei Schiavi: Monument and Metaphor," *Smithsonian Studies in American Art* 1 (Fall 1987): 15-33.

21 Murray notes the connection between Spartacus and Paestum. See Murray, *Southern Italy*, 267. David Davidson, *Connection of Sacred and Profane History, Being a Review of the Principal Events in the World*, vol. 2 (New York: R. Carter & Brothers, 1857), 106. For a quick overview of the revolt of the gladiators, see William G. Sinnigen and Arthur E. K. Boak, eds., *A History of Rome to A.D. 565*, 6th ed. (New York: Macmillan Publishing, 1977), 198-199. Thomas Bangs Thorpe, *A voice to America; or, The model republic, its glory, or its fall: with a review of the causes of the decline & failure of the republics of South America, Mexico, & of the Old World; applied to the present crisis in the United States* (New York: E. Walker, 1855), 64-65.

22 Thorpe, *Voice to America*, especially 13-24.

23 Charles Eliot, *The Bible and Slavery* (Cincinnati: L. Swormstedt & A. Poe, 1859), 273. Horace Mann, *Slavery: Letters and Speeches* (Boston: B.B. Mussey, 1853), 222-223.

24 See Eugene D. Genovese, *Roll, Jordan, Roll: The World the Slaves Made* (New York: Vintage Books, 1972), 648-657. Daniel Webster, *The Writings and Speeches of Daniel Webster*, vol. 13 (Boston: Little, Brown, 1903), 434; quoted in Miller, *Dark Eden*, 10. For one example of the Israelite metaphor, see Henry Highland Garnet's 1843 speech before the National Convention of Colored Citizens in Buffalo in *Walker's Appeal, with a Brief Sketch of His Life* (New York, 1848); and the *Weekly Anglo-African* (New York), 28 March 1863, quoted in Roy E. Finkenbine, ed., *Sources of the African-American Past* (New York: Longman, 1997), 63-66. Miller, *Dark Eden*, 57 and 90.

25 Cooper, *Knights of the Brush*, 165.

Type of the antique Rome! Rich reliquary

Of lofty contemplation left to Time

By buried centuries of pomp and power!

At length—at length—after so many days

Of weary pilgrimage and burning thirst,

(Thirst for the springs of lore that in thee lie,)

I kneel, an altered and an humble man,

Amid thy shadows, and so drink within

My very soul thy grandeur, gloom, and glory!

—EDGAR ALLEN POE,
"THE COLISEUM," 1845

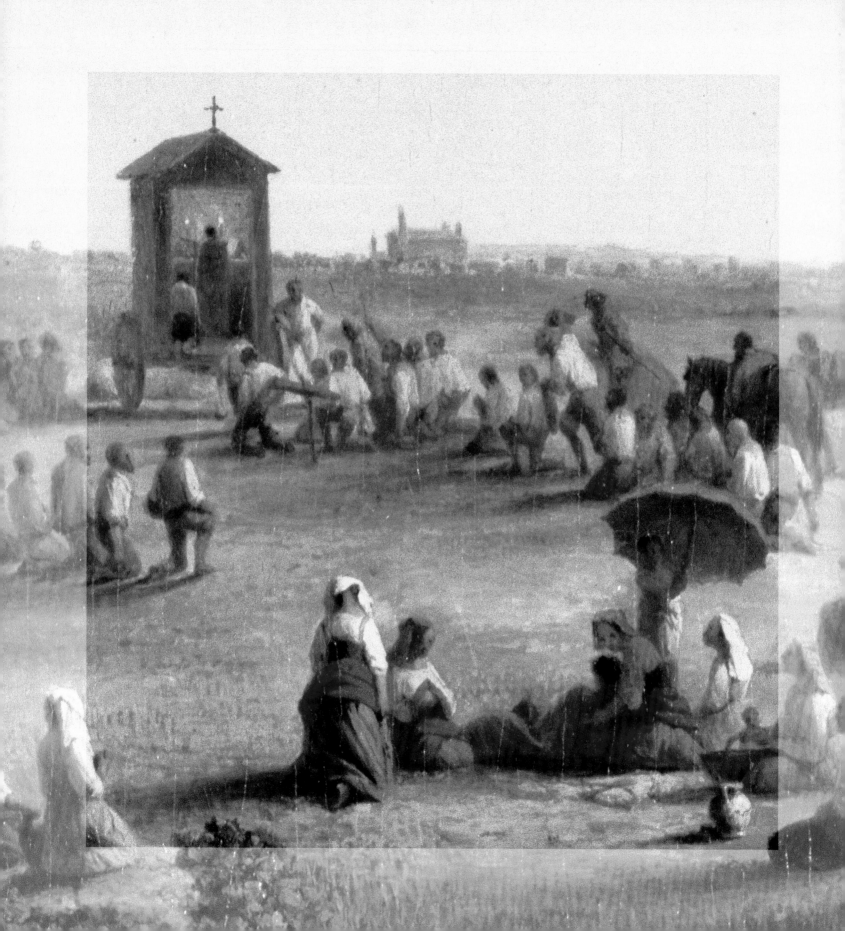

Bibliography

Abbott, John S. C. *The Mother at Home; or the Principles of Maternal Duty, Familiarly Illustrated.*
New York: The American Tract Society, 1833.

Adamson, Jeremy Elwell et al. *Niagara: Two Centuries of Changing Attitudes, 1697-1901.*
Washington, DC: The Corcoran Gallery of Art, 1985.

Alison, Archibald. *Essay on Nature and Principles of Taste.* 1790. Reprint, New York:
G. & C. & H. Carvill, 1830.

America and the Grand Tour: Sanford Robinson Gifford at Home and Abroad. Poughkeepsie, NY:
Vassar College Art Gallery, 1991.

Anbinder, Tyler. *Nativism and Slavery: The Northern Know-Nothings and the Politics of the 1850s.*
New York: Oxford University Press, 1992.

Anderson, Nancy K. and Linda S. Ferber. *Albert Bierstadt: Art and Enterprise.* New York:
Hudson Hills Press, 1990.

Andrews, Keith. *The Nazarenes: A Brotherhood of German Painters in Rome.* Oxford: Oxford
University Press, 1964.

Andrews, Malcolm. *The Search for the Picturesque: Landscape Aesthetics and Tourism in Britain,
1760-1800.* Stanford: Stanford University Press, 1989.

Andrieux, Maurice. *Daily Life in Papal Rome in the Eighteenth Century.* Translated by Mary
Fitton. London: George Allen and Unwin Ltd., 1968.

Atlick, Richard D. *The Shows of London*. Cambridge: Belknap Press, 1978.

Ayres, William et al., eds. *Picturing History: American Painting, 1770-1930*. New York: Rizzoli and Fraunces Tavern Museum, 1993.

Baigell, Matthew. *Albert Bierstadt*. New York: Watson-Guptill, 1981.

_____. *A Concise History of American Painting and Sculpture,* rev. ed. Boulder: Westview Press, 1996.

Baker, Paul R. *The Fortunate Pilgrims: Americans in Italy 1800-1860*. Cambridge: Harvard University Press, 1964.

Barrell, John. *The Dark Side of the Landscape: The Rural Poor in English Painting 1730-1840*. Cambridge: Cambridge University Press, 1980.

Bartram, William. *Travels of William Bartram*. New York: Dover, 1955.

Bedell, Rebecca. *The Anatomy of Nature: Geology and American Landscape Painting 1825-1875*. Princeton and Oxford: Princeton University Press, 2001.

Beecher, Catherine. *A Treatise on Domestic Economy*. 1841. Reprint, New York, 1977.

Beechey, Henry William, ed. *The Literary Works of Sir Joshua Reynolds, First President of the Royal Academy*. 2 vols. London: T. Cadell, 1835.

Berkeley, G. F. H. *Italy in the Making 1815 to 1846*. Cambridge: Cambridge University Press, 1932.

Bermingham, Ann. *Landscape and Ideology: The English Rustic Tradition, 1740-1860*. Berkeley and Los Angeles: University of California Press, 1986.

Biedermann, Hans. *Dictionary of Symbolism*. Translated by James Hulbert. New York and Oxford: Facts On File, 1992.

Bjelajac, David. *Washington Allston, Secret Societies, and the Alchemy of Anglo-American Painting*. Cambridge and New York: Cambridge University Press, 1997.

Black, Jeremy. *The British Abroad: The Grand Tour in the Eighteenth Century*. Phenox Mill: Sutton Publishing, 1992.

Blondell, Ruby et al., trans. and eds. *Women on the Edge: Four Plays by Euripedes*. New York and London: Routledge, 1999.

Blondheim, Menahem. *News over the Wires: The Telegraph and the Flow of Public Information in*

America, 1844-1897. Cambridge and London: Harvard University Press, 1994.

Blumin, Stuart M. *The Emergence of the Middle Class: Social Experience in the American City.* London: Cambridge University Press, 1989.

Boerner, C. G. *Goethe, Boerner und Künstler ihrer Zeit.* Düsseldorf: C. G. Boerner, 1999.

Bounomo, Leonardo. *Backward Glances: Exploring Italy, Reinterpreting America (1831-1866).* Madison, NJ: Fairleigh Dickinson University Press, 1996.

Britsch, Ralph A. *Bierstadt and Ludlow: Painter and Writer in the West.* Provo: Brigham Young University, 1980.

Brooks, Van Wyck. *The Dream of Arcadia: American Writers and Artists in Italy 1760-1915.* New York: E. P. Dutton & Co., 1958.

Bryant, William Cullen. *Funeral Oration Occasioned by the Death of Thomas Cole.* New York: D. Appleton, 1848.

Bryant, William Cullen II and Thomas G. Voss, eds. *The Letters of Willam Cullen Bryant.* Vol. 4. New York: Fordham University Press, 1984.

Burnham, Patricia M. and Lucretia Hoover Giese, eds. *Redefining American History Painting.* Cambridge and New York: Cambridge University Press, 1995.

Burns, Sarah. *Inventing the Modern Artist: Art & Culture in Gilded Age America.* New Haven and London: Yale University Press, 1996.

————. *Pastoral Inventions: Rural Life in Nineteenth-Century American Art and Culture.* Philadelphia: Temple University Press, 1989.

Buell, Lawrence. *New England Literary Culture: From Revolution through Renaissance.* Cambridge: Harvard University Press, 1986.

Calo, Mary Ann, ed. *Critical Issues in American Art: A Book of Readings.* Boulder: Westview Press, 1998.

Campbell, Willam P. *John Gadsby Chapman.* Washington, DC: National Gallery of Art, 1962.

Carbone, Teresa and Patricia Hills. *Eastman Johnson: Painting America.* New York: Brooklyn Museum of Art and Rizzoli, 1999.

Champney, Benjamin. *Sixty Years' Memories of Art and Artists.* Woburn, MA: Wallace and Andrews, 1900.

Chaney, Edward. *The Evolution of the Ground Tour*. London: Frank Cass, 1998.

Christensen, Carol and Thomas. *The U.S.-Mexican War*. San Francisco: Bay Books, 1998.

Cikovsky, Nicolai, Jr., and Michael Quick. *George Inness*. Los Angeles: Los Angeles County Museum of Art, 1985.

_____. *American Paintings at the High Museum of Art*. New York and Atlanta: Hudson Hills Press and the High Museum of Art, 1994.

Coffey, John W. *Twilight of Arcadia: American Landscape Painters in Rome, 1830-1880*. Brunswick, ME: Bowdoin College Museum of Art, 1987.

Colbert, Charles. *A Measure of Perfection: Phrenology and the Fine Arts in America*. Chapel Hill: The University of North Carolina Press, 1997.

Cooper, James Fenimore. *Knights of the Brush: The Hudson River School and the Moral Landscape*. New York: Hudson Hills Press, 1999.

Cooper, Wendy A. *Classical Taste in America 1800-1840*. New York: The Baltimore Museum of Art and Abbeville Press, 1993.

Coppa, Frank. *Pope Pius IX: Crusader in a Secular Age*. Boston, 1979.

Cowdrey, Mary Bartlett. *American Academy of Fine Arts and American Art-Union, Exhibition Record 1816-1852*. New York: New-York Historical Society, 1953.

Cranch, Christopher Pearse. *Bird and the Bell, With Other Poems*. Boston: James R. Osgood, 1875.

Daelli, G. *A Relic of the Italian Revolution of 1849. Album of Fifty Line Engravings, Executed on Copper, By the Most Eminent Artists at Rome in 1849; Secreted from the Papal Police After the "Restoration of Order," And Just Imported into America*. New Orleans: Gabici's Music Stores, [1850?].

Davidson, David. *Connection of Sacred and Profane History, Being a Review of the Principal Events in the World*. Vol 2. New York: R. Carter & Brothers, 1857.

Davis, John. *The Landscape of Belief: Encountering the Holy Land in Nineteenth-Century American Art and Culture*. Princeton: Princeton University Press, 1996.

Dickenson, Donna. *Margaret Fuller: Writing a Woman's Life*. New York: St. Martin's Press, 1993.

Di Scala, Spencer M. *Italy: From Revolution to Republic 1700 to the Present*. Boulder: Westview Press, 1995.

Doezema, Marianne and Elizabeth Milroy, eds. *Reading American Art.* New Haven: Yale University Press, 1998.

Dolan, Jay P. *The Immigrant Church: New York's Irish and German Catholics, 1815-1865.* Baltimore: Johns Hopkins University Press, 1975.

Driscoll, John Paul. *John F. Kensett Drawings.* University Park: Museum of Art, The Pennsylvania State University, 1978.

DuBois, Ellen Carol. *Feminism and Suffrage: The Emergence of an Independent Women's Movement in America, 1848-1869.* Ithaca: Cornell University Press, 1999.

Dwight, Theodore. *The Roman Republic of 1849; with Accounts of the Inquisition, and the Siege of Rome.* New York: R. Van Dien, 1851.

Edwards, John E. *Random Sketches and Notes of European Travel in 1856.* New York: Harper & Brothers, 1857.

Eldredge, Charles. *The Arcadian Landscape: Nineteenth Century American Painters in Italy.* Lawrence: University of Kansas Museum of Art, 1972.

_____. "Torre Dei Schiavi: Monument and Metaphor." *Smithsonian Studies in American Art* 1 (Fall 1987): 15-33.

Eliot, Charles. *The Bible and Slavery.* Cincinnati: L. Swormstedt & A. Poe, 1859.

Emerson, Ralph Waldo. *The Journals and Miscellaneous Notebooks of Ralph Waldo Emerson.* 16 vols. Edited by William H. Gilman. Cambridge: Harvard University Press, 1960-82.

_____. *The Letters of Ralph Waldo Emerson.* 8 vols. Edited by Ralph L. Rusk. New York, 1939.

Epstein, Barbara L. *The Politics of Domesticity: Women, Evangelism, and Temperance in Nineteenth-Century America.* Middletown: Wesleyan University Press, 1981.

Evans, R. J. W. and Hartmut Pogge von Strandmann, eds. *The Revolutions in Europe 1849-1849: From Reform to Reaction.* Oxford and New York: Oxford University Press, 2000.

Evans, Sara M. *Born for Liberty: A History of Women in America.* New York: The Free Press, 1989.

Finkerbine, Roy E., ed. *Sources of the African- American Past.* New York: Longman, 1997.

Foner, Eric. *Free Soil, Free Labor, Free Men: The Ideology of the Republican Party Before the Civil War,* new ed. Oxford: Oxford University Press, 1995.

_____. *Reconstruction: America's Unfinished Revolution 1863-1877.* New York: Harper & Row, 1988.

_____. *The Story of American Freedom.* New York and London: W. W. Norton and Company, 1998.

Formisano, Ronald P. *The Transformation of Political Culutre: Massachusetts Parties, 1790s-1840s.* New York: Oxford University Press, 1983.

Franchot, Jenny. *Roads to Rome: The Antebellum Protestant Encounter with Catholicism.* Berkeley: University of California Press, 1994.

Furth, Leslie. "'The Modern Medea' and Race Matters: Thomas Satterwhite Noble's *Margaret Garner.*" *American Art* 12 (1998): 36-57.

Gaehtgens, Thomas W. and Heinz Ickstadt, eds. *American Icons: Transatlantic Perspectives on Eighteenth- and Nineteenth-Century American Art.* Santa Monica and Chicago: Getty Center for the History of Art and Humanities and the University of Chicago Press, 1992.

Galassi, Peter. *Corot in Italy: Open Air Painting and the Classical-Landscape Tradition.* New Haven and London: Yale University Press, 1991.

Gallman, J. Matthew. *Receiving Erin's Children: Philadelphia, Liverpool, and the Irish Famine Migration, 1845-1855.* Chapel Hill: University of North Carolina Press, 2000.

Gell, William. *The Topography of Rome and Its Vicinity.* London: Henry G. Bohn, 1846.

Genovese, Eugene D. *Roll, Jordan, Roll: The World the Slaves Made.* New York: Vintage Books, 1972.

Gribben, Arthur, ed. *The Great Famine and the Irish Diaspora in America.* Amherst: University of Massachusetts Press, 1999.

Grimal, Pierre. *The Dictionary of Classical Mythology.* Translated by A. R. Maxwell-Hyslop. Oxford and New York: Blackwell, 1986.

Grubar, Francis S. "Richard Caton Woodville: An American Artist, 1825 to 1855." PhD diss., Johns Hopkins University, 1966.

Grzesiak, Marion. *'The Crayon' and the American Landscape.* Montclair, NJ: Montclair Art Museum, 1993.

Guthrie, Stewart Elliott. *Faces in the Clouds: A New Theory of Religion.* New York and Oxford: Oxford University Press, 1993.

Haltman, Kenneth. "Antipastoralism in Winslow Homer," *The Art Bulletin* 80 (March 1998): 112.

_____. "The Politics of Geologic Reverie: Figures of Source and Origin in Samuel Seymour's Landscapes of the Rocky Mountains," *Huntington Library Quarterly* 59 (1997): 303-347.

_____. "Figures in a Western Landscape: Reading the Art of Titian Ramsay Peale from the Long Expedition to the Rocky Mountains, 1819-1820." PhD diss., Yale University, 1992.

Halttunen, Karen. *Confidence Men and Painted Women: A Study of Middle-Class Culture in America, 1830-1870*. New Haven and London: Yale University Press, 1982.

Handlin, Oscar. *Boston's Immigrants: A Study in Acculturation,* rev. ed. Cambridge: Harvard University Press, 1979.

Hare, Augustus J. C. *Walks in Rome,* 4th ed. New York: George Routledge & Sons, 1874.

Harvey, Eleanor Jones. *The Painted Sketch: American Impressions from Nature, 1830-1880*. Dallas and New York: Dallas Museum of Art in association with H. N. Abrams, 1998.

Hatch, Nathan O. *The Democratization of American Christianity*. New Haven: Yale University Press, 1989.

Hawthorne, Nathaniel. *The Marble Faun or The Romance of Monte Beni*. New York: Signet Classic, 1980.

_____. *The Scarlet Letter*. New York: Signet Classic, 1999.

Hazard, Paul. *The European Mind, 1680-1715*. New York: New American Library, 1963.

Hendricks, Gordon. *Albert Bierstadt: Painter of the American West*. New York: Harry N. Abrams, 1973.

Hendrickson, Robert. *The Facts on File Encyclopedia of Word and Phrase Origins,* rev. and exp. New York: Facts on File, 1997.

Hibbert, Christopher. *The Grand Tour.* London: Thames Methuen, 1987.

Hilen, Andrew, ed. *The Letters of Henry Wadsworth Longfellow*. Cambridge: Belknap Press, 1966.

Hillard, George Stillman. *Six Months in Italy*. 2 vols. Boston: Ticknor, Reed, and Fields, 1853.

Holcomb, Adele M. "The Bridge in the Middle Distance: Symbolic Elements in Romantic Landscape," *The Art Quarterly* 37, no.1 (1974): 31-58.

Holt, Michael F. *Political Parties and American Political Development from the Age of Jackson to the Age of Lincoln*. Baton Rouge: Louisiana State University Press, 1992.

_____. *The Rise and Fall of the American Whig Party: Jacksonian Politics and the Onset of the Civil War*. New York and Oxford: Oxford University Press, 1999.

The Home Book of the Picturesque, Or American Scenery, Art and Literature. New York: G. P. Putnam, 1851.

Howat, John K. *John Frederick Kensett 1816-1872*. New York: The American Federation of Arts, 1968.

_____. *John Frederick Kensett: A Retrospective Exhibition*. Saratoga Springs: Hathorn Gallery, Skidmore College, 1967.

Hoyle, Pamela. *A Climate for Art: The History of the Boston Athenaeum Gallery 1827-1873*. Boston: Boston Athenaeum, 1980.

Hughes, Robert. *American Visions: The Epic History of Art in America*. New York: Alfred A. Knopf, 1997.

Huntington, David Carew. *The Landscapes of Frederic Edwin Church: Vision of an American Era*. New York: Braziller, 1966.

Huntzicker, William E. *The Popular Press, 1833-1865*. Westport, CT: Greenwood Press, 1999.

Husch, Gail E. *Something Coming: Apocalyptic Expectation and Mid-Nineteenth-Century American Painting*. Hanover: University Press of New England, 2000.

Hutton, William, ed. *The Toledo Museum of Art American Paintings*. Toledo: The Toledo Museum of Art, 1979.

Irwin, William. *The New Niagara: Tourism, Technology, and the Landscape of Niagara Falls, 1776-1917*. University Park: Pennsylvania State University Press, 1996.

Jacobson, Matthew Frye. *Whiteness of a Different Color: European Immigrants and the Alchemy of Race*. Cambridge and London: Harvard University Press, 1998.

Jaffe, Irma B., ed. *The Italian Presence in American Art, 1760-1860*. New York and Rome: Fordham University Press and Instituto della Enciclopedia Italiana, 1989.

_____, ed. *The Italian Presence in American Art, 1860-1920*. New York and Rome: Fordham University Press and Instituto della Enciclopedia Italiana, 1992.

Jarves, James Jackson. *Italian Sights and Papal Principles Seen Through American Spectacles*. New York: Harper & Brothers, 1856.

Johannsen, Robert W. *To the Halls of the Montezumas: The Mexican War in the American Imagination*. New York: Oxford University Press, 1985.

Johns, Elizabeth. *American Genre Painting: The Politics of Everyday Life*. New Haven: Yale University Press, 1991.

_____. "Histories of American Art: The Changing Quest," *Art Journal* 44 (Winter 1984): 338-344.

_____ et al. *New Worlds from Old: 19th Century Australian & American Landscapes*. Canberra and Hartford: National Gallery of Australia and Wadsworth Athenaeum, 1998.

Johnson, Deborah J., ed. *William Sidney Mount: Painter of American Life*. New York: American Federation of Arts, 1998.

Kasson, John F. *Rudeness & Civility: Manners in Nineteenth-Century Urban America*. New York: Hill and Wang, 1990.

Kasson, Joy F. *Artistic Voyagers: Europe and the American Imagination in the Works of Irving, Allston, Cole, Cooper, and Hawthorne*. Westport, CT: Greenwood Press, 1982.

_____. *Marble Queens and Captives: Women in Nineteenth-Century American Sculpture*. New Haven: Yale University Press, 1990.

Kelly, Franklin. *Frederic Edwin Church and the National Landscape*. Washington, DC: Smithsonian Institution Press, 1988.

Ketner, Joseph D. II and Tammenga, Michael J. *The Beautiful, The Sublime, and The Picturesque: British Influences on American Landscape Painting*. St. Louis: Washington University Art Gallery, 1984.

Kirkland, Caroline M. *Holidays Abroad; Or, Europe from the West*. New York: Baker and Scribner, 1849.

Kirshenblatt-Gimblett, Barbara. *Destination Culture: Tourism, Museums, and Heritage*. Berkeley: University of California Press, 1998.

Knepler, Henry. *The Gilded Stage*. London: Constable, 1968.

Knight, Richard Payne. *An Analytical Inquiry into the Principles of Taste*, 4th ed. London: T. Payne, 1808.

Kohl, Lawrence Frederick. *The Politics of Individualism: Parties and the American Character in the Jacksonian Era.* New York and Oxford: Oxford University Press, 1989.

Leavitt, Thomas A. "The Life, Work, and Significance of George Loring Brown, American Painter." PhD diss., Harvard University, 1957.

Lester, C. Edwards. *My Consulship.* 2 vols. New York: Cornish, Lamport & Co., 1853.

Levine, Bruce. "Conservatism, Nativism, and Slavery: Thomas R. Whitney and the Origins of the Know-Nothing Party." *The Journal of American History* 88, no. 2 (September 2001): 455-488.

Levine, Lawrence W. *Highbrow/Lowbrow: The Emergence of a Cultural Hierarchy in America.* Cambridge and London: Harvard University Press, 1988.

LoRomer, David. *Merchants and Reform in Livorno 1814-1868.* Berkeley: University of California Press, 1987.

Lovell, Margaretta M. *Venice: The American View, 1860-1920.* San Francisco: The Fine Arts Museums of San Francisco, 1984.

Lovett, Clara M. *The Democratic Movement in Italy 1830-1876.* Cambridge and London: Harvard University Press, 1982.

Lubin, David M. *Picturing a Nation: Art and Social Change in Nineteenth-Century America.* New Haven and London: Yale University Press, 1994.

Lucas, Patrick Lee. "Realized Ideals: Grecian-Style Buildings as Metaphors for Democracy on the Trans-Appalachian Frontier." PhD diss., Michigan State University, 2002.

Lunt, George. *Three Eras of New England, and Other Addresses, with Papers Critical and Biographical.* Boston: Ticknor and Fields, 1857.

MacCannell, Dean. *The Tourist: A New Theory of the Leisure Class.* New York: Schocken, 1989.

MacFarlane, Charles. *A Glance at Revolutionized Italy.* 2 vols. London: Smith, Elder, and Co., 1849.

Mann, Horace. *Slavery: Letters and Speeches.* Boston: B. B. Mussey, 1853.

Manoguerra, Paul Andrew. "Classic Ground: American Paintings and the Italian Encounter, 1848-1860." PhD diss., Michigan State University, 2002.

_____. "Anti-Catholicism in Albert Bierstadt's *Roman Fish Market, Arch of Octavius*," *Nineteenth-Century Art Worldwide* 2, no. 1 (Winter 2003). http://19thcartworldwide. org/winter_03/articles/mano.html.

Mariotti, L. *Italy in 1848.* London: Chapman and Hall, 1851.

Martin, Robert K. and Leland S. Person, eds. *Roman Holidays: American Writers and Artists in Nineteenth-Century Italy.* Iowa City: University of Iowa Press, 2002.

Martineau, Harriet. *Society in America.* 3 vols. 1837. Reprint, New York: AMS Press, 1966.

Matthiessen, F. O. *American Renaissance: Art and Expression in the Age of Emerson and Whitman.* London and New York: Oxford University Press, 1941.

McCourbey, John W., ed. *American Art 1700-1960: Sources and Documents.* Englewood Cliffs, NJ: Prentice-Hall, 1965.

McKinsey, Elizabeth. *Niagara Falls: Icon of the American Sublime.* New York: Cambridge University Press, 1985.

McPherson, James M. *Ordeal By Fire.* 3 vols. New York: McGraw-Hill, 1982.

Melder, Keith E. *Beginnings of Sisterhood: The American Woman's Rights Movement, 1800-1850.* New York: Schocken Books, 1977.

Miller, Angela. *The Empire of the Eye: Landscape Representation and American Cultural Politics, 1825-1875.* Ithaca: Cornell University Press, 1993.

Miller, David C., ed. *American Iconology: New Approaches to Nineteenth-Century Art and Literature.* New Haven and London: Yale University Press, 1993.

_____. *Dark Eden: The Swamp in Nineteenth-Century American Culture.* Cambridge: Cambridge University Press, 1989.

Miller, Kerby A. *Emigrants and Exiles: Ireland and the Irish Exodus to North America.* New York: Oxford University Press, 1985.

Mitchell, W. J. T. *Iconology: Image, Text, Ideology.* Chicago: University of Chicago Press, 1986.

_____, ed. *Landscape and Power.* Chicago: University of Chicago Press, 1994.

Mulkern, John R. *The Know-Nothing Party in Massachusetts: The Rise and Fall of a People's Movement.* Boston: Northeastern University Press, 1990.

Murray's Handbook of Rome and Its Environs; Forming Part II of the Handbook for Travellers in Central Italy, 5th ed. London: John Murray, 1858.

Murray's Handbook for Travellers in Southern Italy and Sicily. London: John Murray, 1858.

Myers, Kenneth. *The Catskills: Painters, Writers, and Tourists in the Mountains, 1820-1895.* Yonkers and Hanover: Hudson River Museum and University Press of New England, 1988.

Myerson, Joel, ed. *Critical Essays on Margaret Fuller.* Boston: G. K. Hall, 1980.

Noble, Louis Legrand. *The Life and Works of Thomas Cole.* Edited by Elliot S. Vessell. Cambridge: Harvard University Press, 1964; original, New York, 1853.

Norton, Anne. *Alternative Americas: A Reading of Antebellum Political Culture.* Chicago: University of Chicago Press, 1986.

Norton, Charles Eliot. *Notes of Travel and Study in Italy.* Boston: Ticknor and Fields, 1855.

Novak, Barbara. *American Painting of the Nineteenth Century: Realism, Idealism, and the American Experience,* 2nd ed. New York : Harper & Row, 1979.

————. *Nature and Culture: American Landscape Painting 1825-1875,* rev. ed. New York and Oxford: Oxford University Press, 1995.

Nygren, Edward J., ed. *Views and Visions: American Landscape before 1830.* Washington, DC: Corcoran Gallery of Art, 1986.

Nylander, Jane C. *Our Own Snug Fireside: Images of the New England Home 1760-1860.* New Haven and London: Yale University Press, 1993.

O'Leary, Elizabeth L. *At Beck and Call: The Representation of Domestic Servants in Nineteenth-Century American Painting.* Washington and London: Smithsonian Institution Press, 1996.

Osgood, Reverend Samuel. *Proceedings At a Meeting of the Century Association, Held in Memory of John F. Kensett.* New York, 1872.

Ossoli, Margaret Fuller. *At Home and Abroad; Or, Things and Thoughts in America and Europe.* Edited by Arthur B. Fuller. Boston: Brown, Taggard and Chase, 1860.

Parker, Nathaniel Willis. *Pencillings by the Way: Written During Some Years of Residence and Travel in Europe.* Detroit: Kerr, Doughty & Lapham, 1853.

Parry, Ellwood C. III. *The Art of Thomas Cole: Ambition and Imagination.* Newark, London and Toronto: University of Delaware Press and Associated University Presses, 1988.

Pedley, John Griffiths. *Paestum: Greeks and Romans in Southern Italy.* London: Thames and Hudson, 1990.

Perkins, Robert F. et al. *The Boston Athenaeum Art Exhibition Index 1827-1874.* Boston and Cambridge: The Library of the Boston Athenaeum and MIT Press, 1980.

Pletcher, David. *The Diplomacy of Annexation: Texas, Oregon, and the Mexican War.* Columbia: University of Missouri Press, 1973.

Plowden, Helen Haseltine. *William Stanley Haseltine: Sea and Landscape Painter (1835-1900).* London: Frederick Muller, 1947.

Pinto, Michelangelo. *Don Pirlone a Roma: memorie di un italiano dal 1 settembre 1848 al 31 dicembre 1850.* 3 vols. Torino: Alessandro Fontana, 1850.

Poe, Edgar Allan. *The Raven and Other Poems by Edgar Allan Poe.* New York: Wiley and Putnam, 1845.

Potter, David M. *The Impending Crisis 1848-1861.* Compiled and edited by Don E. Fehrenbacher. New York: Harper & Row, 1976.

Powell, Cecilia. *Turner in the South: Rome, Napels, Florence.* New Haven and London: Yale University Press, 1987.

Proceedings of a Public Meeting of the Citizens of the City and County of Philadelphia, Held January 6, 1848, to Express Their Cordial Approval of the Liberal Policy of Pope Pius IX. in His Administration of the Temporal Government of Italy. Philadelphia: Jos. Severns & Co., 1848.

Proceedings of the public demonstration of sympathy with Pope Pius IX and with Italy in the city of New York on Monday, November 29, A.D. 1847. New York: W. Van Norden, 1847.

Prown, Jules David and Kenneth Haltman, eds. *American Artifacts: Essays in Material Culture.* East Lansing: Michigan State University Press, 2000.

_____. *American Painting: From Its Beginnings to the Armory Show.* Geneva and New York: Skira and Rizzoli, 1987.

Reynolds, Larry J. *European Revolutions and the American Literary Renaissance.* New Haven: Yale University Press, 1988.

Riall, Lucy. *The Italian Risorgimento: State, Society and National Unification.* London and New York: Routledge, 1994.

Richardson E. P. and Otto Whittmann, Jr. *Travelers in Arcadia: American Artists in Italy, 1830-1875.* Detroit and Toledo: Detroit Institute of Arts and Toledo Museum of Art, 1951.

Ristori, Adelaide. *Memoirs and Artistic Studies of Adelaide Ristori.* Translated by G. Mantelli. New York: Doubleday, 1907.

Roberts, Brian. *American Alchemy: The California Gold Rush and Middle-Class Culture.* Chapel Hill: University of North Carolina Press, 2000.

Robertson, Priscilla. *Revolutions of 1848: A Social History.* Princeton: Princeton University Press, 1971.

Roeder, George H., Jr. "Filling in the Picture: Visual Culture." *Reviews in American History* 26, no. 1 (1998): 275-293.

Rosenberg, Charles E. *The Cholera Years: The United States in 1832, 1849, and 1866.* Chicago: University of Chicago Press, 1987.

Rossi, Joseph. *The Image of America in Mazzini's Writings.* Madison: University of Wisconsin Press, 1954.

Rudman, Harry W. *Italian Nationalism and English Letters: Figures of the Risorgimento and Victorian Men of Letters.* London: George Allen & Unwin, 1940.

Schlereth, Thomas J., comp. and ed. *Material Culture Studies in America.* Nashville: American Association for State and Local History, 1982.

Schlesinger, Arthur M., Jr. *The Age of Jackson.* Boston: Little, Brown and Company, 1945.

Schudson, Michael. *Discovering the News: A Social History of American Newspapers.* New York: Basic Books, 1978.

Scott, Jonathan. *Salvator Rosa: His Life and Times.* New Haven and London: Yale University Press, 1995.

Scott, Lenora Cranch. *The Life and Letters of Christopher Pearse Cranch.* Boston: Houghton, Mifflin Company, 1917.

Scully, Vincent. *New World Visions of Household Gods & Sacred Places: American Art and the Metropolitan Museum of Art 1650-1914.* Boston: Little, Brown and Company, 1988.

Sears, John F. *Sacred Places: American Tourist Attractions in the Nineteenth Century.* Amherst: University of Massachusetts Press, 1998.

Sellers, Charles Coleman. *Mr. Peale's Museum: Charles Willson Peale and the First Popular Museum of Natural Science and Art.* New York: W. W. Norton, 1980.

Seward, Barbara. *The Symbolic Rose.* New York: Columbia University Press, 1960.

Shaw, Edward. *Rural Architecture: Consisting of Classic Dwellings, Doric, Ionic, Corinthian, and Gothic, and Details Connected with Each of the Orders.* Boston: James B. Dow, 1843.

Silliman, Benjamin. *A Visit to Europe in 1851.* 2 vols. New York: G. P. Putnam, 1854.

Simon, Janice. "'The Crayon', 1855-1861: The Voice of Nature in Criticism, Poetry, and the Fine Arts." PhD diss., The University of Michigan, 1990.

Simpson, Marc, Andrea Henderson and Sally Mills. *Expressions of Place: The Art of William Stanley Haseltine.* San Francisco: The Fine Arts Museums of San Francisco, 1992.

_____. *The Rockefeller Collection of American Art at The Fine Arts Museums of San Francisco.* San Francisco: The Fine Arts Museums of San Francisco, 1994.

Sinnigen, William G. and Arthur E. R. Boak. *A History of Rome to A.D. 565,* 6th ed. New York: Macmillan Publishing, 1977.

Smith, Denis Mack. *Mazzini.* New Haven: Yale University Press, 1994.

Smith, Timothy L. *Revivalism and Social Reform: American Protestantism on the Eve of the Civil War.* Baltimore: Johns Hopkins University Press, 1980.

Smith, William, ed. *Dictionary of Greek and Roman Biography and Mythology.* 3 vols. London: Taylor and Walton, 1844-49.

Soria, Regina. *Dictionary of Nineteenth-Century American Artists in Italy, 1760-1914.* East Brunswick, NJ: Associated University Presses, 1982.

Sperber, Jonathan. *The European Revolution 1848-1851.* Cambridge: Cambridge University Press, 1984.

Stampp, Kenneth M. *America in 1857: A Nation on the Brink.* Oxford: Oxford University Press, 1990.

Stansell, Christine. *City of Women: Sex and Class in New York 1789-1860.* Urbana and Chicago: University of Chicago Press, 1982.

Stebbins, Theodore E., Jr. *The Life and Work of Martin Johnson Heade: A Critical Analysis and Catalogue Raisonné*. New Haven and London: Yale University Press, 2000.

_____. *The Lure of Italy: American Artists and The Italian Experience, 1760-1914*. Boston: Museum of Fine Arts, Boston, 1992.

Stechow, Wolfgang. *Catalogue of European and American Paintings and Sculpture in the Allen Memorial Art Museum*. Oberlin: Oberlin College, 1967.

Stein, Roger. *John Ruskin and Aesthetic Thought in America 1840-1900*. Cambridge: Harvard University Press, 1967.

Sterling, Charles. *La nature morte de l'antiquité a nos jours*. Paris: Editions Pierre Tisné, 1952.

Stern, Madeleine B. *The Life of Margaret Fuller,* 2nd ed. New York: Greenwood Press, 1991.

Story, Ronald. "Class and Culture in Boston: The Athenaeum, 1807-1860." *American Quarterly* 27, no. 2 (1975): 196-198.

Story, William Wetmore. *Roba di Roma*, 7th ed. London: Chapman and Hall, 1876.

Strickler, Susan E., ed. *John Frederick Kensett, An American Master.* New York: W. W. Norton & Co., 1985.

Suetonius. *The Twelve Caesars.* Translated by Robert Graves. London: Penguin Books, 1957.

Sunderland, John. "Uvedale Price and the Picturesque." *Apollo 93* (March 1971): 197-203.

Sweeney, J. Gray. "The Nude of Landscape Painting: Emblematic Personification in the Art of the Hudson River School," *Smithsonian Studies in American Art* 3, no. 4 (Fall 1989): 43-65.

_____. "A 'Very Peculiar' Picture: Martin Johnson Heade's *Thunderstorm Over Narragansett Bay,*" *Archives of American Art Journal* 28, no. 4 (1988): 2-14.

Sweetman, John. *The Artist and the Bridge 1700-1920*. Brookfield, VT: Ashgate, 1999.

Talbot, William S. *Jasper F. Cropsey 1823-1900*. Washington: Smithsonian Institution Press, 1970.

_____. "Jasper F. Cropsey 1823-1900." PhD diss., New York University, 1972.

Tangires, Helen. "Meeting on Common Ground: Public Markets and Civic Culture in Nineteenth-Century America." PhD diss., The George Washington University, 1999.

Thoreau, Henry David. *A Writer's Journal.* Edited by Laurence Stapleton. New York: Dover, 1960.

Thorpe, Thomas Bangs. *A voice to America; or, The model republic, its glory, or its fall: with a review of the causes of the decline & failure of the republics of South America, Mexico, & of the Old World; applied to the present crisis in the United States.* New York: E. Walker, 1855.

Truettner, William H., ed. *The West as America: Reinterpreting Images of the Frontier, 1820-1920.* Washington: Smithsonian Institution Press, 1991.

———— and Roger B. Stein, eds. *Picturing Old New England: Image and Memory.* Washington, DC and New Haven: National Museum of American Art, Smithsonian Institution, and Yale University Press, 1999.

———— and Alan Wallach, eds. *Thomas Cole: Landscape into History.* New Haven and Washington, DC: Yale University Press and National Museum of American Art, Smithsonian Institution, 1994.

Tuckerman, Henry T. *Book of the Artists: American Artist Life Comprising Biographical and Critical Sketches of American Artists: Preceded By an Historical Account of the Rise & Progress of Art in America.* 1867. Reprint, New York: James F. Carr, 1966.

———— *The Italian Sketchbook,* 3rd ed. rev. and enl. New York: J. C. Riker, 1848.

Tynn, Marshall, ed. *Thomas Cole: The Collected Essays and Prose Sketches.* St. Paul: John Colet Press, 1980.

Urry, John. *The Tourist Gaze: Leisure and Travel in Contemporary Societies.* London: Sage Publications, 1990.

Vance, William L. *America's Rome.* 2 vols. New Haven and London: Yale University Press, 1989.

von Mehren, Joan. *Minerva and the Muse: A Life of Margaret Fuller.* Amherst: University of Massachusetts Press, 1994.

Walker, Andrew. "American Art & the Civil War." *American Art Reveiw* 2, no. 5 (1999): 126-131, 207.

Wallach, Alan. *Exhibiting Contradiction: Essays on the Art Museum in the United States.* Amherst: The University of Massachusetts Press, 1998.

Washington, E. K. *Echoes of Europe; or, Word Pictures of Travel.* Philadelphia: J. Challen & Son, 1860.

Weiskel, Thomas. *The Romantic Sublime: Studies in the Structure and Psychology of Transcendence.* Baltimore and London: Johns Hopkins University Press, 1976, 1986.

Weiss, Ila. *Poetic Landscape: The Art and Experience of Sanford R. Gifford.* Newark: University of Delaware Press, 1987.

Whitney, Thomas R. *A Defence of the American Policy, as Opposed to the Encroachments of Foreign Influence, and Especially to the Interference of the Papacy in the Political Interests and Affairs of the United States.* New York: De Witt & Davenport, 1856.

Wilmerding, John, ed. et al. *American Light: The Luminist Movement, 1850-1875: Paintings, Drawings, Photographs.* Washington, DC: National Gallery of Art, 1980.

_____. *American Views: Essays on American Art.* Princeton: Princeton University Press, 1991.

Wilton, Andrew, and Ilaria Bignamini, eds. *Grand Tour: The Lure of Italy in the Eighteenth Century.* London: Tate Gallery Publishing, 1996.

_____. *The Art of Alexander and John Robert Cozens.* New Haven: Yale Center for British Art, 1980.

Wolf, Bryan J. "All the World's a Code: Art and Ideology in Nineteenth-Century American Painting." *Art Journal* 44 (Winter 1989): 328-337.

_____. *Romantic Re-Vision: Culture and Consciousness in Nineteenth-Century American Painting and Literature.* Chicago: University of Chicago Press, 1982.

Wood, Gordon S. *The Creation of the American Republic 1776-1787,* new ed. Chapel Hill and London: The University of North Carolina Press, 1998.

_____. *The Radicalism of the American Revolution.* New York: Vintage Books, 1991.

Worthington, Ann Fairfax. *Toward a More Perfect Union: Virtue and the Formation of American Republics.* New York and Oxford: Oxford University Press, 1991.